SUPPORT FOR THE ARTS

IN ENGLAND AND WALES

D1322381

A REPORT TO THE CALOUSTE GULBENKIAN FOUNDATION BY

Lord Redcliffe-Maud

Master of University College, Oxford

Calouste Gulbenkian Foundation
UK and Commonwealth Branch
London 1976

© Calouste Gulbenkian Foundation 1976
98 Portland Place, London WIN 4ET

Designed and produced by Ruari McLean Associates Ltd,
Dollar, Scotland FK14 7PT

Printed in Great Britain by T. & A. Constable Ltd,
Edinburgh EH7 4NF

ISBN 0 903319 06 3

second impression September 1976
third impression April 1979

SUPPORT FOR THE ARTS
IN ENGLAND AND WALES

Contents

APPENDICES

Preface

This enquiry was initiated by the Foundation at the request of the Standing Conference of Regional Arts Associations and the Arts Council of Great Britain.

We were most happy that so distinguished a person as Lord Redcliffe-Maud accepted the Foundation's invitation to undertake the enquiry. It would have been impossible to find another person so well qualified for the job. His long and eminent career in public service and his unrivalled knowledge of local government add special authority to this report which reflects too his enjoyment of, and enthusiasm for, the arts.

Therefore, on behalf of the Foundation, I thank Lord Redcliffe-Maud and Anthony Wraight for their tireless work informed by wide-ranging journeys which have allowed them to see what is actually happening to the arts and artists today throughout England and Wales. The result is a comprehensive, stimulating work.

Though the Foundation has responded to the initiative of the Arts Council and the RAAs, the enquiry has been quite independent and financed entirely by the Foundation: the report, though formally addressed by Lord Redcliffe-Maud to the Foundation, is in fact intended as a public document and is published by us in the hope that it will provoke further discussion and deliberation on the issues it raises.

For its own part, the Foundation is considering urgently its own policies and priorities in the light of Lord Redcliffe-Maud's recommendations, so that our help to the arts can better complement that given by other bodies.

I am sure that this report will prove a milestone in the history of arts patronage in England and Wales and not the least important of the reports associated with the name of Lord Redcliffe-Maud.

CHARLES WHISHAW
Member of the Board of Administration
Calouste Gulbenkian Foundation
May 1976

I *Introduction*

Why an Enquiry now?

'Depend upon it, Sir, when a man knows he is to be hanged in a fortnight, it concentrates his mind wonderfully!'* The present state of the nation should have much the same effect. We have no intention of hanging ourselves, or of letting anyone else hang us. But inflation, unemployment and our debts to foreigners compel us to take stock and concentrate the mind on what we need to do. Can we make better use of our resources and, in particular, of the money we hand over in rates and taxes for public spending? Where are the growth points that we must cherish even in hard times like these?

In 1940 our national prospects could hardly have been worse. There was everything to be said for cutting out the frills and concentrating on national survival every resource we had. Yet that was the year when for the first time our government deliberately put taxpayer's money into a fund, created by the Pilgrim Trust 'for the encouragement of music and the arts'. A council known as CEMA was created. By 1945 its work had proved so valuable that nothing could be allowed to snuff it out. A permanent body with a royal charter, the Arts Council of Great Britain, took its place and this year will spend £37·15m of taxpayers' money on our behalf. Is this a frill that must be cut, or is it indispensable? How should it be related to other forms of cultural patronage?

Another national body, to support the art of film, had been created under the Companies Act before the war, as a limited company without guarantee named the British Film Institute. This year some two and a half million pounds of taxpayers' money went to support it. Too much, or not enough?

And in the 'seventies a third national body came into being, the Crafts Advisory Committee, to assist official efforts in support of artist-craftsmen.

Meanwhile the British Broadcasting Corporation, as an inseparable

* Dr Samuel Johnson, Letter to Boswell, 19 September 1777.

part of its general work and on a scale comparable to that of the Arts Council's patronage, spends 15% of its revenue from licence fees on arts and artists of all kinds. The independent television and radio companies have a commitment of a similar kind, under the terms of licence from the Independent Broadcasting Authority; but they can act only within the limitation of a single channel and, as they depend financially on revenue from advertisers, their top priority is bound to be the attraction of mass audiences. The Annan Committee on the Future of Broadcasting will no doubt cover in its report this crucial subject of arts patronage through broadcasting, but in the meanwhile no review of help for the arts can ignore the part broadcasting at present plays at national and regional level.

Local authorities have long been responsible for local libraries, museums and galleries and, since the turn of the century, for education. A few big cities have also been pioneers in the support of their own theatre or orchestra and other towns have used for patronage of music, drama and various forms of entertainment the limited financial powers given them all by Parliament in 1948. On 1 April 1974 all these existing local councils outside Greater London (1,500 in England and Wales) ceased to exist and were replaced by new ones at two levels, county and district, numbering only 422 in all (a total, with those of Greater London, of 454). Each new type of council has its own powers and duties, those in six metropolitan areas having significantly different ones from those in the rest of England and Wales, while in Greater London those created by act of Parliament ten years earlier for the most part are unchanged. But, as a result, *all* councils now have larger powers to support the arts and crafts than the old councils had: powers are no longer confined to urban areas or limited financially; in every part of the country both county and district possess concurrent powers of patronage; none has a *duty* to support the arts or crafts, save as a part of the general *education* duty imposed on councils responsible for education. Re-organisation therefore for the first time sets local government free to bring both arts and crafts into the mainstream of its activity – and at the same time leaves it free to do no more than the very little it has done before. Further, it gives this freedom to two elected bodies, county and district, in each place, with no legal prescription about how they should divide work for the arts between them. Here, then, is one good reason for using the present economic stand-still to review each local scene and seek agreement between county and districts everywhere about the best division of labour among local governors.

Another reason is the fact that almost every part of England and Wales now falls within the scope of what is called a Regional Arts Association (RAA). These bodies are not in any sense creatures of Parliament, as local authorities are. They have no taxing power, direct or indirect. Their constitutions are their own invention, and not identical though they have much in common. Twelve are in England, three in Wales. The oldest of them came into existence in South West England in consequence of an Arts Council decision in the late 'fifties to close its own regional offices and of the wish of local arts bodies in the South West to form their own association. The next major development was a determined movement in the North East in the 'sixties. This, unlike that in the South West, came chiefly from the old local authorities. They wanted to promote cultural activity over a wide area based on Tyneside and recognised that only if they combined forces could they achieve their purpose economically. 'Northern Arts', as it now calls itself, has proved the wisdom of this recognition over the last ten years and has gone on to demonstrate how valuable a regional arts association can be in the new world of the new local authorities. Lady Lee of Asheridge (then Miss Jenny Lee), as Minister Responsible for the Arts, and Lord Eccles, her successor in office, found new money from the taxpayer for the Arts Council to pass on to regional arts associations as they sprang up all over England and Wales in recent years, and they and their successors have put all their weight behind the regional movement. Nowhere have local authorities given as much support to it as in the North, but none of the RAAs has failed to persuade local government to accept partnership and subscribe rate-money to its funds. What should be the future of RAAs? What can they do better than either local authority or Arts Council in isolation? Who should finance them and on what terms? What should they seek to do themselves and what by subsidising others? These are among the questions to be urgently explored, and given at least provisional answers, if we are to make full use of precious funds during this time of crisis and are to be ready for better times before they come.

These are the reasons why the Gulbenkian invitation seemed irresistible. And the Trustees have done everything they could to help me. They accepted the terms of reference that seemed to me most likely to serve our common purpose. They paid my expenses, and they gave me, as secretary to the enquiry, their Assistant Director, Mr Anthony Wraight, who has proved an indispensable colleague from

first to last. Responsibility for every word of this report is mine alone, but without the contribution of his own personal experience in many parts of the field of this enquiry, his judgement, his drafting and organising skills, the report could not have been written.

Procedure

We set ourselves a target of one year for completing our travels with submission and publication of a report during the first half of 1976. On 8 December 1974 we announced the establishment of the enquiry and our terms of reference: 'to study the future pattern of national, regional and local patronage of the arts in England and Wales, including the work of regional arts associations and the role of local authorities, and to make recommendations'. We invited any interested organisation or person to submit written evidence as soon as possible, and supplemented this public announcement by separate invitations to a number of bodies and individuals from whom we were specially anxious to hear. In the course of 1975 we visited all the 12 regional arts associations in England and the three in Wales. Some 23 counties and some 44 districts in all the regions were good enough to let us visit them for discussion, exchange of views and a sight of their cultural activities, and many councils supplemented this oral evidence by written submissions (the local authorities and others who helped us in various ways are listed in Appendix 4). We thus travelled some 11,500 miles for purposes of the enquiry, as well as holding a number of meetings in London. Any value that this report may have is due to our good fortune in finding, wherever we went, councillors, local government officers, artists and representatives of art organisations, who spared the time to see us, allowed us to ask questions and express provisional views, and showed us at first hand examples of their problems and achievements. I doubt whether anyone has been given a better chance than I to see at first hand what is being done and attempted in England and Wales to encourage professional and amateur artists and craftsmen of many different kinds and to spread artistic experience and enjoyment throughout our society at national, regional and local levels. Our terms of reference did not cover Scotland but we were lucky enough to have several opportunities, in Edinburgh and elsewhere, to exchange views with Scots and, in particular, to learn from the Scottish Arts Council who were in process of making an enquiry in Scotland on lines similar to those of our own. I also found much value in Sir James Richards' recent Report on *Provision for the Arts* in

the Republic of Ireland (for the Irish Arts Council and the Gulbenkian Foundation).

I owe a special debt of gratitude to Lord Gibson, the Chairman of the Arts Council of Great Britain, Sir Hugh Willatt who was the Council's Secretary-General when I started work, Mr Roy Shaw who succeeded him as Secretary-General in July 1975, and other senior officers of the Council. Their courtesy and collaboration have been invaluable from start to finish and have enabled me to share some of my views with them before reaching final conclusions. I have been particularly concerned that my enquiry should not be a reason for postponement of any decisions that the Council might wish to reach, but should perhaps be of some use in helping to solve the difficult problems of devolution that the Council has to face. Thanks to Lord Gibson and his colleagues I have some hope that my enquiry will prove a help rather than a hindrance to the development of the Council's work.

It would be tedious to list here all those who have helped me – a full list is given in the Appendices. But I must mention my gratitude to politicians of all parties who have given me the benefit of confidential discussion, and in particular to two of Her Majesty's Government, Mr Harold Lever, MP, and Mr Hugh Jenkins, MP. Finally I must thank my wife, for helping at many points of the Enquiry and tolerating for more than twelve months discussion of one subject in our home.

Some definitions
What do I mean when writing of 'the Arts' or 'cultural activities' in this report?

(1) I have first in mind objects, events, occasions which would not exist or happen without artists: that is, without people, professional or amateur, paid or unpaid, who create something new to see or hear or touch.

(2) But I have also in mind the experience of other people, not the artists, who see, hear, touch what the artists create. And sometimes this experience of the audience is as essential to the work or the occasion as the artist.

(3) We can distinguish 'performing' arts from the visual and the literary because they involve not only the creative artist who composes music, writes a play, designs a dance or festival, but also performers who sing, play, act, dance or perform in one way or another. Music,

theatre, opera, dance are obvious examples of performing arts but festivals (of one art, say music, or of several arts) are also primarily performing arts.

(4) Of the visual arts the commonest examples are painting, sculpture and photography. Here we need no performers, only creative artists. The crafts are visual arts too, distinguished by the fact that they are generally designed to meet a need – to be useful as well as beautiful: pots, rugs, furniture and the like. But visual artists and craftsmen need space to show their works, materials to use in making them, and transport. Museums, galleries, workshops and studios therefore come under this head. Film and television, which need performers and are therefore in a sense performing arts, are also visual ones.

(5) Finally, there are the literary arts of fiction and poetry, barely distinguished from the rest of literature by their characteristic use of imagination. As plays and playwrights come under the heading of performing arts, what I call the literary arts do not require performers (though their works are indeed often read aloud). But besides poets and novelists they need publishers and printers. And they need libraries too.

(6) Architecture, despite its huge importance, I have deliberately excluded, except as it serves other arts and the buildings that they need.

(7) By 'cultural' activities I mean all that involve any of the performing, visual, or literary arts and crafts mentioned above. Gardening, walking, riding, fishing and many other forms of sport and recreation are in some sense cultural activities, but for my purpose I must concentrate on 'arts'.

(8) By 'patronage' I mean the support or encouragement of any art or artist whether direct (say, by promoting concerts) or indirect (by helping someone else to promote). Unfortunately the word retains from its past history a flavour of condescension, implying a touch of superiority or dictation on the patron's part. I totally repudiate such implication and can only ask the reader to do likewise. Another historical overtone I find less offensive: that which suggests the consumer's choice of a line of goods or service that he likes to 'patronise'.

Why patronise the arts?
What cultural activities are thought worth patronising depends of

course on the potential patron's taste. When that patron is a private person, corporate or individual, or a prince of church or state, he decides for himself whom or what to patronise. Fortunately today this question can still arise (the late John Christie of Glyndebourne and Sir Robert Mayer come to mind) but, each year that passes, it arises far less often than it did. However, if somehow we can combine our individual efforts, through the machinery of national or local government or by associating ourselves in voluntary ways, we become *corporate* patrons and can do for ourselves what none of us could achieve individually. If this ceases to happen, only those arts will be available which 'pay for themselves', and only available to those who can afford to pay for them at the box office. *Pyjama Tops, Hair, Oh! Calcutta*, pop groups, the circus and the pantomime will survive. But in the end there will be no serious theatre, either traditional or new; no opera or dance; no symphony or chamber orchestras; no painting or sculpture except by amateurs (that is, by those who earn most of their livelihood in other ways); no museums or galleries or public libraries; no raising of standards; no innovations; eventually no excellence.

Let there be no mistake about it: successful corporate patronage means the solution of most formidable problems. How do we corporately decide how much we can afford to spend on cultural activities, in competition with housing, hospitals or roads? Which forms of art, traditional or new, shall we invest in, and what are our priorities? The private patron answers such questions himself, by reference to his own whim and subjective judgement. How does the public one reach similar decisions? What weight should public patrons attach to tastes of the minority pressure groups concerned? What weight to party politics? And for how many years can public patrons commit themselves, at national or local level? If only for a year, how can the arts they patronise make forward plans which are essential to effective action? And how can the proper claims of public accountability be reconciled with those of freedom for artistic genius? Can the dead hand of bureaucrats foster the living arts?

Such are the ominous questions to be answered over the next five or ten years. We can take encouragement from the past history of our public library service – some warning from that of provincial galleries.

Arrangement of the report
The next part of the Report (II) sets out conclusions and recommendations – some general (II A) and some particular (II B), with a summary

of main conclusions at the end (II c). That may be more than enough for many readers. But we found the pattern of arts support that we now have in Britain highly complex and confusing. Some readers may care for an account of it. In Part III, therefore, we have set out some features of the structure, some comments on it that were made to us in evidence and others that we were ourselves inclined to make as we went round. In Part IV we seek to illustrate the consequences for various arts and artists that follow present practices of art support.

II *Conclusions and recommendations*

A. GENERAL

Post-war progress
Today the arts are being practised and enjoyed on a scale astonishing to someone travelling for the first time through England and Wales in search of them, especially if he remembers the pre-war period. Children of five to twelve are painting, drawing, modelling in clay or plasticine, miming, dancing, singing, playing recorders, writing verse, arranging flowers – all on a scale imcomparably wider than before the War. Older children work in youth orchestras and learn, because they want to learn, some instrument at Saturday morning music schools. Innumerable choral, orchestral, operatic and dramatic societies practise and perform, often conducted by professionals and with professional soloists on the night. Painters and sculptors, potters and carpenters – some professional craftsmen and many amateurs – work on and show some of the results at annual exhibitions up and down the country.

Much of the increased activity stems from the Education Act of 1944. Schooling in Britain still seeks first the arts of literacy and numeracy, but other arts have been creeping in from the curricular periphery, infiltrating the barbed wire of examinations and seeking to give our children experience of *creating* something, as well as of accurate numbering and clear thought. But this post-war school development is chiefly due to the enthusiasm and skill of individual teachers, working in their particular schools, under their own local authority. The national growth is therefore most uneven. Moreover, the great majority of each age-group leaves school at sixteen (at fifteen until recently) and, although since 1944 local authorities have had a *duty* to provide them with opportunities of further education throughout adult life, no Government has felt able to give national

priority to this further 'non-vocational' education. There is no sign of Government action on any of the sensible suggestions made in 1973 by the Russell Report on Adult Education (*Adult Education: A Plan for Development*, HMSO). Further, whereas for those of *academic* ability who stay on at school beyond sixteen and then seek full or part-time education at university or polytechnic, all Governments have made generous provision since the 'sixties, those who leave school at sixteen are in comparison still gravely disadvantaged. No Government has yet suggested that *they* ought to have the chance to develop proved ability in music or drama if they wish. A young player, for example, in the National Youth Orchestra who does not wish to make music his profession may find himself on leaving school without an orchestra to join and with no chance of further improving his skill as a musician.

This same post-war period has seen a flowering of professionalism in the arts in England and Wales unparalleled in our history. Playwrights, actors, actresses and directors have given us a leading position on the international stage. For the first time since Purcell England has bred composers whose work attracts the admiration of musicians in continental Europe, the Soviet Union and the United States. London has become one of the leading centres of world drama, music, opera and dance. Festivals of international reputation have established themselves in Edinburgh, Wales and several English centres. British sculptors and artists have become world figures. And in most regions of the United Kingdom theatres have been built, resident and touring companies founded, on a scale we have not known before. The arts are now a field in which Britain can claim excellence in quality and extent that no one can deny.

No grounds for complacency
But that is by no means the whole story. Large areas of Britain constitute a Third World of underdevelopment and deprivation in all the arts and crafts. Architecture, almost everywhere, is the worst example. The individual artist-craftsman is among the worst sufferers. School-leavers of sixteen (and amateurs in general) have been already mentioned. Local government since 1948, and still more since 1974, has had the legal power, and therefore chief responsibility, for seeing that opportunities for enjoyment of the arts are made available to all our citizens who wish for it. Some town councils and education authorities have used these powers but the great majority have, until very recently,

hardly used them at all. The consequence is *patchy* provision: excellent, for example, in Swindon (now part of Thamesdown District) where successive councillors have been inspired by a single enthusiastic officer, or in Leicestershire where the education authority has followed leadership from exceptional chairmen or chief officers; but, over wide areas, negligible.

Moreover, the very nature of an elected council makes long-term commitment difficult. It can build a theatre and help to establish a drama company or orchestra, but continuing maintenance and support depend on council decisions year by year, so that *precariousness* as well as patchiness is still characteristic of arts patronage. Further uncertainty results from Government slowness in deciding the size of grants to the Arts Council – even when a body dependent on its share of grant must, like Covent Garden or any of the great orchestras, make forward plans and engage artists one or two years in advance. Further, the Arts Council's sympathy with bodies affected by this uncertainty inclines it to continue year by year its help for ventures once it has started to support them. This leads in turn to an accumulation of on-going commitments and limits the Council's capacity to meet new needs as they arise.

More money needed
What artists and the arts in Britain most of all need is money. So do we all; but British artists, whether professional or amateur, have shown since the War what great increase in happiness results for all of us from a financial investment small enough to be negligible compared with national investment in any other public service. We are now spending £5,000m a year on education. In 1972-73, the last year for which statistics are available, we spent as a nation less than £100 million of public money on all forms of art, from museums and galleries to music and the theatre.

Planning must not wait
At the time of writing the arts are in such dire financial straits that all we can hope to do is to secure survival. But, besides that, we can use the 'survival period' to set our house of patronage in such good order that, as inflation comes under control, we can be sure of making progress towards a level of investment in the arts that bears defensible comparison with our potential as a nation of artists.

Local democracy the clue to progress

For the new money in a few years' time we must look first to demo-cratic local government. And it will only come if artists and other enthusiasts refuse to take no for an answer, organise themselves as pressure groups, acquaint themselves with local government practices, and act with scrupulous responsibility in using money that their local patrons forcibly extract from all our pockets. The drive must come from artists and art enthusiasts in every district and county. It must be transmitted in the first instance to the one or two like-minded councillors and officers who are the crucial links with local power: it is they that must in turn persuade their colleagues, especially the political leaders of both majority and minority groups within the council, that investment in the arts is now the mark of civilised communities.

National leadership needed

The pioneering leadership of local groups must be made easier for fellow citizens to follow. And this can best be done by finding national taxpayer money to match local contributions from the rates. Such is the historic framework of past local government progress: local pioneers in education, child welfare, dental clinics, school meals, housing, care for the handicapped, have all in their time been spurred to spend more local money by the offer of increasing grants from national funds. Hence the importance of using some of the Arts Council's national money, directly and through regional arts associa-tions, to induce local councils to raise matching contribution from the rates.

Regional arts associations

Judicious mixing of national and local finance is a matter for the Arts Council itself when dealing direct with local councils, say in joint subsidy for a theatre company. But it must increasingly be entrusted to the Regional Arts Associations (RAAs). Their business is to know, better than any London-based body can, the local authorities and arts organisations of the region and take decisions about regional priorities. An increasing share of Arts Council money must therefore come into their hands, not only to pay their staff properly and secure a high standard of quality among their officers, but also to give them negotiating power and influence with local councils. (See pp. 88-100.)

Public opinion

Arts will not get the public patronage they need without a fundamental change in public attitudes. Opinion throughout England and Wales must be transformed by the enthusiasm of artists of all kinds and their supporters. Thousands of such enthusiasts now exist but they are, and will still be in the 'eighties, a small minority both of the nation as a whole and of each neighbourhood. Unless they take deliberate and successful steps to spread enthusiasm among their friends and fellow workers, the majority of politicians of all parties will remain either indifferent or hostile to the pressure for increased arts patronage; even when the economic climate becomes less oppressive, there will be far too small an increase in public spending on the arts. Action must start with those who recognise the arts as sheer necessities and know that arts need money from us all. These people must form unofficial arts councils where they live, or strengthen existing ones. Artists of all kinds are no less free than other workers to organise themselves in unions or co-operatives but, whether or not they do so, they must also seek to make common cause with local amateur enthusiasts, or we shall lack the fundamental change in public attitudes that we need.

Business opinion

We spend large sums of public money every year in training artists and designers, at first degree level in colleges and polytechnics up and down the country and at post-graduate level in the Royal College of Art and elsewhere. It is a scandalous waste of national resources when these trained men and women fail to find employment inside Britain and, finding it overseas, contribute to the successful competition in Britain of foreign imports, better designed to meet consumer needs than products of our own industry and commerce. A major change is therefore needed in present attitudes of British businessmen to the discovery, training and use of the rare talents of our artists and designers. (See p. 36.)

Purpose of arts support

First, for whose benefit should we support the arts from public funds? 'The many and the few' is my broad answer. The many, because no one is incapable of some enjoyment or experience of the arts if he has opportunity to use his own peculiar powers of creation and recreation. The few, because at all times and in all places creative talent is rare and

genius very rare indeed. Our society, it seems to me, will not become more civilised if it ignores the claims of either group. As our resources are, and will always be, strictly limited, some questions of priority cannot be shirked. But if we look more closely at the question 'whom should we public patrons help?' the answer needs to be rather more complicated. 'The many' and 'the few' do not together constitute the whole population. They must be thought of, rather, as the largest and smallest of a whole series of concentric circles. The innermost circle consists of the few people of *genius* – composers, playwrights, poets, painters, sculptors, designers on the one hand, and soloists, conductors, actors, directors on the other. Wider than the circle of genius is that of *talent*, of many various kinds. Still wider is the circle of those capable of professional teaching of their art (for instance, music) though not themselves so talented as the professional performers. Outside that circle are the *active amateurs* – singing in choral societies, playing in orchestras, brass bands and pop groups, acting in drama societies or community art, but earning their livelihood in other ways. Beyond them is the still wider circle of those who enjoy the arts as *audience*, whether of broadcast or of live performance. And beyond them, 'the many'. No circle is at any moment static or exclusive. All of them fade into each other like colours in a rainbow. And with *all* of them we are concerned as public patrons.

As patrons *what* is our concern for them? First, it is to give each person in each circle *opportunity* – to compose, perform professionally, teach, perform as amateur, enjoy as audience – and in each case the opportunity of *progress* to a higher standard, whether of composition, performance, teaching or capacity to enjoy demanding works (say, Beethoven as well as jazz, contemporary music as well as Beethoven).

But we are also concerned that individuals make progress of another kind: from passive to active, lower to higher, standards of enjoyment. The flat image of concentric circles needs to be three-dimensional – a pyramid, with rare creative genius at the top and the base gradually becoming broader year by year. Our purpose as patrons, therefore, must include the hope that individuals in the intermediate circles graduate upward as their experience widens and their discrimination grows.

Methods of arts support
How should we public patrons decide how much support in total we should give the arts, how much to each, and how the claims of 'many',

'few' and intermediate circles can be reconciled? Clearly the broad decisions must be taken by representatives responsible to us, either through Parliament or through our other self-governing institution, local government. But in this delicate and dangerous field of patronage we want decision-takers to be expert and well informed as well as representative. How can these various requirements best be met? My answer is: by education, public service broadcasting, the arm's length principle, devolution and local government.

Education and training. The excellence of our artists, professional and amateur, and our increasing enjoyment of old and contemporary art depend in each case more on education than on anything deliberate arts patronage can do. A revolution, therefore, in educational policy over the next ten years which brought the arts nearer the heart of the curriculum in British schools (and teacher-training institutions) is what I would most dearly like to see. This would affect the quality of our future as nothing else could do, without significant increase in the expenditure on education we would in any case incur. 'The many' would learn to use eyes and ears, discriminate against ugliness and enjoy good design. 'The few' would discover, and begin to use, creative talent. All might make some progress up the pyramid. The training of 'the few' when they leave school may well deserve more money than it gets at present, but meanwhile we can make better use of what we spend. The recommendations of the Vaizey Report (*Going on the Stage*, Gulbenkian Foundation 1975) on training for the stage should not, and need not, wait for better times.

Adult and further non-vocational education (at Morley College, London, for example) already offers *some* of 'the many' just what they need when they stop full-time formal education: the opportunity under professional guidance to go further in their enjoyment and practice of the arts. Here what we need is another revolutionary change, this time in the scale of national expenditure. Within the next five years or so, the adult education movement must receive priority such as it has had at no time in our history, and when it does the arts must at last have their chance.

Meanwhile we must reject the long-established fallacy that 'arts support' and 'education' are two separate things. More positively, we must insist that those responsible for them are natural allies, and see to it that they collaborate at national, regional and local levels.

Broadcasting. Second only to education (and itself in some sense part of education) I put our unique system of broadcasting and television. Whatever its imperfections, and whatever improvements the Annan Committee may enable us to make, the system that has emerged over the last half-century has done outstanding service to the arts. It gives artists of talent and genius their opportunity by using them. It makes new and old works of art available to all who want them, and intro-duces them to many for the first time. It sets amateurs new standards of performance. It educates public taste in all the arts. Long-playing records, paperbacks, our public library service and the Arts Council of Great Britain have all greatly enhanced enjoyment and experience of the arts, but the BBC, partly despite the competition of independent broadcasting and partly because of it, has done us prouder still. (See pp. 107-109.)

The arm's length principle. We have begun to find a satisfactory sub-stitute for the old private patron of the past – a substitute which neither dictates to artists nor imposes on them conditions incompatible with artistic freedom.

No doubt this problem can never be completely solved. But we have perhaps gone further to solve it than any other country, whether totalitarian or democratic, by a device for which the original credit goes to the late H. A. L. Fisher. As President of the Board of Education in 1919, he first established the University Grants Committee (UGC) as an unelected body of university men, appointed by the Chancellor of the Exchequer, on whose advice the Government of the day asked Parliament each year to vote money for distribution, without strings, to each university. This system has survived, with modifications, for more than fifty years and now distributes nearly £500m of taxpayer money a year. Politicians have thus acted, unconsciously perhaps, on the principle that we get full value from the taxes taken from us for university education only if we leave each university free to decide educational policy, with a measure of guidance from the UGC but without vestige of dictation from either politicians or the bureaucrats who serve them.

This is the principle on which the Arts Council, since its creation in 1946, is voted public money (£28·5m in 1975/76). By self-denying ordinance the politicians leave the Council free to spend as it thinks fit. No Minister needs to reply to questions in Parliament about the beneficiaries – or about unsuccessful applicants for an Arts Council

grant. A convention has been established over the years that in arts patronage neither the politician nor the bureaucrat knows best.

It would be madness to destroy the Arts Council or to abandon this arm's length principle. We can of course improve our use of it: for example, we can appoint to the Arts Council and its panels, without increasing total membership, more members with local government experience, more artists and more members with knowledge of England outside London. But we must cling to the principle that politicians should deny themselves responsibility for detailed decisions about the distribution of the grant.

In particular, we must reject proposals (such as those made by Mrs Renée Short's working party to the Labour Party Conference of 1975 – *The Arts: a discussion document for the Labour Party*) for replacing Arts Council and Regional Arts Associations by an elaborate structure of elected bodies at district, county, regional and national level – a structure based on mistrust of democratic local government, on compulsory co-option of artist union representatives and other members in numbers equal to that of elected councillors, on indirect election by local bodies to regional ones and by the latter to a new national Council. We must with equal firmness reject the *New Statesman* proposal (17 October 1975) to deprive the Arts Council of all but advisory powers (except for grant-giving below £50,000) and substitute the direct responsibility of Ministers.

Devolution. We must now decide to devolve wide decision-taking power from the national level. There will always be arts patronage of great importance which must be done by the Arts Council and other national bodies. But if that work is to be done, devolution must be their firm and continuing national policy. (See p. 38.)

Local government. We must look to local elected councils, at district and county level, to become the chief art patrons of the long-term future, developing a comprehensive service as part of the main fabric of local government. (See p. 40 and pp. 100-107.)

Private patronage. It would be disastrous if arts patronage in Britain ever became a state monopoly. There is no present danger of that happening, either at national or at local level, but we would be foolish to suppose it never could. It has already happened in large parts of Europe and wherever totalitarian governments exist. Here it would in due course

mean the loss of individual freedom, both for the artist and for us as audiences. Only such work as the authorities thought good for us could be created or enjoyed: the judgement of our rulers, local or national, would replace our own personal choice – in music, drama, books and broadcasting.

Each method of arts support mentioned above offers some safeguard against the *abuse* of state monopoly. And against monopoly itself there is the powerful safeguard of arts support by patrons other than the state. Before the war these patrons, unofficial 'British volunteers', were themselves almost monopolists of patronage. Since then, within the context of the new public patronage, they have continued pioneering work in all the arts. They have two roles of cardinal importance for the future. The first is to pioneer and innovate with such success that in the end a *public* patron happily takes over the result – two good examples are the Robert Mayer concerts for children and the London 'Proms', now part of the on-going business of the BBC. This helps to ensure the future of the enterprise and releases volunteer energy for new work.

The second role is to make good deficiencies of public aid – for instance, helping an established enterprise to raise standards of performance or stage a new production which neither public funds nor takings from the box office would allow.

How can we recruit new British volunteers as patrons of the arts? Over the next few years, though public funds at such times most need supplementing, it would be idle to expect too much from the private patrons; nor should we rely at any future date on anyone but ourselves to find, as taxpayers, the bulk of the support the arts will need. But there are several sources that we must take deliberate steps to tap. In recent years some of our banks, insurance companies, commercial and industrial firms, have shown not only a shrewd self-interest but imagination in financing arts events. A new and promising Association for Business Sponsorship of the Arts has now been formed, to act as a clearing-house of information and advice for firms that think of sponsoring the arts. More must be done, by this and other means, to perform 'honest brokerage' functions between business (both in the private and the public sectors) and arts organisations.

In the United States, where until recently the arts have been largely dependent on private rather than public patronage, the taxation system has made concessions to the benefactor on scales which find no parallel in Britain. It would be unreasonable, and useless, to suggest revision of

our tax-system on American lines. But why should we regard our own as sacrosanct? New taxes, of great moment for the arts, are on the way – Wealth Tax is only one of them. Surely this is the time to look again at the effect on arts, not only of VAT but of all personal and corporation taxes.

Trades Unions in the past have not regarded interest in the arts as one of their concerns. We found no evidence of general change in this position, though in parts of Wales and northern England support for local festivals and colliery bands is given by branches of the National Union of Mineworkers. It is at least encouraging that the Trades Union Congress last year appointed a working party on the arts.

Finally, there are the trusts and foundations which support the arts – trusts such as the Pilgrim, Leverhulme, Gulbenkian ones which cover arts as well as many other causes, and special trusts such as the National Arts Collection Fund. Their value, like that of individual art enthusiasts, lies in disinterestedness of motive: they do not have to justify help to the arts either as sales promotion or endorsement of high quality in the donor. They are an indispensable and unique part of private patronage. Their characteristic contribution must remain what it has always been: imaginative readiness to take risks and explore, backing the experimental and the little known for trial periods. Their future mission is to consolidate alliance both with the public patron and with other volunteers. But the sum of their real wealth is now restricted. We can expect no large finance but great imagination from these discriminating friends of all the arts. (See pp. 109-114.)

'Only connect'

While money for the arts is as hard to come by as it is at present, the fewer changes we make in the existing framework the better, for any such change is likely in the short run to put more of the precious funds available into administration and leave still less to spend on artists themselves. Five years from now, though by then I hope new chartered councils will have been established for museums, film and crafts, we should still follow the same principle and refuse to make tidiness our goal. If so, we must accept the complementary principle: 'Only connect'. At every level there are, and will be, several bodies which can work effectively only if they work together.

At the United Kingdom level, the Cabinet must contrive to treat certain of the arts in England, Scotland and Wales as indivisible. The several Cabinet ministers concerned must have a senior one to har-

monise their efforts. And their departments must keep correspondingly in touch with one another. So must the Arts Councils, whatever changes may result from Scottish and Welsh devolution. (See pp. 32 and 64.)

At national level, not only must departments with interest in education, arts, sport, broadcasting or tourism keep in touch: it is still more important that the Arts, Sports and British Councils, BBC and IBA, should do so too, at chairman, chief officer and executive levels. A new assembly, at which representatives of all these bodies could formally confer, would almost certainly be a great waste of time. Nor do we want elaborate patterns of cross-membership (which would increase the size of councils and the time their leading members must give up). But present arrangements for liaison as a whole seem quite inadequate. At some points they are already excellent and I have no doubt that if the need is better recognised it can be met – sometimes by new consultative machinery, often by telephone.

At regional level there is less excuse than at the national for lack of 'connection'. Whereas arts, galleries and museums, film, crafts, broadcasting, come under quite separate national bodies at the centre, they are all the business of a regional arts association. Here then we have an instrument specifically designed for comprehensive aid to the arts. Here too is a body with a built-in purpose of collaboration – between all types of local council, central and local government, councillors and artists, public and private patronage.

At local level the first and most obviously needed connection is between the two tiers of local council, county and district, because both have concurrent powers of arts patronage. It is essential therefore that in each county an on-going arts development plan be worked out and, if possible, agreed. Here there are two specially important points. First, agreement must be reached between the new county and those districts within its borders which before 1974 were county boroughs – Plymouth, for instance, now a district in Devon county. And, secondly, agreement must be reached between the councils which are responsible for *education* and those which are not; for the latter have the same powers of *arts* patronage as the former, and a county arts development plan must embrace both 'education' and 'the arts'. This covers an important difference between metropolitan and shire counties: in the former, it is not the county (such as Merseyside) but the district (such as Liverpool) that is the education authority; in the shires the opposite is true, Devon county being responsible for education and not

Plymouth. Connection between county and district is equally needed in both cases – and perhaps equally difficult to get.

Connection is needed also between neighbouring counties, both metropolitan and shire. Hence the potential value of the regional arts association, stretching as it does through several counties and offering them the chance to harmonise their arts development plans.

Within each local authority the need is clearer still for intimate and continuing connections – in the planning and use of education, sports and other buildings so that they serve more than one purpose in the neighbourhood; linking the work of education, library, museum, arts and leisure departments so that coherent use is made of all resources.

Further, there is the crucial democratic need in each locality to bridge the gap between the governors and the governed: to encourage open two-way traffic in ideas between the council, artists and art organisations, so that on both sides mutual understanding and confidence may grow.

Connections of another kind are also needed. Public and private patronage should each complement the other, whether in theatre building or commissioning new work. The subsidised and the commercial theatre are in competition but there are many points at which they can collaborate and many common interests which they share.

Finally, now is the time, despite financial problems, to make our arts available to other countries and their arts to us. (See p. 76.) There is no language barrier to confine within frontiers music or visual art or even (thanks to translators) drama and literature. In recent years air-travel and broadcasting have opened the world to artists of all nations. Here then are tremendous opportunities we must exploit. Much has been done already. Our opera, drama, visual artists, orchestras are international in more than name. But we know far too little of the art of other countries, and we have hardly started to explore new opportunities offered by our membership of the European community. The bulk of this report concerns support for British art and British artists, but parochialism is the enemy of the arts. If the British Council, Arts Council, local authorities and private enterprise pool their resources in a common effort, there is great gain in store for international understanding and the arts.

B. PARTICULAR

Ministers and Departments

Every Prime Minister must of course make his own arrangements for distributing responsibility amongst his colleagues, and these arrangements will partly depend on his own interest in the arts. What matters most is not machinery but Government determination to give some priority to the arts and not (like every pre-war Government without exception) regard the whole subject as irrelevant. But we now have some experience of alternative methods for handling the arts as a government responsibility, and if one is to make coherent recommendations about arts patronage at local and regional levels, one must make certain assumptions about organisation at the top. Mine are as follows.

1. A Cabinet Minister, with such seniority and personal status that he can speak with confidence to the Prime Minister and the Chancellor of the Exchequer, should be made responsible for general supervision of government policy towards the arts, sport and leisure opportunities. But this should not be his only duty. Either he should have the responsibility of the present Secretary of State for Education and Science, perhaps with a new title that included Arts as well as Education and Science; or, preferably, he should be a Minister without Portfolio not only responsible for arts, sport and leisure, but also available for other particular assignments which the Cabinet or Prime Minister might invite him to accept from time to time. He might be assisted by Ministers, not in the Cabinet, with special responsibility for the arts and for sport and recreation respectively.

2. No change in present departmental responsibilities would be essential. But the Senior Minister referred to above should have a small high-powered office which would be responsible to him for maintaining contact with any department that included among its duties concern for any of the arts, the crafts, film, television and radio, sport, the national heritage, historic buildings, the countryside, parks and open spaces.

The accounting officers of these departments (education and environment, in particular) would continue to be responsible for that part of their work that concerned any of these subjects. But the Senior Minister would make it his business, in consultation with whichever

of his colleagues were concerned, to ensure funds for the whole range of expenditure on arts, sport and recreation.

3. Whatever detailed arrangements among his Cabinet colleagues each Prime Minister chose to make, the continuing aim of HMG would be to keep itself and other politicians 'at arm's length' from artists and arts organisations, resisting temptation to prescribe officially (or even seem to prescribe) a cultural policy for the nation which favoured the work of certain writers, painters and musicians and disapproved that of other artists. HMG would therefore continue to encourage the arts through specially appointed bodies rather than through conventional Whitehall departments, setting its face against the creation of a single bureaucratic ministry, responsible to Parliament through a Minister of Culture, such as exists in many other countries. Apart from the objection to such an arrangement that it might subordinate artists to politicians, it seems to me unlikely that at present a Prime Minister would easily find a senior Cabinet Minister who would be happy to confine his energies and influence to such a post – and what the arts will always badly need is an experienced politician whose word will carry weight in Cabinet.

Arts Councils for Scotland and Wales
The Scottish and Welsh Arts Councils, though in practice they are effectively independent bodies, are at present committees of the Arts Council of Great Britain. Even if change does not become necessary as part of the new arrangements contemplated for Scottish and Welsh government, there would be advantages in giving the two countries their own chartered Arts Councils, provided this were done (as it could be) without severing ties which benefit all three countries. Whatever new arrangements are made to match the establishment of elected assemblies in Scotland and Wales, we should aim at achieving the following objectives:

1. The formidable expense involved in the performance of grand opera at an acceptable level of excellence makes nonsense of a complete separation of English, Scottish and Welsh companies for purposes of public subsidy. National support for opera must therefore be regarded as a United Kingdom responsibility. (See pp. 131-137.)

2. There are strong arguments for regarding ballet in the same way.

3. The National Theatre should not become English but continue to be British.

4. Whatever arrangements are made by a Prime Minister for allocating responsibility for the arts to one of his senior Cabinet colleagues, HMG should not treat the arts as separate objects of public subsidy within the boundaries of England, Scotland and Wales. Means must be found (and they could be) for settling how much of the United Kingdom taxpayer's money should go each country for arts support, while leaving each country free to supplement its share of UK resources with further contributions from its own citizens.

5. There should be Arts Councils for Scotland and Wales, established by Royal Charter. The Arts Council of Great Britain should retain its title and continue, as at present, to confine itself (i) to arts activities in England and (ii) to such activities as the National Theatre, opera and ballet which must be financed on a UK basis. But there must also be some Joint Committee, say of the three Chairmen, responsible for presenting estimates to the United Kingdom Government as a single whole. Such estimates should be considered, as soon as the control of inflation makes this feasible, on a rolling triennial basis.

6. The present overlapping membership between ACGB and the Scottish and Welsh Arts Councils would disappear, and the three Arts Councils would appoint their own chief officers and staff. But every effort must be made to avoid staff duplication, to ensure the general availability of expertise throughout the United Kingdom, and to encourage the closest working relations between staff in all three countries.

The Arts Council of Great Britain (ACGB)
Whether or not Scottish and Welsh Arts Councils one day receive Charters of their own, the Arts Council of Great Britain should have the following characteristics.

1. All members, including the Chairman, should be appointed by whichever Cabinet Minister is designated by the Prime Minister as having general responsibility for the arts.

2. No member should be appointed as representing any particular interest. Before the Minister appoints either a Chairman or any other member, he should have regard to the composition of the Council as a whole and seek to ensure a balance in geographical terms, in variety of artistic interest, and between the value of members with previous experience of Council work and that of new members. He should take

account of names suggested by the local authority associations, by regional arts associations, and by artists and their representative bodies (such as Equity and the Musicians Union).

3. The Chairman must be the chief link between Council and Minister. As such, he must have direct access to the Minister, especially in discussion of current and prospective finance and of future membership of the Council; and the Minister must feel free to share with the Chairman any policy considerations that he or his Cabinet colleagues wish the Council to bear in mind. The aim should be to achieve a common mind between Council and HMG on broad policy for the arts, on the understanding that HMG attaches continuing importance to the political independence of the Council and that the Council fully accepts the limitations on its freedom that are implicit in its public accountability.

4. Without infringing the responsibility to Parliament of the Accounting Officer (that is, the Permanent Under-Secretary) of whatever department includes grants to the Arts Council in its vote, the Chairman of the Council should be allowed to answer any questions the Public Accounts Committee of Parliament may wish to put to him. This has already happened on one occasion but might well become normal practice. Further, if either House of Parliament thought fit to appoint a Committee to concern itself with the arts (still better, perhaps, if a joint Committee of both Houses were established) this would not be inconsistent with the 'arm's length' principle already mentioned but would give the Council, through its Chairman, a public opportunity of explaining its activities and engaging in dialogue with representatives of the public it seeks to serve. A precedent already exists in the House of Commons Committee on the Nationalised Industries.

5. For the present, the scope of the Council should not be enlarged. On the other hand, there would be grave disadvantages in reducing or fragmenting the present Council's responsibilities. It can be argued that grants to Covent Garden, the National Theatre and the Royal Shakespeare Company should be made direct by HMG and cease to be part of the Council's responsibility. Such a change might be welcome to the Companies concerned and would acquit the Arts Council of the charge that it favours its big national clients at the expense of smaller and less notable applicants for grants.

But I think the change would prove to be in no one's interest. There can be no escape from the need for decision by HMG about total taxpayer expenditure on the arts in any year whatever channels may be used for its distribution. And someone must each year decide priorities between, for example, the various art-forms; between the claims of London and the provinces; between established institutions and the embryonic. At least in the first instance, these difficult questions of priority and balance should surely be considered by one body – and by a body qualified to exercise informed artistic judgement rather than by civil servants or politicians. (See pp. 121 and 133.)

Assuming that the Arts Council of Great Britain is best left with its present range of responsibilities, there would be great advantage if Chartered Councils were eventually created with similar responsibilities at national level for arts not covered by the Arts Council: that is, for museums and galleries, film and the crafts. But only on one condition should this be done, namely that each council would be likely to receive grants from national taxpayers year by year on scales much higher than Parliament provides at present in aid of those three kinds of activity. At the time of writing this condition cannot be satisfied. In the immediate future, grant increases to match continuing inflation are all that we can expect. I am convinced, therefore, that the time has not yet come to create new chartered councils. But we should decide now that we shall need them and use the present time of stringency to work out detailed plans for execution at the soonest possible date.

Museums and galleries

Thus, the Standing Commission on Museums and Galleries should be converted in due course into a Museums Council, with not only the advisory functions of the Standing Commission but with Parliamentary grants on a triennial basis and power to pass them on, both to the trustees of the national institutions and to local authorities. The new Council should also have a Housing-the-Museums fund to administer, similar to the Arts Council's Housing-the-Arts fund which has proved invaluable, since its establishment in 1965, as a national supplement to the capital found by local authorities and private subscribers for theatre building and adaptation.

The other recommendations made in the Wright Report of 1973, together with the admirable planning work already being done by the Standing Commission on Museums and Galleries and the Museums Association, provide most of the material needed for comprehensive

action by the new Council when it is set up. Meanwhile, the Area Museums Councils, without waiting for the new Council to be established, must develop their work and co-ordinate it more closely with that of regional arts associations and local authorities, so that in each place there is a clear division of labour between local authorities, area museums council and regional arts association.

One important aim must be to create a unified career structure for staff employed in national and provincial museums and galleries. Another must be to improve the present inadequate arrangements for training the staff needed for conservation work, and make full economic use of them when they are trained. Pursuit of these aims need not, and must not, await the establishment of the proposed Museums Council.

The possibility should be explored of establishing outside London outposts of such national institutions as the Tate Gallery, on lines already pioneered by the National Portrait Gallery at Montacute. Provincial galleries should receive more help, especially financial, towards the purchase of works of art than they receive at present through the scheme now admirably administered by the Victoria and Albert Museum. (See pp. 70 and 153.)

British Film Institute (BFI)

The British Film Institute (see pp. 76-80 and 161-165) should now be invited to work out plans for its eventual conversion into a Chartered Council, similar to the Arts Council, when substantially more money can be made available by Parliament for its work. The new council should include television as well as film within its title and area of responsibility, but its powers and duties in the field of television cannot be defined until the Annan Committee has reported and decisions have been taken on any of its recommendations that are relevant to the new Council's work. Legislation will be needed enabling the new Council to require for deposit in the National Film Archive any film shown publicly in Britain that the Council chooses for this purpose. A Housing-the-Cinema fund of adequate size must be provided for the Council to administer, on lines similar to the fund administered by the Arts Council, in collaboration with local authorities and regional arts associations.

The new Council's charter should not provide (as does the present BFI constitution) for the membership of individuals or bodies.

Meanwhile the BFI should progressively devolve money and decision-making to regional arts associations and seek increasingly close

collaboration with local authorities in both metropolitan and shire areas.

To enable good films to be more widely accessible, the BFI should encourage the development by local authorities of civic or community cinemas in towns, and the use of mobile cinemas in rural and other areas.

Some film societies deserve help from their local authorities. Regional arts associations, in consultation with the local authority, should also be ready to consider such requests for help.

Crafts and design

The Crafts Advisory Committee (CAC) (see pp. 83-84 and 165-168) should continue as an independent body for the present, working through local authorities, regional arts associations and craft societies.

When Parliament is prepared to vote substantially larger sums for encouragement of crafts, consideration should be given to establishing a Chartered Council, similar to the Arts Council, in place of the Committee.

The relations of such a Council to the Design Council and the Arts Council should be the subject of discussion at an early date between the three existing bodies, so that their present respective roles may be clarified and future possibilities explored. Such discussions should start from recognition of the urgent national need to make better use of trained artists, designers and craftsmen in industry and commerce, to increase mutual understanding between such persons and their potential employers, and to improve existing arrangements for training the artists, designers and craftsmen of the future.

Meanwhile, the Crafts Advisory Committee, Arts Council and Design Council should strengthen present arrangements for liaison. Agreement should be sought on the distinction between artists, craftsmen and designers and on the relationship of their respective roles.

The Committee should increasingly use regional arts associations as its working partners up and down the country.

Regional arts associations should appoint crafts officers wherever funds permit, and all of them should regard the crafts as an integral part of their work. The joint appointment by the CAC, Design Council and Welsh Arts Council of a crafts and design officer for Wales might well lead English regional associations to make similar appointments covering crafts and design.

Regional Arts Associations

If Regional Arts Associations (RAAs) (see pp. 88-100) did not exist in all parts of England and Wales, we would have to invent them. Such invention would be difficult, and impossible for any central body such as the ACGB or Welsh Arts Council to achieve. Certainly, neither Parliament nor Whitehall could create bodies such as the present RAAs: only people in the regions could do that. And fortunately those people have already created them. However, decisions are urgently needed about their future and I suggest they should be made on the following lines.

1. RAAs should remain autonomous bodies and not become regional outposts of the ACGB or the Welsh Arts Council.

2. At least for the present, Parliament should leave them alone. The time may come when proposals for provincial councils in England, with powers devolved from London, are seriously considered and, if so, the proper place of regional arts associations in the new pattern will be one of the questions to be answered. Again, if a recent White Paper on Sport and Recreation (Cmnd. 6200) leads to proposals for legislation, decisions will be needed about the proper definition of 'recreation' and about future relations between RAAs and the proposed new regional councils for sport and recreation. The RAAs would still be needed, though clearly they would have to establish close links with the new bodies. Meanwhile, if some Parliamentary Committee is established (as was suggested above) with special interest in the arts, it should be free from time to time to invite the views of a regional arts association on questions it was examining. RAAs would thus become better known to the public and their work more widely understood.

3. It would be wrong to fragment grants at present made to the Arts Council from national revenue by granting parts of them direct to RAAs, for this would involve decision by Whitehall on questions of arts policy for which ACGB should remain responsible.

4. But the RAAs and the Arts Council must convert their existing partnership into much more of a reality than it has yet become. It is time for a new concordat, based on the following principles but worked out between the Council and each RAA in recognition of the differences between RAAs resulting from peculiarities of history, geography and arts provision in the various regions.

(i) ACGB, on its side, wishes to devolve on RAAs *all* decisions *except*

those which can be shown, now and as time goes on, to require decision by a national body.

(ii) ACGB therefore hopes and intends that an increasing proportion of its grant from HMG will each year be passed on to the RAAs for them to use at their discretion.

(iii) Accordingly, each year each RAA will submit estimates on a rolling triennial basis, in time for full discussion with ACGB. Firm decisions will be taken about the grant for the coming year and provisional decisions about items of expenditure in the two succeeding years.

(iv) In submitting its estimates each RAA will include a forecast of its income from local authorities. But in order that ACGB may have an indication of the *total* contribution to arts expenditure that can be expected from local authorities in the region, a rough estimate must be made of local government's contribution not only to the RAA but to cultural activities themselves in its own area. Where, for example, a local council is itself likely to be building or maintaining a theatre, this as well as its contribution to the RAA should be taken into account by ACGB in assessing the interest taken locally in arts promotion.

(v) A crucial factor which must influence ACGB in determining its grant is the need of each RAA to employ staff of the quality required to justify an increasing measure of devolution. How far, for example, a Regional Association is capable of accepting responsibility from ACGB for monitoring theatrical or musical activities must partly depend on the expert advice available from its own staff. Further, the standing of an Association in the eyes of the local authorities of the region, and their readiness to consult the Association about their own plans and policies, rightly depend upon their confidence in the skill and experience of the RAA staff employed. Again, the working partnership between the Arts Council and Association will be valid only to the extent that there is mutual confidence between the staff employed on both sides, and this is bound to depend on a common standard of qualification. For all these reasons Regional Associations must be in a financial position to offer salaries, security and other conditions of service comparable to those of Arts Council staff. Equally important, RAA staff salaries must be competitive with those of local government.

(vi) Regional Associations, on their side, must recognise their obligation as disposers of taxpayer money for which the Arts Council is responsible and, in particular, justify the policy of devolution against

criticism that money voted to the Council has been handed over to regional bodies dominated by representatives of local government. One means to this end would be to include in the membership of each Association, and of its executive, persons co-opted at the suggestion of the Arts Council because of their artistic experience. This would require some modification by Associations of their own constitutions.

(vii) The local authority should be recognised, both by Arts Council and Associations, as the chief local patrons of the future. Local authorities, on their side, should recognise their RAA as:

(a) a consortium of neighbouring county and district councils and a valuable instrument of their joint action – e.g. where the natural catchment area for a tour of actors, musicians or pictures is wider than a county.

(b) a symposium of artists and art organisations, on the one hand, and local governors on the other, enabling both sides to increase mutual confidence and their understanding of each other's problems.

(c) a means of judiciously mixing national taxpayer money, from the Arts Council, with local government funds. Thus a local council can be encouraged to put its money into a new arts centre or other project by the offer of revenue from the RAA.

(d) a means of artistic experiment and innovation which a Regional Association can undertake in the first instance and a local authority can later decide to support if the experiment is judged successful.

(e) a special means of aiding urban, suburban and rural areas where local resources cannot successfully compete with cultural deprivation.

(viii) The basic funding of the RAA would therefore be through the Arts Council. It has been argued that this should be the *sole* source of Association finance. If it were, the whole patronage pattern would be simplified; the Association would be in less danger of domination by elected local councillors and local arts patronage less exposed to the vagaries of party politics. But, on balance, I do not think this argument should prevail. Locally elected representatives of the public must be responsible for deciding how much money should be forcibly extracted from local taxpayers for cultural purposes and how it should be spent. For most of them such exercise of arts patronage is something new, but until they learn from experience how to practise this gentle art and, in particular, come to recognise that the public only gets full value from public money spent on the arts if politicians, by a self-denying

ordinance, keep themselves at arm's length from the artists and art organisations that they subsidise, there is no future for arts patronage through local government. Further, if regional associations were wholly dependent for funds on the Arts Council, there would be more risk of their becoming, or at least seeming to become, mere agents of the national body and forfeiting their independent status. Certainly their whole future would depend on growing Arts Council support. Moreover, there are good logical grounds for local government subscription to Associations. There are common services such as consultancy, publicity and marketing that an Association can offer to the authorities of a whole region or sub-region more economically than each could provide for itself; these services clearly justify local council payments to the Association. Most important of all, some regional associations (Northern Arts, for example) first came into existence because the old local authorities wanted to concert action, and the associations have now provided the new ones with a sound method of collaboration. It would inevitably set back this partnership if joint subscription by authorities to the associations were discontinued.

Short- and long-term relations between RAAs and local government. The local authorities must eventually become the chief source of local support for the arts: the districts that are centred on major town populations (the old county boroughs in particular) supporting professional and amateur music, drama, film, crafts and visual arts; the shire counties and metropolitan districts using their education powers for the benefit of all who have left school as well as those still in full-time education; both shire and metropolitan counties supporting not only projects that draw audiences from areas wider than a district but those also that get insufficient support from their own district because of its relative poverty.

This is the long-term aim. When we achieve it regional arts associations will have done their present basic job but will retain region-wide functions as well as some grant-aiding that cannot be devolved from the centre to each and every local authority. They will continue to be a focus on the arts, a continuing source of new enterprise and of help for the individual artist.

But the expansion of local authority support will be slow, even when the immediate period of stringency loosens its grip. Regional arts associations have a vital role to play during this period, as partners of local government and leaders in promotion of the arts. If devolution

from the Arts Council is to proceed forthwith (and it must) it is inevitable that RAAs will get a larger proportion of their total funds in the short-term from the Arts Council. However, the independence of the RAAs depends upon their stance midway between local and central government, and it is essential therefore that local government should continue to play a major part in funding the associations. The nature of the services RAAs provide is ample justification for larger grants from local authorities in both short and long-term. But local authorities will increasingly use their own professional staff to advise them and administer their own support for the arts; the increase in their arts expenditure will be split between greater support of strictly local activities, and greater support for co-operative activities in the region through associations. Meanwhile, the RAA will become increasingly valuable to local councils as its grants and devolved functions from the Arts Council grow and its staff becomes more competent. For the next year or two, until local government is able to accept much more direct responsibility, RAAs will continue to do some of the local funding that must eventually be the job of local authorities—but it should be deliberate RAA policy to lead local authorities to take over from them as supporters of established local projects so that RAA energies and resources (both central and local) can be re-deployed in new ideas and in areas of special need throughout the region.

Local authorities (See pp. 100-107.)

Metropolitan counties and districts. For arts patronage, what matters most in Greater London and the six metropolitan areas of England is that county and district councils should *agree* about their respective roles and their relationships with regional arts associations. Such agreement must vary according to the past and present character of arts activity in each area but the following common principles seem to emerge as sensible guides to agreement.

1. A metropolitan *county* can levy a tax on all the ratepayers of its area, by a 'precept' which requires all districts to collect so many pence (or parts of a penny) additional to the rate levied by each for their own district purposes. It should use this power to support not only (a) activities in which people from all parts of the metropolitan area (or at least from a wider area than one district) can participate, but also (b) activities in areas too poor to support them only from district re-

sources. Thus Merseyside County Council rightly precepts on districts to help pay for the Walker Art Gallery, instead of leaving ratepayers only in the district of Liverpool to pay. If these two principles were followed in all metropolitan areas, not only would there be a large increase in public patronage of operatic, orchestral, fine art and theatrical activities that attract audiences from a wide area, but the more affluent citizens of a great urban society would help their neighbours in central and less wealthy parts of the city to experience and enjoy the arts. In London and the six metropolitan counties, the product of a penny rate represents millions of pounds a year. For example, in Greater London a penny rate in 1975/76 produced £18.95m, in Tyne and Wear £1,989,076, in Merseyside £2,700,335. And in each of these counties there are great cultural needs to meet: not only 'third worlds' of underdeveloped art potential, but opportunities for visits from opera and ballet companies, which cannot visit provincial centres because at present there is no theatre outside London that can adequately accommodate them.

2. Apart from these county responsibilities, it is the metropolitan *district* that must accept the leading role in patronage. As education authorities, they have the crucial duty of ensuring that no child leaves school without some personal experience of the arts. This must mean extension to all schools of opportunities for practising arts and crafts, which have in some schools become an increasingly common part of school life since the war. All metropolitan districts also have educational duties towards school leavers and adults. Once funds become available, they must be used to provide opportunities for every citizen who wishes to develop his own talent – by playing an instrument, joining a choir, acting, painting, or writing. The districts are already seeking to achieve these ends through colleges of further education, polytechnics and adult education centres, and they must develop this work as an inseparable part of their arts policy. Many of them have the great advantage of the inherited experience and tradition of the county boroughs, boroughs and urban districts which preceded them as local authorities and were among the pioneers of patronage. This inheritance can be exploited and enriched in future in the suburban as well as urban areas, as the new districts bring together educational and other powers in a concerted local government concern for cultural progress.

3. There is now an Association of Metropolitan Authorities (AMA) which unites London and all metropolitan county and district councils

for common purposes. Within each metropolitan county it is essential that districts and county should concert cultural plans, but the AMA seems the right instrument whereby London and all six metropolitans can share their experience in the arts field and solve common problems.

4. As to the function of regional arts associations in metropolitan areas, the county council of Greater Manchester (GMC) has expressed the view that it no longer needs the North West Arts Association (NWAA); that body was needed before local government reorganisation but has now served its purpose. Merseyside meanwhile has left the NWAA and formed its own Merseyside Arts Association (MAA), serving an area roughly co-incident with Merseyside Metropolitan County but wider at certain points. If, therefore, Greater Manchester also withdrew from NWAA, Lancashire to the north and Cheshire to the south would both be isolated: there would be no regional link between the several parts of a wide area which must look to Manchester or Liverpool for large-scale opera, music and drama. Evidence given by Manchester and other metropolitan districts strongly disagrees with that of the GMC and favours the continued inclusion of Greater Manchester in NWAA. It seems quite clear, therefore, that NWAA should not be broken up, but renewed efforts must be made to reach agreement among all concerned.

This view is reinforced by examination of the boundaries fixed by the 1972 Act. Both Greater Manchester and Merseyside are defined much more narrowly than the Royal Commission proposed: they embrace only part of the continuously built-up areas and exclude large parts of Cheshire and Lancashire which in fact look to Manchester or Liverpool, not only for work but for many kinds of leisure activity and especially for those like opera that require large capital expenditure.

Shire counties. Like metropolitan districts, shire counties start as patrons of the arts with the advantage of having sole responsibility for education. Moreover, the areas they cover are continuous, no longer consisting, as they did before local government reform, of geographical counties surrounding quite separate urban islands in which county borough councils were the sole authorities for education and all other local government functions. But education and libraries are the sole functions with an arts connection which belong only to the shire county: all other aspects of the arts are the responsibility both of the county and the district. Here therefore the chief need, as in the

metropolitan areas, is for agreement between county and districts, in particular those districts which before 1974 were county boroughs: say, the new Hampshire and the districts of Southampton and Portsmouth; between the new Devon and the districts of Plymouth, Exeter and Torbay; between Avon county, Bristol and Bath; or between the new Norfolk and the Norwich district. Reorganisation offers new opportunities that were available neither to the old counties nor to the county boroughs, but it guarantees none of them. In every county there is one condition of successful public patronage: agreement between county and district councils on how concurrent powers are to be used.

Change in the law. During the present period of economic restraint it would be wrong, in my opinion, for Parliament to impose any new *duty* on local authorities. But as soon as the Government considers that more expenditure can be allowed including an increase in arts support, the law should be changed: counties, both metropolitan and shire, and districts too, should have a duty to ensure a reasonable range of opportunities for arts enjoyment throughout their area. Such legislation would be consistent with the existing concurrent powers of county and district: it should require each county to consult with districts and the regional arts association and seek the agreement of county and districts to an arts development plan whereby the needs of the whole county might eventually be met.

It has been argued that Parliament should go much further and not only lay such a duty on all local councils but prescribe a minimum rate which they must levy on ratepayers. Such prescription seems to me inconsistent with the principles underlying local democracy and unenforceable in practice: on both grounds I think it objectionable. For the present I hope that Parliament will make no changes in the law. Both counties and districts should now concert plans for the coherent development of the arts, as many have already done, in preparation for the day when increased spending becomes possible. They will thus help to justify those who believe in the potential strength of democratic government as a support of the arts.

But artists and art organisations must learn to put judicious pressure on councillors. They are most likely to succeed by forming local alliances between all concerned. Such unofficial groups, which already exist in many places, could become a normal part of each community. Experience has already proved that a parish, district or county arts

council can establish good relations with the local authority and in due course become a channel not only of new ideas for arts development but of financial help.

The present time of acute financial stringency must not be treated as one in which no action can be taken to support the arts. Even without increased expenditure much can be done. We must use buildings, especially schools and colleges, for purposes additional to those for which they were designed. As amateurs, we must do for ourselves what we cannot yet pay others to do for us, and do it, if professionals will help us, better than before. We must use present time to prepare and agree plans for implementing when progress becomes possible. We must survey the local scene and seek agreement on the order in which the various arts should be developed, the parts of the area where progress is most needed and the buildings, new or adapted, that we require. Such planning should be done at parish, district, county and regional levels.

Local authorities: internal organisation. Parliament would be unwise to prescribe how councils should organise themselves for arts purposes, even if in due course it converts powers into duties. Still less should Parliament require the appointment of an officer with special arts responsibility. In the past Parliament has marked the national concern for a particular local government service (police, health, education, child care, or the social services) by prescribing in legislation that councils should appoint a committee and a chief officer for that purpose, often providing at the same time that the constitution of the committee and the choice of the chief officer must have the approval of a Minister. Some of these provisions still survive (for police, education and social services) but, following advice from various official bodies, Parliament in the 1972 Local Government Act deliberately increased the *freedom* of a local council in these matters. This is surely the right principle to follow in the arts field, where definition of the subject is not easy and no single pattern of administration will suit all councils. This makes it all the more important for each local authority to take the question of its internal arrangements seriously and be ready to make changes as its experience grows. Judging from what the new authorities have done so far, the following guide-lines seem worth considering.

1. If one committee is entrusted with all services concerned with leisure, there should be a sub-committee responsible for arts, as

distinct from sport and outdoor recreation. Alternatively, there should be a main committee for the arts and arrangements made to secure close liaison with the committee concerned with other forms of leisure activity, especially in planning new buildings (or the adaptation of existing ones) for the joint purpose of music, acting and exhibitions on the one hand and sports on the other. At Milton Keynes, for example, a large new sports centre serves as an admirable concert hall, thanks to joint planning; at Abingdon the old gaol has been splendidly adapted as a centre for the arts and sport. But there are examples elsewhere of a new sports centre proving too expensive to convert for alternative arts purposes because the question was never considered at the planning stage. Local authorities would be the more likely to avoid such mistakes if it became generally known that neither Sports Council nor Arts Council would approve a building grant unless both were satisfied that possible joint use had been examined.

2. If, besides any arts committee or sub-committee, a council continues to appoint separate committees for museums and galleries or libraries, special liaison between them must ensure the use of buildings wherever possible for other arts purposes besides the main one. With proper planning, especially when new buildings are required, without damage to its main purpose a library can become an arts centre where gramophone records and film strips can be used or borrowed, lectures given, pictures exhibited, plays and concerts performed, and where unofficial societies of various kinds can meet. Museums and galleries can often serve a similar variety of uses. In all shire counties and metropolitan districts, interconnection between certain committees is of paramount importance: the arts work of the Council *must* be linked with that of the education and social services committees. Each council will decide for itself how this can best be done. It is a question in the first instance for the council's chief executive. Its answer will partly depend on the council's general arrangements for the 'corporate management' of all functions as a coherent whole. But every council that takes seriously its work for the arts must insist on close relationships between the committees and departments mainly or marginally concerned.

Wales
We found the position in Wales (see pp. 85-88 and 98-100) in some ways similar to England: a central body charged to help the arts with

central government money; regional associations growing in strength and competence; some local authorities enthusiastic in the arts field but held back by financial stringency. In much therefore of what we say in this Report we do not wish to make separate recommendations for the two countries, but here we sum up what seems of special relevance to future arts support.

We have already recommended that the Welsh Arts Council should have a separate charter of its own. (See pp. 31 and 32.) In discussing new constitutional arrangements for a Welsh Assembly, maintaining the arm's-length principle for the Welsh Arts Council is of paramount importance. Continuing links with the Arts Council of Great Britain must also be assured, especially at staff level. The Welsh regional associations need to work more closely with the Welsh Arts Council than they have so far done and for this purpose the future Council should include in its membership at least two persons from each association, though without breaching the principle that no members of Council are *representatives* of any interest. The new Council's responsibility should cover not only the arts, as understood under its present constitution, but also crafts and film. Its membership should correspondingly include persons qualified by their experience in these fields. In co-operation with the Arts Council of Great Britain and the British Council, it should seek to increase mutual contact and understanding between the art and artists of Wales and the art and artists of foreign and Commonwealth countries.

The co-existence of the Welsh and English language presents a unique problem for the arts in Wales but at the same time a unique cultural heritage which must be widely fostered and enriched. Wales is outstanding in the truly popular arts of singing and poetry and these find special reflection in eisteddfodau, amateur arts and many kinds of celebration. The University of Wales and all its colleges take a great interest in the arts and have succeeded, better than most English Universities, in meeting the needs of the communities in which they work. But geographically the country is small, indeed not much larger than some English regions, and its population is less than that, say, of the North West Arts Association area. Communications are not good and North Wales feels a strong regional difference from the South. There are few really large centres of population, and therefore no widespread number of buildings that offer good housing for the arts.

These factors weigh against devolution of as many functions to Welsh regional arts associations as to some English ones. Most,

therefore, of the specialist art forms can and should continue to be supported directly by the Welsh Arts Council. Similarly, the major arts centres and theatres are appropriately dealt with as a circuit and therefore need to be an all-Wales function. This applies also to major questions affecting the Welsh language, major touring, the promotion of film culture and the national festivals. On the other hand, regional associations are essential. In the Welsh context they seem to be specially well placed to encourage local participation in the arts, support festivals that are less than national in scope, organise and assist small-scale touring by professional artists, and co-operate with local education authorities in arts-and-education programmes, community arts, help for the local individual artist, local arts centres, arts societies and clubs. Special projects to enrich local cultural life seem work that the Welsh regional associations are specially qualified to promote (the expansion of theatre-in-education would be an example). In brief, they should develop the role of stimulator, rather than subsidiser, of the arts.

Associations should seek to lead their local authorities to take on more direct support for local arts events. For their part, the authorities should use the associations (a) for regional or sub-regional work that no one council could well undertake and (b) for trying out new ideas which, if successful, can later win the support of local government. Further, the Welsh associations have an information and publicity role that they have only recently started to develop. There is no doubt that the regional associations are valuable, but they must not use funds or energy in duplicating work that can effectively be done by the Welsh Arts Council.

Thus language, size and other factors which distinguish Wales from England lead to the conclusion that devolution must not be taken as far within Wales as within England. In Wales the national and local levels of life are closer together than they are in England. On the other hand, the Welsh appetite for the arts and the enthusiasm which the regional arts associations have helped to build up, put RAAs in a strong position to develop regional projects in conjunction with the local authorities. (See pp. 98-99.)

At present, the funding of RAAs is greater from the Welsh Arts Council than from other sources—and local government cannot be expected to make good this disparity in present economic circumstances. However, the Welsh Arts Council must not operate a standstill in its contributions as this would severely damage local arts develop-

ment. In the short-term it is inevitable, as in England, that the pro-portion of central funding of RAAs will increase, but in this instance less because of devolved functions than because RAAs must exercise a leadership role in arts development. Several local authorities in the Principality have programmes of arts support, but it is an even more patchy picture than in England—not surprisingly, in view of the distribution of population and resources. RAAs offer a means of arts development in deprived areas, and of encouraging local government to engage in projects of proven success. Their staffs offer expertise and their committees bring together all who care for the arts.

In deciding levels of grant to RAAs, the Welsh Arts Council should not observe any formula, but rather the needs of each RAA in the light of performance, future plans, local government contributions and direct arts spending by local councils.

The present staff of Welsh RAAs seem right in size for the basic jobs and should continue to work closely with Welsh Arts Council staff. New appointments should be related to the needs of new projects during their first two or three years of development.

As soon as conditions allow, Welsh local authorities must make a steadily growing commitment to arts support: direct support for local professional and amateur art-events of proved worth and indirect support through RAAs for common services, expertise, and innovation. Without continuing and increasing support for RAAs the develop-ment of the arts in Wales will be restricted to a few localities; without more direct local government support for the arts in their own areas there will not even be that. The Welsh Arts Council cannot be a sole provider but needs regional and local co-operation. As in England, districts, counties and RAAs must agree arts development plans which must not wait upon easier times but be a preparation for them.

Support for artists
The main achievements of the Arts Council during its first thirty years are the re-creation of theatre in the provinces, fostering national institutions such as the great orchestras and national theatre, opera and ballet companies, and the direct touring of art exhibitions. All these activities, especially the last, have of course given individual artists their chance. But the Council has also set itself to find ways in which direct encouragement can be given to painters, sculptors, composers, playwrights, poets and other creative artists. What more can be done in future for such people? And who can best do it, at national, regional

49

and local level? We are not doing enough at present for any kind of talented artist, craftsman or designer: indeed, our failure is more obvious here than in any other field of art support. And there is no single panacea. What we need is concerted action by all relevant institutions: schools, colleges, universities, polytechnics; local authorities, regional and other arts associations; Arts Council, British Film Institute, Crafts Advisory Committee; industry and commerce; the private foundations; and the broadcasting authorities.

1. *Broadcasting* (see pp. 107-109) can claim to have done more for the artist in Britain than any other agency during the last half-century. For the future no doubt sensible proposals will come from the Annan Committee, and at this stage we can only hope that whatever Government is in office when decisions have to be taken will resolutely resist proposals for dismantling the BBC and IBA or creating a government department in their place. Meanwhile, the IBA and independent companies can strengthen the case for allowing them a second TV channel by proving more convincingly than they have so far done that, despite the handicap of their confinement to a single channel, they attach no paramount importance to the attraction of mass audiences but are concerned to provide programmes of increasingly high quality. Already they can point to some particular achievements, past and present: Verdi's 'Macbeth' and other opera from Glyndebourne; occasional National Theatre and Royal Shakespeare Company productions; regular arts programmes such as 'Aquarius', 'Northern View', 'Studio One' (from Cardiff) and 'Parade' (from Manchester). Again, a few fellowships have been awarded (by Yorkshire TV, for example) to young as well as established artists; and through the Television Fund, established out of revenue earned by advertising, grants have been made since 1968 to a wide range of organisations (including a Repertory Theatre Trainee Director Scheme and the National Film School), amounting in all to a round million pounds. Until the question of the second channel has been settled, the best hope of improvement by independent broadcasting on this record is not in the greater use of nationally subsidised opera, drama and music but in regional patronage of small professional touring companies (such as Yorkshire TV's use in 1975 of 'Welfare State').

The BBC patronage record is so good that the chief fear for the future lies in financial stringency. The Government therefore, when considering applications for an increase in the licence fee, must take

full account of what the BBC does for the creative artists and performers.

2. *Employment of artists in education.* But the long-term future of artists is in the hands of educators. The lead given since the war by a minority of schools, colleges, teachers and education authorities must now be followed by the rest. Our children and grandchildren must have, at all stages of their education, the chance of acquiring arts and habits not only of reading, writing and mathematics but of discrimination and creative action – of making music, writing poetry and plays, acting and dancing, designing and applying creative skills.

For these things to happen a revolution is needed in the curriculum and teaching methods of the great majority of schools and colleges of education. Here the Schools Council has a large part to play. But whatever progress we make in adapting curriculum and teaching methods in comprehensive and other schools, so that all children have a better chance of developing their artistic talent, special steps must be taken if the exceptionally gifted child is to have his opportunity as a potential artist while still at school. Some future must be found for the choir schools, still supported precariously by cathedrals, colleges and private foundations. Here boys of musical ability have combined general education with training in choral singing. Now, as direct grant schools either become independent or are absorbed into the comprehensive pattern, it will be more difficult than ever (it was never easy) to preserve the choir school and ensure a smooth transition for their pupils into the secondary stage of education. If local authorities fail to solve this problem, the musical child will no longer have his present special opportunity, and we shall all be losers. The Education Bill which, at the time of writing, is before Parliament, provides for special treatment of the talented young musician. And if we are sufficiently determined to find in comprehensive schools enough flexibility, there is no reason why they should not learn to spot exceptional artistic talent and develop it, as part of a new school tradition in which music and other arts take their essential place. Whether or not this happens will depend chiefly on the school principal and the specially qualified teachers that he or she must be encouraged, by school governors and education authority, to have as members of the staff.

The school must be alert to the needs of really gifted pupils for special tuition while they are still at school and must encourage them,

when they leave school, to go on to the appropriate college or university. And when the college stage has been completed, bursaries and grants should be available for study with a 'master', either at home or overseas, and towards purchase of instruments. Fortunately such awards are now provided by some foundations, often on the advice of music college heads; but their provision should in due course be supplemented out of public funds, for the essential further training of the really gifted.

For all these reasons the employment of artists in education is essential.

(i) We need the artist inside our schools and colleges, as *full-time* members of the staff, trained like the specialist in mathematics or chemistry and with similar professional qualifications endorsed by the appropriate institution – the Joint Board of the Royal Music Schools, for example.

(ii) But we also need the *part-time* artist: the professional instrumentalist, the painter, sculptor or craftsman, who gives part of his time and earns part of his livelihood teaching in school, college or polytechnic but is also a free-lance. Such artists are particularly vulnerable at times like these when education, forced to find economies somewhere, yields to the temptation of economising on work still thought to be of only secondary importance. Their salvation lies only in the conversion of educationists to the belief that arts are as important to society as reading, writing and arithmetic, not a disposable extra.

(iii) The alliance of a progressive education authority with an imaginative theatre company (say, in Leeds, Lancaster, or Newcastle-upon-Tyne) has proved the value of *theatre in education* by organising, in consultation with the teachers, regular visits to schools during school hours of a professional group of actors, associated usually with the regional theatre company, who give performances specially designed to involve the audience and infect young people with enthusiasm for the theatre. There is no reason why experiments of this kind should not become the normal practice wherever a subsidised theatre exists. If so, the prospects of ending the alienation of 'theatre' from the normal life of ordinary citizens will be much improved and it will gradually cease to be 'extraordinary' for young people to learn while still at school to enjoy theatre. *Musical* education, thanks to the BBC, the long-playing record and the post-war work of Hertfordshire and other progressive education authorities, has already gone far to justify such hopes.

(iv) *Poets* too have demonstrated here and there what can sometimes be done for the creative literary talent of the young. The reading aloud of poetry in school-hours and its discussion with the writer have supplemented the work of teachers. Poetry-reading societies have become common features in some parts of the country. The generosity of both public and private bodies has enabled centres to be established in the Devon and Yorkshire countryside, where for a few days a group of enthusiasts can practise creative writing in the company of professional writers who have the gift of sharing their own special skill. The survival and development of such experiments depend on a continuing mixture of private and public money. (See p. 157.)

(v) Some *universities* in Britain are taking an important share in patronage within local communities; by making their theatres and concert halls available for public performance, as in Wales and at Southampton, Newcastle-upon-Tyne or Exeter; by acting host to a resident quartet, a poet, a prose writer, composer or visual artist; by giving public access to their own libraries, museums and galleries. Every university should play such a part in one way or another, according to its own judgement of local opportunities. But to a large extent British universities depend on public funds, provided directly through the University Grants Committee (UGC) and indirectly by student fees paid by the local authorities. Their plans for arts patronage need therefore the broad approval of the Government. Unpromising though the immediate prospects may be, now is the time for universities and UGC to work out agreed procedures for public aid to local arts activities. It should be accepted on both sides that, as national funds become less scarce, there is a national interest in developing the role of universities, each in accordance with their local circumstances, as patrons of music, drama and the visual arts.

3. *Employment in industry and commerce.* We shall not gain what we might from educational developments unless our industry and commerce undergo similar changes of attitude towards artistic talent. Engineers and the manufacturers must cease to be alienated from artists, designers and craftsmen. We urgently need to find ways whereby an alliance between people of these types can be consolidated, for the good of our export trade and balance of payments as much as for that of creative talent. At the Royal College of Art a start has been made in this direction. In 1974, for example, the College collaborated with the Design Council in a pioneer course on 'design management',

under Sir Misha Black, to help young leaders in industry and commerce to identify good design and make the best creative use of it. In 1976 the College will publish the results of a two-year project sponsored by the Department of Education and Science about the teaching of design awareness in general education, and a major exhibition and conference under the title 'Design for Need' has just been held. Such initiatives hold out some promise. But now we need a national campaign. No quick result can be expected. But we are now forced by economic circumstances to recognise the acuteness of our national problem. Now is the time to organise concerted action to bridge the gap between artist, designer and businessman.

4. *Other kinds of help for artists.* Both for our own sake as a nation and for the sake of individual artists, we must make full use of the rare gift of talent – and pay a living wage for it. This must mean, most of all, artist employment: in broadcasting, education, industry and commerce. But there are other things, though they are less important, that we must also do for him. Exhibition space must be available, at a low rental or fee, to painters and sculptors in all centres of population. Besides using for this purpose arts centres, theatres, school and college buildings, we should adapt disused churches, cinemas and warehouses all over the country, as has already been done successfully in many places; for no artist should be unable to show his work for lack of covered space, and for some years to come we must accept the certainty that purpose-built new galleries will be exceptional. Studio space at a low rental must be sought out by similar means. Here too a fair start has been made in recent years, thanks in the main to co-operation among artists themselves, but on a scale that fails to meet national need.

The artist-craftsman's miscellaneous needs are also pressing. They include space to work in; help to finance materials and equipment and the employment of apprentices; exhibition and marketing assistance. The Crafts Advisory Committee, the Design Council and the regional arts associations could together make excellent use of any further funds that can eventually be found. Meanwhile coherent plans must be worked out in consultation with existing craftsmen's guilds and societies.

Some New Town Corporations, such as Stevenage, Milton Keynes and (in Scotland) Glenrothes, already employ town artists as members of their staff, with excellent results. This innovation should in due course become a part of normal local government practice, especially

in the planning of a new estate and the design of urban landscape and street furniture. We must learn all we can from experiments made in other countries to give artists employment rather than charity. The Works Progress Administration arts scheme of the late 'thirties in the United States and some elements of current effort to help visual artists in the Netherlands suggest promising directions for us to explore. I recommend that the Arts Council and other bodies should continue and intensify the search for ways in which new opportunities can be found for all kinds of British artist to earn their living by their work.

The battle for VAT zero-rating on all works of art – whether on pictures, sculpture, concerts or theatre tickets – must be fought out. So must the fight for the author's public lending right.

Support for various forms of art
Drama: opera: ballet. Public support for the National Theatre, Royal Shakespeare Company, Royal Opera and Ballet, English National Opera and other national companies should continue to be channelled through the Arts Council of Great Britain, rather than by direct grants from the Treasury or any other Government department. As soon as economic conditions allow, such grants should be made on a rolling triennial basis rather than annually.

Regional theatres and companies should continue for the present to receive grants from the Arts Council and local authorities, as soon as possible on a rolling triennial basis rather than annually. But the Arts Council should seek forthwith to involve regional arts associations in monitoring all such subsidised theatres and companies and in decisions about the levels of grant and any other conditions attached thereto.

Itinerant drama companies offer a valuable service for places in urban, suburban and rural areas which lack theatres. They deserve support from local authorities, regional arts associations and the Arts Council, especially at the present time when resources are too scarce to allow the building of new theatres. (See pp. 118 and 174.)

Long-standing plans for the establishment of a Theatre Investment Fund for use by the commercial theatre should be implemented without delay. By this and other methods, we must seek to combine public and private patronage of the theatre, ensure that each complements the other and avoid wasteful duplication.

Local education authorities should give wider and more substantial support to Theatre-in-Education (TIE) which has already proved its value in some areas. Such support is justified not only on strictly

educational grounds but as a means of increasing future adult audiences by introducing young people to the theatre at an impressionable age. The success of theatres for young people already established in a few centres of population should be followed up by local authorities in other conurbations. The art of puppetry, which has now proved its value for young people without help from public funds, deserves the relatively small financial aid that it requires for wider development.

Amateur drama can make excellent use of small-scale funds for equipment, professional aid and other purposes. Local authorities and regional arts associations should treat such requests with special sympathy at the present time.

Music. The Arts Council should initiate discussions between the four subsidised London orchestras and the BBC, in the light of recommendations made in the 1970 Peacock Report, of subsequent experience and of present and future shortage of funds available for music. Particular questions to be re-examined are whether the Council will be able in future to give adequate subsidies to four London orchestras, whether standards would be raised if any or all of those orchestras were re-constituted on the basis of contracted players, and what consequences such change would have on employment in the musical profession. Arts Council grants to the London Orchestral Concerts Board should as soon as possible be placed on a rolling triennial basis.

The Council should continue to make grants direct to regional orchestras but should bring regional arts associations into close consultation about such decisions.

Chamber orchestras deserve help, from the Arts Council and from regional arts associations, for the performance of contemporary music and towards meeting their administrative costs. The Arts Council should gradually devolve to regional arts associations and local authorities the grant-aiding of all musical and other festivals, except those achieving national or international status.

Chief responsibility for the encouragement of contemporary music should continue to rest with the Arts Council and the BBC. But regional arts associations should also regard this as one of their objectives and, in particular, should encourage the commissioning of new works for festivals and other special occasions.

Funds for the recording of new music for use at home and overseas should be increased.

The dearth of good concert halls, especially outside London, must eventually be reduced by new building. Meanwhile, improvements of some No. 1 tour theatres should be designed so far as possible to meet musical needs as well as those of touring theatre and ballet.

Local education authorities must make provision for selecting children and young people who have outstanding musical ability and ensuring their appropriate education at primary and secondary levels. Full use should be made of special schools, such as the Menuhin school and choir schools, but all comprehensive and other secondary schools should also include special concern for musically gifted students among their objectives. The Schools Council should give a lead in the research and development that are required before the needs of children specially gifted in music, ballet and other arts can be met on a national scale.

Local authorities and regional arts associations should have particular regard to the needs of amateur musicians.

The service given by professional musicians as performers or adjudicators at competitive musical festivals should be recognised and financed.

Local authorities should extend their service of loaning music and instruments for use by amateurs. (See p. 130.)

The visual arts. An enquiry into the present economic conditions under which artists and sculptors live and work would be valuable, in order to establish the facts (for example, about the number of those able to earn a livelihood from full-time practice of their art and about the recently reduced opportunities of part-time employment as teachers) and to recommend ways in which present conditions should be improved.

Artists and sculptors must be enabled to exhibit their work to the public under reasonable conditions if they are to judge for themselves their chance of earning a livelihood as artists. Local authorities and arts associations, regional and local, should seek to ensure that all public buildings that can be used or adapted for exhibition purposes (such as county and town halls, schools, colleges and libraries, as well as galleries and museums) are made available to visual artists of all kinds.

A policy of acquiring for exhibition purposes disused churches, halls, warehouses etc. should be vigorously pursued by local authorities until improved economic conditions make new building possible.

'Artist-in-residence' is an arrangement which has proved valuable

both for the host institutions and for artists, but its further successful development will depend on judgement in the selection of artists and clear definition by hosts of the purposes to be served.

The purchase by local authorities of works of art, for exhibition in schools, colleges and elsewhere, should be widely encouraged. Professional advice about such purchases should be sought from artists, whether invited by local authorities to serve as advisers, co-opted as committee or panel members, or employed in the museums and galleries department.

The commissioning of works of art as integral parts of a new public building, whether by national or local authorities, should come to be generally accepted policy. Account should be taken of experience of other countries, such as Holland, where such policy is imposed by legislation. (See p. 148.)

Literature. Legislation to establish a public lending right for authors should be passed at the earliest opportunity and Parliament should progressively make public funds available for this purpose at an appropriate level.

Local authorities should use their libraries to make available information about new publications and, in view of the shortage of bookshops in many areas, legislation should in due course be passed to clarify the power of libraries to sell books. Local authorities should make increasing use of libraries, without prejudice to their main purpose, for exhibitions, concerts and meetings.

The 'writers-in-residence' arrangement should be encouraged at institutions where use can be made of carefully selected writers. Local authorities should be prepared to subsidise the use of writers in schools and colleges and the fees of students attending courses in creative writing provided by voluntary organisations and bodies such as the Arvon Foundation.

What can be done to launch the unknown writer and unpublished poet is a problem that our society has not yet started to solve. The Arts Council and some Regional Arts Associations are of course seriously considering it. Experiments in subsidising literary magazines, the publication of anthologies, poetry readings, and direct grants to poets have had some marginal success and must continue longer before a final judgement can be made. At present we cannot claim that any official process of selection, either of writer or subsidy, promises better success in talent-spotting than the commercial publisher. On certain

conditions, therefore, we should not hesitate to subsidise some publishers from public funds. (See pp. 154-157.)

Provision for the handicapped

All concerned with any form of arts activities, at all levels (national, regional and local), should give special consideration to the needs of the handicapped and disabled of all ages. The objective in all cases should be to enable such people to take part in the cultural activities of their choice, like any other member of the public, and, so far as their disabilities allow, without treatment as a special group. But this can seldom be achieved without deliberate effort and specially devised arrangements. Thus, in theatres, cinemas and concert halls wheel-chairs must be available for those who need them and some priority given for booking convenient seats. In the design of all new buildings and the adaptation of existing ones, those responsible must insist that architects take full account of all such needs. There is a strong case, too, for offering special seat prices to the disabled through some kind of public subsidy.

Exhibitions of the work of the handicapped should be encouraged, especially of children's work (such as those organised by the Invalid Children's Aid Association). But there is special advantage when such work is shown as part of a general exhibition not confined to work by the disabled.

The use of music and other arts in occupational therapy must be developed, and the research work of voluntary organisations (such as the British Society for Music Therapy) deserves encouragement from public funds.

Local authorities of all kinds, but especially county councils both metropolitan and shire, should accept responsibility for meeting the special cultural needs of the handicapped and the disabled, both as potential artists and as audiences.

The art development plans, which need to be drawn up by county and district councils in collaboration with regional arts associations, should all include special provision for these groups.

Regional arts associations should give high priority to these groups in regional plans and should equip themselves with specialised knowledge in order to advise the local authorities who consult them.

Other recommendations

Research and information. Support for the arts in the United Kingdom

at present suffers gravely from lack of information about the experience and policy of other countries. It suffers too from ignorance in each part of Britain of what is being done in other parts. Valuable reports are made from time to time about particular problems, on the initiative of the Arts Council or of foundations such as the Gulbenkian, Pilgrim or Leverhulme Trustees. Better value would be obtained from money spent on the arts and wiser plans laid for further progress if there were established a new autonomous institution for information and research which could supply the Arts Council and other national bodies, local authorities, regional arts associations and private enterprise with facts and ideas collected systematically from inside the country and from abroad. If funds were made available in the first instance by a foundation or group of private benefactors, matching finance from public sources, national and local, should be found. (See p. 177.)

Universities. As soon as present restrictions on university finance can be relaxed, the University Grants Committee (UGC) should encourage universities to take further steps to make available to the local community their art, museum, library, drama and music services and buildings. Where this requires additional finance (for example to keep buildings open for public use at times when for university purposes they can be closed) the UGC should take account of the fact in fixing grants. Local authorities should also be prepared to subsidise arrangements approved by them whereby the local university helps to provide a cultural service to the public.

C. SUMMARY OF MAIN CONCLUSIONS

1. During the last thirty years England and Wales have achieved a richer flowering of the arts of music, opera, drama, literature, painting and sculpture, and a greater increase in the enjoyment of them, than in any comparable period since the start of the industrial revolution.

2. This would not have happened unless taxpayers and ratepayers had become patrons of the arts and developed new methods of public patronage to complement the private patron through national and local government.

3. The proportion of public expenditure at present devoted to the arts in England and Wales is still such a minute fraction of the total that to reduce it would make no perceptible contribution towards the reduction of total public expenditure. Unless it is now steadily increased, at least to keep pace with inflation, much of the post-war investment in the arts will prove to have been wasted and we shall find ourselves unprepared to make progress when economic conditions make progress possible.

4. It was in 1940, at the worst period of the war, that the new pattern of arts patronage was inaugurated. It succeeded in making positive use of the nation's artistic talent and, by doing so, enhanced national morale. In the totally different circumstances of the present economic crisis we have a similar opportunity to achieve two objectives: to ensure the survival of our artistic achievements and so help to strengthen the national will through steadily increasing enjoyment of the arts.

5. The new local authorities created by the 1972 Act are the chief arts patrons of the future. Local government is the democratic instrument whereby individual members of a community combine their efforts for common purposes within limits laid down by Parliament. Local communities in district and county have recently lost some of their traditional functions (sewage-disposal, for example, water and health) but they now have power (though no legal duty) to ensure that all members have the opportunities to practise and enjoy the arts. The future of the arts in England and Wales now chiefly depends on the extent to which, and the pace at which, these local councils come to

regard the use of their arts patronage powers as part and parcel of the social fabric which they already help to sustain through their provision of education, housing, the social services, roads, land-use control, police, fire-protection and the rest of local government.

6. It is chiefly through our use of this democratic instrument that we must decide how much we want to spend on the arts in each district and county; what proportion of that expenditure we want to use for music, for drama, for museums and galleries; what proportion to spend in support of amateurs and professionals respectively; and whether support should be given by subsidy or by direct provision. Through our elected representatives and the staff they employ, we must learn a new art of public patronage, just as we have learnt something in past years of the arts of providing education and housing. We still have much to learn about these traditional forms of local self-government but yet more about the new art of public patronage. However critical of local governors we tend to be (and however good the reasons for our criticism), we must put our faith in local governors as the future instruments of patronage on our behalf. I can see no preferable alternative.

7. As in the traditional local government service, so in arts patronage the local ratepayer must have the help of national taxpayers. At present two of every three pounds spent by a local council comes from the taxpayer, mainly through the rate support grant (RSG). But, in addition, for arts patronage Parliament provides some funds each year out of what we pay in national taxes. Part of this money sustains the National Gallery and other such institutions. Part of it goes to the Arts Council, the British Film Institute and the Crafts Advisory Committee; and part of these latter sums can be passed on to Regional Arts Associations (RAAs). The Arts Council now subsidises all the RAAs and has recently declared its policy of further devolution to the regions. Already substantial sums go also from the Arts Council direct to regional arts, often in partnership with local authorities; and henceforth increasing Arts Council grants to RAAs will be mixed judiciously, not only with local council contributions to the RAA, but, as matching grants, with new local council investment in their own arts activities. Thus we as ratepayers will find our local efforts further supplemented from national taxes.

8. The Arts Council is right in principle to trust the RAAs with a larger share of national money and to hand over to them wider powers of patronage. This is another act of faith, not in the Associations only but in local government. It must be justified not only by the behaviour of the Associations but by that of local government too – and if in any case it proves not to be justified, the Arts Council must withdraw its trust. Such a withdrawal would be deplorable but the alternative still worse. The taxpayer's money is given by Parliament to the Arts Council, instead of being dispensed in the traditional way by civil servants on the responsibility of Ministers, only because we think arts patronage is more likely to achieve its purpose (and give us value for our money) if bureaucrats and politicians keep themselves at arm's length from the operation. If the Arts Council are to be justified in passing their public obligation on to the RAA, the RAA must seek to act on the same arm's length principle; and if the RAA is to do that, its local government members must have in mind the same considerations. Of course they (and the RAA) are publicly accountable and must insist that they are kept fully informed and the accounts duly audited. Of course they must pay heed to their constituents' judgement. But they must pay heed too to the conditions of artistic excellence – to the creative artist's need for a degree of *freedom* and to the requirement of *continuity* in the development of major artistic enterprises. No rule of thumb can differentiate between questions of 'artistic' judgement (what plays to stage, what music to play, what pictures to exhibit) and 'political' questions (how much can we afford on arts, how much on housing). But local governors can learn to recognise the difference between the two kinds of question and by their self-restraint refuse to let decisions on artistic questions (whether taken by their own council or by the RAA) be dominated by the will of party caucuses.

9. County and district councils must in each place work out their respective roles and agree procedure for collaboration. Shire counties and metropolitan districts, as education authorities in each area, have chief responsibility for fostering the arts through schools, colleges of education, polytechnics, colleges of further education, and the adult education service. Districts which before 1974 were county-boroughs have special opportunities in the rest of the arts field because of their past experience. The aim must be to agree coherent plans of arts development (at district, county and regional levels) which can be implemented as soon as progress becomes practicable. These plans

should knit together art services which in the past have been in separate compartments, such as education, libraries, museums and galleries, community development or entertainment. They should include film and the crafts. And they must provide encouragement for amateur as well as professional activities.

10. Each RAA must retain a character, constitution and independent status of its own, prescribed neither by Parliament nor by the Arts Council. All should remain voluntary organisations, without taxing power. All local authorities – county and district, metropolitan and shire – should choose to belong. All should subscribe funds, on formulae agreed region by region, but no council should regard its RAA subscription as relieving it of obligation to support the arts in its own area. The Arts Council should supply taxpayer money for supplementing what ratepayers find, on the basis of three-year expenditure estimates prepared by each RAA and as an increasing contribution to an association's total income. This taxpayer contribution must be used in part as matching grants to elicit further local funds for a council's own arts activity. In fixing future subsidies to the RAA, the Arts Council should take account of the support given by local authorities not only to the RAA but to the arts in their own areas.

11. The main reason for gradual devolution of decision-taking to RAAs is that decisions about most arts activities (in the first instance arts centres, festivals and community arts) are more likely to be wise if taken locally and in close association with local authorities than if taken in London. But there is another important reason: the Arts Council is itself much better placed than local or regional bodies to take a wide range of other decisions, and it must be enabled to concentrate its energies on these. Obvious examples are opera, dance, orchestral music, national and international touring, and those aspects of drama that can best be considered from a wider than local point of view. The Arts Council must therefore focus part of its attention on these things. But there are other important subjects which need *national* attention. Examples are the training of arts administrators for work at all levels, and 'honest brokerage' designed to put industry and commerce (in both the private and the public sector) in touch with artistic enterprises which they might sponsor. Further, the Arts Council is in a better position than any other body to link up its own arts patronage and that of local and regional authorities with the kindred activities of broad-

casting and education and of bodies such as the British Council, the British Film Institute and the Crafts Advisory Committee. Finally, and perhaps most important of all, it is the Arts Council, with its special access to knowledge of the needs of all the arts, that must maintain contact with Her Majesty's Government and exert informed pressure in support of the claim on taxpayers that the arts can reasonably make.

12. Public support for the arts, on a steadily increasing scale, is a condition of our society becoming more civilised. That public support will increase only if a growing proportion of our society willingly consents to the forcible extraction of more money from their pockets in the form of rates and taxes. That consent will be forthcoming only as individuals discover from personal experience that their happiness is enhanced by taking an active or a passive part in art activities, alone or in company. There are therefore no short cuts to higher levels of civilised life. Progress depends ultimately on education: on children discovering some artistic talent while at school and, for the rest of their lives, developing that talent and discovering new ones. Even that is not enough. They must have opportunities for using, not only in leisure time but as they earn their livelihood in industry or commerce, such artistic talents as they have. We need therefore a fundamental development of educational practice, designed to include arts in the regular curriculum as well as literary and mathematical subjects. And we need changes in industry and commerce that will give design and craftsmanship their proper place. We deceive ourselves if we think 'support for the arts' can properly be confined to the subjects with which this Report mainly deals. However, that is no reason for postponing action to support the arts in ways that are already practicable.

13. As taxpayers we are bound to ask ourselves two questions: how much increased public expenditure on arts is now proposed and what scale of priorities does this Report suggest that we should follow? Neither of these reasonable questions can be answered here. Only the Cabinet (and Parliament) can decide how much support the arts should have from national taxes, only the local councillors can decide how much from the rates. And our priorities in arts expenditure must depend in large part on those decisions. All we can say with confidence is this: the more each Government and each local council takes from our pockets for the arts, the wider the choice we have in settling our priorities among the various recommendations made in this Report.

III *Present framework of arts support*

'*Box Office*'

The present British framework of arts support from public funds reflects certain assumptions. Parliament has never sought to incorporate all of these views in comprehensive legislation. No Government has asked Parliament to do so. But implicit in present arrangements some principles can be detected.

1. The individual customer knows best. Each of us knows what he likes and should be free to make his choice. The individual must decide how much of his money and time to spend on the arts, generally and in particular. Artists and art organisations should be free to sell their goods and services, in competition with each other and with all kinds of other goods and services. The commercial market is the best way of matching supply with demand and giving freedom both to the artist and to the individual 'consumer' of the arts.

2. There must be various exceptions to this rule. In some circumstances some of the arts should be free. They must be paid for, all the same. So, if the individual consumer is not to pay, we must combine our individual efforts through the machinery of government and contribute, whether we like it or not, whatever taxes central or local government tells us to pay. Thus we must pay for the education of all children of five to sixteen and all young people over sixteen who wish to go on with education and have proved their ability. And as their education must include the arts, we must all pay for the arts in education. There is another older (and less obvious) exception to the market rule: public museums and galleries and the public library service must be free, without charge to individual users; so we must all pay for them. Pandora's box of arts-without-individual-payment has already had its lid lifted an inch or two.

3. But more significant than those extreme exceptions to commer-

cialism is the device of mixing public and private enterprise in arts provision. Thus a board or trust (seeking no profit itself) can provide plays, opera, dance or concerts; those who wish (and can afford) to pay something towards the cost can buy a seat; taxpayers can guarantee the undertaking against loss, or pay a subsidy, or be themselves promoters of the project. As taxpayers we thus contrive that fine art, drama, opera or music, which private enterprise would not find profit in providing, is made available for those who want to pay for it, at prices which we think they can afford. In consequence we are still free to exercise our individual choice, by buying or not buying tickets for a particular performance; but we can choose from things which would not be there without the subsidy; and, thanks to the subsidy, we pay less than the real cost of what we see or hear.

Although the arts have always had benefactors and patrons to subsidise them, more of the arts managed to pay their way in the past than do today. Some people maintain that this only shows that the arts have increasingly lost touch with the public, who do not value them sufficiently to pay a realistic price. It would be wrong, say critics of subsidy, to sustain art forms which appeal only to small minorities and should have the stimulus of commercial pressure to force necessary change. It is undeniable that contemporary music, theatre, painting and sculpture often bewilder or bore the public. All art, whether traditional or revolutionary, demands a public which has learned to enjoy it. Moreover, most art forms have undergone a revolution since the early years of the century. In retrospect some of these changes, from representational to abstract painting for example, have now been generally accepted by wider sections of the public. But neither in painting nor music have we reached agreement, even among serious critics, on standards of judgement by which the genius can readily be distinguished from the phoney.

The arts are an essential element of our national life, and it is right that our money should be collected as taxes and spent in support of them. But it is also right that those who find them a specially important part of their lives should make an extra contribution at the box-office. This has an additional advantage: box-office income provides a useful indicator of public reaction and spurs the companies to attract as large an audience as they can.

For reasons quite unconnected with the gap between contemporary art and the public, the need for public support to complement commercial sales and box-office takings has become greater in recent years.

The arts are labour-intensive. It takes as many people to perform Beethoven's Ninth Symphony today as it took fifty years ago or when it was written. But meanwhile the price of labour has been increasing more rapidly than any other factor of production. And if labour of all kinds is increasingly expensive, trained and talented labour is still the most expensive kind – and the kind on which the arts rely.

We still pay artists badly. We still get our arts cheap, and we expect to go on doing so because they have been cheap in the past. The amount of public help Britain gives to the arts is small when compared with that given by countries with populations smaller than ours (Sweden or Holland, for example) and minute in comparison with other sectors of government spending. Our artists are still amongst the worst paid of the labour force, and they therefore claim with some reason that it is they who largely subsidise the arts. Certainly they now demand what they think proper payment, and some of them, but not all, are now organised to get it.

Now therefore we must pay more at the box-office and more as taxpayers. The only alternative is to see the standard of our arts rapidly decline. The first cutbacks will be in areas of experiment, new work and help for the creative artist. But soon the standards, then the very existence of the theatre companies, orchestras and opera will be threatened. The omens are already there to see.

There is no 'right proportion' of the total costs that we should meet by payments at the box-office. The conditions of each art should be continuously studied by bodies such as the Arts Council and, as a condition of continuing subsidy, realistic box-office targets should be set for each type of company.

The Government

The department of Government which has chief responsibility in England and Wales for aiding the arts, crafts and museums is the Department of Education and Science (DES). Within the main department there is an Arts Department with its own Minister, called Minister for the Arts. The first such Minister (in fact a Parliamentary Under-Secretary of State) was the then Miss Jennie Lee, now Lady Lee of Asheridge, who was appointed in 1965; hitherto government help to the arts had been a responsibility of the Treasury. With the change of Government in 1970, Lord Eccles became Minister (as Paymaster-General); in 1973 Mr Norman St John-Stevas was appointed; and he was succeeded in the new Government of 1974 by Mr Hugh Jenkins;

Lord Donaldson succeeded him in 1976, with the rank of Minister of State. The status of the Minister in various governments has ranged from cabinet rank to Under-Secretary of State. Sport and recreation, without clear distinction from 'the Arts', have their own 'Minister for Sport' within the Department of the Environment.

The Arts Department works to a budget within the vote of the DES. From that budget, grants-in-aid are made to the Arts Council of Great Britain, the British Film Institute, the Crafts Advisory Committee and to the British Museum, the Victoria and Albert Museum and certain other national museums; other grants are made to the Area Museums Councils and to the bodies shown below.

In 1975/76 the main heads of arts expenditure in the department's estimates were as shown in table overleaf.

In making these and other grants, the Ministry responds to detailed applications from respective bodies, which show past performance and forward planning. The Ministry has assessors who attend meetings of some of the councils and boards of the bodies concerned. Though accounting procedures and the changing value of money make year-by-year comparisons difficult, the total sums spent on the arts by the Department have been:

1964/65: £12m
1965/66: £13·6m
1966/67: £16·4m
1967/68: £18·5m
1968/69: £19·2m
1969/70: £21.4m
1970/71: £26·1m
1971/72: £31·9m
1972/73: £38·6m
1973/74: £43·3m
1974/75: £48·1m

These figures exclude attributions from other programmes.

However, the Department of Education and Science is not the only government department involved in giving support to the arts. Some two-thirds of local government expenditure is now found by Central Government and disbursed to local authorities by the Department of the Environment as Rate Support Grant (RSG). Again, we shall see later that the British Council has an arts role, and that Council is funded by the Foreign and Commonwealth Office. Nor shall we forget in this

British Museum	£4,065,000	
Science Museum	2,001,000[1]	
Victoria and Albert Museum	3,229,000[2]	
Imperial War Museum	908,000	
London Museum	59,000[3]	
National Gallery	1,778,000	
National Maritime Museum	1,240,000	
National Portrait Gallery	540,000	
Tate Gallery	1,714,000	
Wallace Collection	250,000	
National Galleries of Scotland	739,000	
National Museum of Antiquities of Scotland	233,000	
Scottish Education Department expenditure on Royal Scottish Museum, etc.	748,000[4]	
Scottish Council for Museums and Galleries	24,000	
Scottish Opera: special capital grant towards cost of conversion, Theatre Royal, Glasgow	400,000	
Sub-total		17,928,000
Arts Council of Great Britain	26,150,000[5]	
South Bank Theatre Board	1,310,010[6]	
British Film Institute	1,969,000	
National Film School	310,000	
Area Museums Councils in England	550,000	
Bodies associated with crafts	545,000	
Research projects in Museums and Galleries, including local museums, and the arts	50,000	
Sir John Soane's Museum	48,000	
Museum of London	478,990[3]	
Sub-total		31,411,000
British Institute of Recorded Sound	100,000[7]	100,000
Gaelic Books Grant (Glasgow University)	8,500[7]	8,500
National Museum of Wales	2,094,500	
Council of Museums in Wales	20,000	2,114,500
Grand total		51,562,000
Add attribution from other programmes (approx)		7,200,000
		£58,762,000

Notes

1. In the previous year a sum of £135,000 was allocated to the Science Museum towards purchases by local museums, but this is a cumulative fund which is topped-up only when necessary.

2. Includes £400,000 to a fund administered by the Victoria and Albert Museum from which grants are made to local museums and galleries towards the cost of approved acquisitions.

Notes continued on opposite page.

Report the considerable contribution to the arts made by broadcasting, financial support for which (outside the independent sector) is found from licence fees, administered by the Home Office.

In Wales, Government support for the Arts is at present channelled from the Arts Council of Great Britain to the Welsh Arts Council. The Welsh Office performs in Wales the art functions of most English government departments.

Some assistance to the arts has also come from the Urban Aid Programme administered by the Home Office.

The English Tourist Board and the Wales Tourist Board have given capital assistance to some arts projects where their development has helped to promote tourism in Development Areas. These Boards are funded by the Department of Trade. That Department also concerns itself with matters affecting the film industry and publishing.

Funds for training for the arts come mainly from local education authorities, but some grants to national institutions (Royal College of Art, Royal Academy of Music, Royal College of Music, National Film School, for example) come direct from the DES.

Thus it is misleading to think of the Minister for the Arts as the controller of Central Government funds for arts support; there are several ministries involved in what is a complex pattern. Nevertheless 'Arts Department' funds form the main government support, certainly in the sector of the creative and performing arts.

The Arts Council of Great Britain (ACGB)
The Arts Council was established in 1946 by Royal Charter. It had evolved from the wartime Council for the Encouragement of Music and the Arts (CEMA). Those seeking a history of this evolution are

3. In mid-year the London Museum became the enlarged Museum of London, so these two entries should be read in conjunction. They include a capital item of £250,000.

4. Includes sums totalling £60,000 to funds for acquisitions by local museums and galleries in Scotland.

5. The grant to the Arts Council was raised later in the year by a supplementary grant to £28,450,000. Supplementary grants were also made to some of the other recipients of DES grants, but the figures in the above list show the original estimates only. Of the original grant to the Arts Council, £3,000,000 and £2,050,000 respectively were allocated by the Arts Council for arts expenditure in Scotland and Wales.

6. Capital part-grant towards costs of the new National Theatre building.

7. These grants are not made under the same departmental programme as the other entries, but are at least in part concerned with the arts.

referred to Eric W. White's excellent history of *The Arts Council of Great Britain* (Davis-Poynter, 1975). The Charter gave the Council an independent status under a Council appointed by the Chancellor of the Exchequer; it had as its purposes to develop 'a greater knowledge, understanding and practice of the fine arts exclusively, and in particular to increase the accessibility of the fine arts to the public . . ., and to improve the standard of execution of the fine arts and to advise and co-operate with Our Government Departments, local authorities and other bodies. . . .' In 1967, a new Charter was granted which confirmed a change of responsibility for the Council from the Treasury to the Department of Education and Science, and amended the purposes by referring to 'the arts' instead of 'the fine arts'. Scotland and Wales have Arts Councils within the new framework, and these advise ACGB on the exercise of its functions in those countries.

The Council (whose Chairman and members are now appointed by the Secretary of State for Education and Science, in consultation with his Scottish and Welsh colleagues, and retire on a rotating basis), appoints a Secretary-General and specialist staff in various departments to deal with music, drama, the fine arts, etc. The Council uses its budget each year so that it can respond to each art form (including some uses of film, though general encouragement of film is the responsibility of the British Film Institute). In its first year of operation (1945/46) the Arts Council received a grant-in-aid of £235,000. In 1975/76, the grant-in-aid was £26,150,000 (subsequently increased by a supplementary allocation to £28,450,000).

The basic principles hitherto followed by the Council appear to have been: (a) not to formulate dogmatic policies, but to respond to the initiatives of artists and audiences; (b) to concentrate on the professional rather than the amateur and leave support for 'education' to other bodies; (c) once central standards had been established, to ensure that they were maintained; (d) to direct an increasing proportion of its total resources to the regions; (e) to balance its expenditure between fostering new work and the revenue support of on-going enterprises.

CEMA had established regional offices for its activities which were largely promotional, and these offices were inherited by the Arts Council. But the Council engaged increasingly in grant-giving rather than direct promotion. In 1952, three of the regional offices were closed, another in 1953, and the remainder in 1955. It was felt that they were expensive outposts which had outlived their function. As we

shall see, this action was influential in bringing about the birth of regional arts associations. However, the Arts Council has in recent years continued to provide, and even expand, the direct provision of some services, and while this is a small part of the whole activity of the Council, it should not be overlooked. Examples of direct provision (as opposed to grant-giving) are the Contemporary Music Network, DALTA (the Arts Council's Theatre Touring Service), the Exhibitions Service, the Wigmore Hall, and the administration of the Hayward Gallery on behalf of the Greater London Council.

In the early years the number of client organisations or individuals dealt with by the Arts Council was relatively small. Thus in 1951/52 the Council made an approximate total of 300 grants, bursaries and awards in England totalling about £340,000. In 1974/75 the figures were approximately 1,220 and £16,634,472 respectively. To assist it in considering applications and policy, the Council appoints Panels and Committees of specialist advisers, each panel being chaired by a member of the Council. Council members and advisers are unpaid except for reimbursement of expenses. A full list is included in the Council's annual reports, to which the reader is referred for greater detail regarding the policy and operation of the Council over the years. But we should note that it is the Council which takes responsibility for decisions, not the panels (which are advisory), and that the Council is advised on finance matters by a Finance Committee which comprises the Chairman and Vice-Chairman of the Council, the Chairmen of the Scottish and Welsh Arts Councils, and the Chairmen of the Panels. We shall also refer later to the Council's Regional Committee.

We heard a great deal of praise for the Arts Council, especially from local government representatives and artistic organisations, and some strong criticisms. Of the latter, the most often repeated were:

(a) that the method of appointment of the Council, Panels and committees was undemocratic and resulted in an 'élitist' view of art that was unrepresentative;

(b) that too great an emphasis was given to the performing arts, and insufficient to encourage the creative artist; that there was implicit in the Arts Council set-up a tension between the on-going costs of supported organisations and the need to encourage new work, and that this became especially dangerous at a time of economic difficulty;

(c) that the 'five nationals' (The Royal Opera, the English National Opera, the Royal Ballet, the National Theatre and the Royal

Shakespeare Company) were extravagant; that they were accorded too large a proportion of the Council's total expenditure on the arts (£5,772,750 in 1974/75, out of a total of £16,635,572); and that these bodies might better be separately dealt with by the Government;

(d) that the Council had been generally unsuccessful in its attempts to encourage local authorities to see the arts as an area where they should be active;

(e) that there had for long been a damaging gap in the area where the arts impinged on education, a gap which the Arts Council had made few efforts to bridge;

(f) that representatives from the Arts Council were too rarely seen in the regions and did not attend meetings in the regions consistently;

(g) that the Arts Council did not sufficiently consult others (especially in the regions) before deciding on a course of action; and

(h) that the 'response' policy of the Arts Council meant in effect that the Arts Council had no policy of its own, so that he who shouted loudest got most.

The British Council

The British Council was established in 1934 by Royal Charter. Its aims are:

(a) to promote a wider knowledge overseas of Britain, its people and institutions;

(b) to develop closer cultural ties with other countries;

(c) to promote a wider knowledge of the English language;

(d) to administer educational aid programmes,

all these objectives involving the mutual benefit of Britain and any other country concerned. Part of the Council's purpose can be achieved by publicising overseas British artistic activities. The Council therefore helps to bear the costs of overseas travel of British orchestras, and of opera, drama and ballet companies. It helps to arrange foreign tours (sometimes on an 'exchange' basis where a cultural agreement exists with a foreign country), and also arranges exhibitions of British art abroad. The Executive Committee of the Council is appointed through nominations from Ministries (for example, the Foreign and Commonwealth Office, the Department of Education and Science, the Ministry of Overseas Development, the Department of Trade and Industry). These nominations produce eight members who invite other members to a total of 30 in all, including Members of Parliament from both

Government and Opposition. The Executive Committee elects its own chairman and its members retire on a rotating basis. The Council has advisory committees to help it formulate policy; and it appoints staff in Britain and abroad to pursue its aims.

The total funds of the Council in 1974/75 were £39m, of which £22m was grant-in-aid from the Foreign and Commonwealth Office (FCO) and the remainder was used by the Council on behalf of the Ministry of Overseas Development. Council expenditure is largely on its extensive staff overseas, its libraries and English language teaching, exchange study visits and scholarships, etc. The arts play only a small though important role in the Council's general activity (for details of which the reader is referred to the Council's Annual Reports), and it is important to bear in mind that the Council is concerned to display British artistic achievements rather than to act as a patron. In the financial year 1974/75, direct expenditure (i.e. excluding headquarters expenditure and overheads) on the arts was:

Drama, Music, Opera, Dancing

Net funds for tours	£229,000	
Supplementary allocation for W. Europe, separate funds for E. Europe, plus virements from other Departments	128,000	
		£357,000

Fine Arts

Exhibitions, including the British Council's own Circulating Exhibitions	£53,000	
Supplementary allocation for W. Europe, plus separate funds for E. Europe	25,000	
Expenditure recoverable from FCO on Council of Europe exhibition	2,000	
		£80,000
Total		£437,000

Although these figures indicate the amount of British Council support for the Arts many of its other activities and services are related,

for example: films, youth exchanges (under which youth orchestras, young drama groups, etc., may travel), university and other interchange, scholarships and a world-wide network of libraries.

The Council is at the present time considering with the Arts Council the implications of the decisions of the recent Helsinki Conference (*Conference on Security and Co-operation in Europe—Final Act;* HMSO 1975, Cmnd. 6198), which *inter alia* required the signatories to work for greater cultural exchange. Until now the British Council has considered it to be outside its normal terms of reference to support foreign artists or companies wishing to appear in this country. The Arts Council has sometimes given such support, but has always felt that its major priority was to help British artists.

The British Film Institute (BFI)
The Institute was established as a company limited by guarantee in 1933. Its purposes were:
(a) to encourage the development of the art of the film;
(b) to promote its use as a record of contemporary life and manners;
(c) to foster public appreciation and study of it from these points of view.

The Institute is controlled by a Board of Governors, who are appointed by the Secretary of State for Education and Science and retire on a rotating basis. At present, two of the Governors are appointed by the Minister after consideration of the results of a ballot among the full members of the Institute. As a company, the Institute is subject to the Companies Acts, and its membership retains some of the functions of a company structure. Thus there is an annual general meeting where Chairman and Governors can be questioned on their policy and on the accounts. Indeed, the members have the power to dismiss the Governors; on the other hand they do not have the power to accept or reject the accounts, only to examine them. The services of the Institute are available to the public, but members have special rights (annual general meetings, National Film Theatre, special price for some publications, etc.).

Most of the Institute's functions since its inception have been concerned with the direct provision of such services as the National Film Archive, publications, the National Film Theatre, the Central Booking Agency and other film availability services, information and documentation, educational advisory service and the Experimental

Film Production Committee. This last committee developed into the Film Production Board in 1966, and concentrates its limited funds (obtained partly from general institute funds, and partly from the 'Eady Money' – a Government fund raised from exhibitors and used to stimulate British film production) on helping film-makers who could not make their films within the context of commercial production.

Since 1961, when the Institute's Memorandum of Association was amended, additional aims have been:

(d) to foster study and appreciation of films for television and television programmes generally;

(e) to encourage the best use of television.

Although the Archive now has a Television Acquisitions officer and the educational advisory service organises lectures and provides advice and film extracts for study courses on television, and although the Institute has issued several publications on the medium, there is no doubt that this side of the Institute's work remains underdeveloped, largely for financial reasons.

The Institute has also a Regional Department which has the task of pursuing the aims of the Institute outside London and in conjunction with local authorities, regional arts associations, the Welsh Arts Council, etc; and administering a Housing-the-Cinema Fund. It also offers assistance towards deficits incurred by the forty-odd regional film theatres (originally set up in almost all cases through BFI initiative, but now run by independent local bodies), and has begun to enable the giving of grants to specific film events or organisations in the regions. In general, the department acts as a link between the BFI and the regions. Like the other BFI departments, it now has an advisory committee which assists the Institute to formulate policy.

In 1974/75, the income of the Institute was:

DES grant-in-aid	£1,437,000
DES grant for the Housing-the-Cinema Fund	100,000
Income earned from services	707,140
Membership subscriptions and donations	128,933
VAT collected	71,762
Accumulated balance brought forward	16,229
	£2,461,064

Expenditure in the same year was:

National Film Archive	£405,276
Information and Documentation	88,640
Educational Advisory Service (including grants to university centres)	105,330
Editorial Department (including grants to independent film journals)	113,248
National Film Theatre	452,980
Film Availability Services	355,689
Regional Department (including grants to Welsh Arts Council and regional arts associations; and deficit guarantees to regional film theatres; and Housing-the-Cinema Fund)	271,569
Production Board	148,480
Grants to other bodies	92,019
Capital services	339,227
To capital account	1,706
VAT incurred	71,762
	£2,445,926

Accumulated balance brought forward	£16,229	
Deficit for the year	1,091	
	15,138	15,138
		£2,461,064

From this it will be seen that in the words of Lord Lloyd of Hampstead, the present Institute Chairman,

'the role and function of the British Film Institute is really very different from that of the Arts Council. It must always be remembered that the Arts Council operates largely as a grant-giving body and does not, broadly speaking, conduct any operations of its own . . . the Institute on the other hand is primarily concerned with . . . the conduct of a variety of enterprises which it carries out itself. Accordingly, the Institute retains an overall responsibility even in those areas where grants are given, to continue to give help and guidance to those bodies to whom it is giving support. At the same time, the Institute regards it as an important element of its policy to ensure as much autonomy and freedom of action to these grant-aided bodies as is consistent with the Institute's own overall responsibility to encourage the art of the

film whether through its own direct activities or by means of other bodies to whom appropriate financial support is afforded.'

(BFI *Annual Report* 1974/75)

In fact, BFI grants given to other organisations can be grouped as follows:

Grants to university centres	£18,018
Grants to regional arts associations	70,900
Grants to other bodies	92,019
Grants to independent film journals	4,555
Deficit guarantees to regional film theatres	46,674
	£232,166

This is about 9% of total expenditure, and is an increasing figure. In particular, the grants to regional arts associations have grown in recent years as the associations have begun to employ film officers and to encourage film alongside the other arts. This process can be expected to continue.

Some criticism has been heard of the BFI for its allegedly 'centralist' views and its 'lack of flexibility'; in particular it was felt in some quarters that the BFI was so involved in its own operations that it paid insufficient heed to what others were doing or wished to do. In short, it failed to respond sufficiently to the initiatives of others, and had too rigid a view of what needed to be encouraged and in what way. It may be that as the Institute expands its grant-giving (directly and through regional arts associations, when economic conditions permit) the balancing of considerations involved in 'doing' on the one hand and 'responding' on the other will become less difficult.

The National Film Archive has insufficient money to store its collections in proper conditions, to transfer old films on to safety stock, and so on. But what is worse, it has no *right* to acquire those films and television programmes that it wishes to preserve. It is at present dependent on the willingness of copyright owners either to sell or give material. The Institute has been pressing for some years for legislation to enable the Archive to have the power of 'deposit by demand', that is to require the deposit of any film or programme that it selects, once it has been publicly shown.

The Institute has established relationships with several individual

local authorities (particularly where it has helped to establish a regional film theatre), and some members of its advisory committees are local authority members. But it is not generally well known to local governors, nor has it established relations with any of the national local authority associations. In the past it has happened that one or two governors of the Institute have also been members of the Arts Council, thus providing a useful channel of information between the two bodies in addition to that which exists informally at officer level; but the question of establishing a regular interchange of information between the two bodies does not seem to have been considered. There has been some officer contact with the British Council, but again on an occasional basis only.

In summary, the Institute seems to have outgrown its original company structure; to be at a period of growth, particularly in relation to the regions, which requires a degree of flexibility that the Institute has not yet managed to reconcile with its own direct provision; to need for its Archive a right of deposit by demand; and to need the strengthening of its contacts with other bodies at the centre and with local authorities (by direct contact, by way of regional associations and by way of the local authority associations). For the present work of the Institute in relation to film, its funds are quite insufficient. When the BFI approached the then Minister for the Arts in the 1960s with the suggestion that the Institute should have more money in order to extend its activities into the regions, Miss Jennie Lee welcomed the move and supported it. However, as we have seen, the actual increase has proved sufficient only for some tentative grant-giving and for support to regional film theatres, whereas logic required the Institute to take on for film the wide-ranging role in grant-aid that the Arts Council has developed in the other arts. It was not realised that the job would require a quite dramatic increase in subsidy. In consequence the Institute is now at a standstill and its efforts in the regions have been successful in stimulating a demand which cannot be met. If its funds are insufficient for film, they are still more woefully insufficient for the role given it fifteen years ago in the field of television.

The Standing Commission on Museums and Galleries
This Commission is not a patronage body as it does not disburse financial assistance to others. It was set up in 1930 as an advisory and reviewing body, with the following terms of reference:
(a) to advise generally on questions relevant to the most effective

development of the national institutions as a whole, and on any specific questions which may be referred to it from time to time;

(b) to promote co-operation between the national institutions themselves and between the national and provincial institutions;

(c) to stimulate the generosity and direct the efforts of those who aspire to become public benefactors.

Its members are appointed by the Prime Minister, one-half of the members being nominated by national institutions. The Commission reports to the Secretary of State for Education and Science, the Secretary of State for Scotland and the Secretary of State for Wales. Its latest report, the ninth, was published by HMSO in 1973 and covered the years 1969/73.

The report looks in some detail at the operation and needs of national and provincial museums, and makes recommendations on such subjects as conservation, staffing, new buildings and other capital projects, the Area Museums Councils and so on. The Commission also reports on any special subject that it has been asked to examine: for example, how national institutions might be able to show their collections more widely throughout Britain. Again, the Commission undertakes projects of its own devising, a current example being a survey of the financing of university museums.

The Commission advises the Government on the destination of works of art accepted in satisfaction of estate duty; on the grant-in-aid of purchases by provincial museums (a fund administered for England and Wales by the Victoria and Albert Museum, and for Scotland by the Royal Scottish Museum); on proposed purchase grants for the national institutions; and on the annual estimates of the Area Museums Councils. The Commission is usually consulted by the Government when changes are being considered in taxation and other measures which may affect museums and galleries. It advises the Department of the Environment on the building programmes of national museums.

The members of the Commission are unpaid, except for expenses; the small office staff are civil servants employed by the Civil Service Department. The Commission is housed by the Department of the Environment, and the costs of administration are voted along with those for Royal Commissions.

Suggestions were made, during the course of the Enquiry, that the work of this body should be incorporated in that of the Arts Council, as there was overlap of interests particularly in the work of galleries.

The contrary view was that museums covered a much wider spectrum than the arts, and that the problems peculiar to museums demanded a separate focus upon them.

Reference was frequently made to the recommendations of the Wright Report (*Provincial Museums and Galleries*, HMSO, 1973), the report of a committee appointed by the Minister for the Arts in 1971. This report made a strong plea for a new method of organisation for assistance to museums. Among other recommendations, it urged that a 'Housing the Museums' Fund be established; that a more uniform system of staff salaries be agreed; that selected museums be designated as training institutions and receive appropriate special assistance; that measures be taken to ensure increased and better training of conservators; that local education authorities be more aware of the role that museums can play in education; that Area Museums Councils receive additional resources to expand their services; that there should be a central body to present annually to the Government the case for financial resources, to allocate resources to the Area Museums Councils (renamed as Provincial or Regional Museums Councils), to approve certain museums for development as centres of excellence, and to make grants from the proposed Housing the Museums Fund. Although extra monies have been found to expand somewhat the work of the Area Councils, nothing else of much significance has been done by the Government since the publication of the Wright Report to implement its recommendations. In effect, what it calls for is a new 'Museums Council'; but this cannot be established until money is found to enable it to do its job.

The Area Museums Councils referred to above, now comprise:
The Council for Museums and Galleries in Scotland
The Council of Museums in Wales
Council for the Museum Service for the North of England (*Area*: Northumberland, Durham, Tyne-and-Wear, Cleveland)
North Western Museum and Art Gallery Service (*Area*: Cumbria, Lancashire, Greater Manchester, Cheshire, North Staffordshire, West Derbyshire, Merseyside, the Isle of Man, and Northern Ireland)
Museum and Art Gallery Service for Yorkshire and Humberside
Area Museums Service for South Eastern England (*Area*: Beds, Berks, Bucks, Cambs, Essex, Hants, Herts, Kent, London, Norfolk, Oxon, Suffolk, Surrey, Sussex)

Area Museum Service for the South West (*Area*: Cornwall, Devon, Somerset, Avon, Glos, Wiltshire)

Area Museum and Art Gallery Service for the Midlands (*Area*: Derbyshire, Hereford and Worcs, West Midlands, Leics, Lincs, Northants, Notts, Salop, Staffs, Warwickshire)

These areas, which are rather different from those of regional arts associations, may soon be altered to conform more closely to the actual location of museum collections. The RAA areas do not usually offer a broad enough base of museums and galleries on which an area museums service could be properly based. Lincolnshire and Humberside, for example, has an active arts association but would prove far too small an area in museum terms for a separate area council.

The first area council was established in the South-West in 1959 with the encouragement of the Museums Association. It had as aims: 'to promote closer co-operation; to improve technical facilities; to obtain and distribute financial assistance to museums and galleries within the region; to form a link with the Standing Commission on Museums and Galleries; and to endeavour to secure aid from the Government and private bodies'. On the Council were representatives of the participating counties, of the then county boroughs, of non-county boroughs, the museums, the universities and the Museums Association. Since local government reorganisation, this pattern of representation has been changed to match the new boundaries. The regional arts association does not attend as an observer.

The Midlands Council was formed in 1961, North West in 1962, the North in 1962, and Yorkshire in 1962. But in 1963 the Standing Commission reported urging greater government help for the Area Councils, and when that was given, in the form of a 50% grant of gross expenditure, the remaining areas of the United Kingdom quickly set up Councils. As they are not statutory bodies, no two are identical, but all offer services such as conservation and preservation, exhibition organising, consultation on display, cataloguing, etc.

In some areas there is overlap with the work of regional arts associations (particularly in organising small touring exhibitions); and liaison between Area Museum Councils and RAAs is not as close in some areas as would be desirable.

The Crafts Advisory Committee (CAC)
This body was set up in 1971 by the Minister for the Arts (Lord Eccles) to advise him on the needs of the artist-craftsman. It had been

felt that the crafts deserved encouragement and support from a central body, and that this function was not one that could be undertaken by the Arts Council. The Chairman of the new committee was Sir Paul Sinker, who was also the Chairman of CoSIRA (The Council for Small Industries in Rural Areas). The Design Council provided administrative services to the new committee, and its Director, Sir Paul Reilly, became CAC's Chief Executive. The Committee had a working budget of £45,000 in its first year, and a responsibility only for England and Wales (funds for crafts in Scotland are administered separately).

The Committee has in mind, in considering the term 'artist-craftsman', those whose work, although often rooted in traditional techniques, has an aim which extends beyond the reproduction of past styles and methods.

The Committee now has a small specialist staff and office and ex-hibition space in London. Apart from its own exhibition area, it has fostered the merger of previously existing craft organisations into the British Crafts Centre which is representative of British craftsmen and has its own London exhibition premises. Assistance has similarly been given to the Federation of British Craft Societies, also formed in 1970/71, to enable the numerous craft societies to speak with one voice. The Committee organised a large exhibition of 'The Craftsman's Art' at the Victoria and Albert Museum in 1973, and has co-operated with the British Council to organise touring exhibitions for Europe.

By 1972/73, the Committee's grant from the DES had grown to £178,000, and by 1973/74 to £300,000. In the current year it is £524,600. This growth has been accompanied by a steady growth in grant-giving, mostly direct to craftsmen through a number of specific schemes: for workshop training (i.e. apprenticeship grants); to help craftsmen acquire their own studios or workshops; for equipment purchases; individual bursaries and special projects. The CAC has advisory sub-committees to help it formulate policy.

During its short life the CAC seems to have made a lively start. It is developing its relations with regional arts associations and with the Welsh Arts Council and wishes to increase its co-operation with the Arts Council and others. Inevitably it is difficult for a new, small body to make a nationwide impact, and most local authorities have not heard of it; on the other hand, it does have regional effect through its close links with the Federation of British Craft Societies.

Opinions were expressed that the position of CAC as an advisory

body to the DES (although in practice a grant-making body in its own right) was anomalous, and that it was confusing to have a quite separate body from the Arts Council to deal with the crafts, especially when it emphasised those aspects of the crafts that were closest to the arts. This was not seriously contested, but views were put forward that amalgamation with the Arts Council might well mean, as in the past, that crafts would be regarded as secondary to the fine arts. Where amalgamation would make for a tidy administrative pattern, it was claimed that no real benefit would accrue to craftsmen or to the public, and that the crafts needed a separate and energetic focus on them.

For greater detail of the work of CAC, the reader is referred to *The Work of the Crafts Advisory Committee, 1971-1974*, published by CAC. The Committee also publishes an informative magazine, *Crafts*.

The Welsh Arts Council

As we have already noted above, the Charter of the Arts Council of Great Britain was changed in 1967. One of the new elements of the revised Charter was the recognition of the work of the previous Scottish and Welsh Committees of the Council, and it sought to strengthen their position in the following terms:

'1. The Council [*i.e. the Arts Council of Great Britain*] shall, with the approval of Our Secretary of State for Scotland and Our Secretary of State for Wales, appoint committees, to be called the Scottish Arts Council and the Welsh Arts Council, to exercise, or advise them on the exercise of, their functions in Scotland and Wales.

2. Subject to such approval, the Council shall appoint as chairman of each committee a member of the committee who is a member of the Council.

3. The Council may appoint to either committee persons who are not members of the Council and, subject in the case of the chairman of each committee to such approval as aforesaid, may at any time revoke the appointment of any member of either committee.'

There are two Welsh members of the Arts Council of Great Britain, and one of them becomes Chairman of the Welsh Arts Council. The members of the Welsh Arts Council are appointed by the Arts Council of Great Britain, after consultation with the Secretary of State for Wales. There is no time limit laid down for membership, but in practice it is usually offered for a three-year term, members being eligible for re-appointment.

The Welsh Arts Council appoints subject committees to advise it on Art, Drama, Music, Literature, etc., with one of its own members as

committee chairman in each case. There is also a Finance and General Purposes Committee comprised of the subject committee chairmen with the Chairman and Vice-Chairman of the Welsh Arts Council. The Council appoints a Director and staff.

Assessors from the Welsh Office and the Welsh Office of the Department of Education and Science attend meetings of the Welsh Arts Council. Assessors from among Her Majesty's Inspectorate in Wales attend meetings of the subject committees.

The Welsh Arts Council is directly accountable to the Arts Council of Great Britain, the Secretary-General of which remains its accounting officer. Its premises are the responsibility of the Arts Council of Great Britain. The Welsh Arts Council submits an annual estimate to the Arts Council of Great Britain, and receives a budgetary allocation from it; within this allocation, the Welsh Arts Council is largely autonomous in its policies and ability to offer grants. Its accounts form a separate section of those of the Arts Council of Great Britain, and can be examined in the Annual Reports of the latter, although in addition the Welsh Arts Council has in recent years published its own bilingual annual report.

The Welsh Arts Council receives grants also from the British Film Institute and the Crafts Advisory Committee for the purpose of carrying out their policies in Wales. However, both these bodies retain in London some direct involvement in the administration of their functions in Wales, and their specialist staff and services based in London are called upon when required by the film and craft officers employed by the Welsh Arts Council. (The Crafts and Design Officer appointment is in fact supported by the Welsh Arts Council, by the Crafts Advisory Committee and by the Design Council.)

The Welsh Arts Council had in 1974/75 a total expenditure of £2,010,775, of which £154,577 was on operating costs. £1,814,498 was spent on the arts, as follows:

Music (includes Welsh National Opera and Drama Company Ltd £600,000)	£757,588
Drama (includes Welsh National Opera and Drama Company Ltd £108,900)	375,139
Art	86,707
Literature (includes Welsh Books Council £32,165)	116,194
Festivals	40,956
Regional Arts Associations	166,890
Arts Centres and Regional Projects	182,650

Housing the Arts 46,500

'Oriel' Bookshop 41,874

It will be seen that the total grant to the Welsh National Opera and Drama Company is £708,900, or about 40% of total arts expenditure. (In 1971/72 it had been approximately £400,000 in a total arts expenditure of £863,082, i.e. nearly 50%.)

Wales is sparsely populated except for the North and South coasts. Road and rail communications are poor, especially between North and South. Until the last few years, there were very few facilities for any of the arts except in the major cities. On the other hand, there is a remarkable natural enthusiasm for the arts amongst Welsh people generally, and this finds expression particularly in music and literature. The policy of the Welsh Arts Council has been to co-operate directly with local authorities, university colleges and other educational institutions, and with other government agencies so as to improve conditions for the professional arts (though a certain amount of assistance to amateurs is given through support to the Welsh Amateur Music Federation and to the Drama Association of Wales). Thus in recent years a circuit of medium-scale theatres has been built up at Milford Haven, Aberystwyth, Harlech, Bangor and Mold to supplement the larger theatres in Swansea and Cardiff. However, physical provision remains poor for the visual arts, for museums (there is no sizeable museum anywhere in North Wales), and for orchestral music. Neither are there many arts centres in rural areas or small towns which could act as a focus of local activity. There are no regional drama companies in Wales (as there are in England and Scotland), except for the enterprising Cwmni Theatr Cwmru based in Bangor, and small community theatre companies at Swansea, Aberystwyth, in Powys, and associated with the Quality of Life project in Clwyd; and the Cardiff Open Air Theatre, Theatr yr Ymylon and Caricature Theatre (puppets).

The Welsh Arts Council has had a special policy of encouragement for the Welsh language, and devotes resources to help Welsh writers and the publishing of books in Welsh.

The Council is an important organiser of exhibitions and of touring events. Its accounts show also that it still makes a great many small grants to support specific events throughout Wales, notwithstanding the existence of regional arts associations.

The Council has encouraged the growth of three regional arts

associations covering Wales: the North Wales Arts Association (formed 1967), the West Wales Association for the Arts (formed 1970) and the South East Wales Arts Association (formed 1973). The principle of financial partnership with local authorities has not worked well, however, as the latter have never approached parity of contribution to the associations with the Arts Council. The North Wales Association's income from the local authorities has grown from £8,200 in the first year to £26,710 in 1975/76; the West Wales Association from £19,302 to £30,000 and the South East Wales Association from £11,000 (a half-year) to £30,000. In 1975/76 the Welsh Arts Council gives the associations £40,000, £50,000 and £75,000 respectively; these sums are based on a population basis, and on a desire not to let Welsh Arts Council contributions become greater than local authority contributions by more than a ratio of 5 : 2. This has meant that the associations have ceased to expand their work, while their administrative costs have increased as a proportion of total income. As a result, the Welsh Arts Council has had to take back responsibility for paying the costs of symphony concerts. Moves to devolve to the associations further functions from Cardiff have also been stopped. These problems are discussed further on pp. 98–100.

In the White Paper *Our Changing Democracy: Devolution to Scotland and Wales*, HMSO, 1975, it is suggested that any future legislation to devolve functions of government from London to Scotland and Wales, should include the devolution of the arts, though the Arts Council of Great Britain is shown as a 'nominated body'. 'If changes are needed in bodies constituted by Royal Charter or Warrant, these bodies will themselves have to apply for the necessary amendments to their constitutions.' Presumably, therefore, there is a possibility that in future the Welsh Arts Council may look to a Welsh Assembly for funds; but no detailed proposals have yet been put forward as to how such an arrangement would work or how the essential arts links with England and Scotland might be maintained.

Regional Arts Associations and Area Arts Associations
As mentioned on p. 73, the Arts Council's decision to close its regional offices in the 1950s was one cause of the birth of regional arts associations. The regional offices had been in Newcastle, Leeds (later York), Manchester, Cambridge, Birmingham, Nottingham, London, Southampton and Bristol. (In addition to a Cardiff office, the Welsh Committee had a North Wales office at Wrexham.) The nine regions

were inherited from war-time CEMA, and were based on the Civil Defence regions. Initially, the reduction in their number was both an economy measure and an attempt to make the boundaries of the regions relate better to peacetime arts needs. Finally, however, it was realised that a large proportion of Council expenditure (about 5%) was going on the costs of the regional offices, which had been useful mainly as agencies to assist the Council with its direct promotions (music, drama and art tours). As more assistance was given to art and music clubs and to regional theatres, the amount of direct provision of such tours had decreased and, in the opinion of the Council, could be managed more efficiently and economically from London. The Council had previously had no regional committee; nor upon closure of the regional offices did it form one.

However, the regional offices had also been most useful to artistic organisations in their areas and the advice given by regional staff was greatly valued. Closing the offices saved more than £20,000 a year but was extremely unpopular in the regions. The South West, with few theatres or concert halls, had relied on the Council's Bristol office to co-ordinate small tours and to book the artists. The arts centres and arts clubs in the region sent a delegation to London in 1956; as a result the Arts Council gave a grant towards administration (supplemented by one from the Gulbenkian Foundation in 1959), and the South Western Arts Association (now South West Arts) was born. This first Association was in effect a regional federation of arts centres, clubs and societies. In 1958, a Midlands Arts Association was established on similar lines.

In the Report *Help for the Arts* (Gulbenkian Foundation, 1959), Lord Bridges and his colleagues suggested that 'there might be advantages in . . . a group of neighbouring local authorities with strong common interests . . . appointing an arts officer for the area covered by the whole group'. The next year local authorities in the North East came forward with a variation on this idea: it was to set up a local body, the North Eastern Association for the Arts, to distribute monies made available by the local authorities under their powers in the 1948 Local Government Act (Section 132), and in particular to channel aid to the Northern Sinfonia Orchestra. The Gulbenkian Foundation gave a grant towards the salary of a Secretary (later Director); and most of the principal local authorities in the region (which comprised Northumberland, Durham and part of the North Riding of Yorkshire) contributed a total of £50,000 in the first year. The Arts Council responded to this

initiative with a grant of £500 (for 1962/63), but by the following year had raised this sum to £22,000.

This was not a federation of local arts societies, but a consortium of local authorities, the private sector, the artists and others in the region, with the broad aim of encouraging the arts. In effect it was designed to be a regional arts council, but with the advantages that it could look for support to local authorities, to private sources and to the Arts Council in London, as it had an independent stance between all three. The philosophy was that such associations would raise standards and stimulate new work and would:

(a) divorce the political element from direct public patronage of the arts;

(b) be close to the ground and aware of local needs and problems, although covering enough territory to avoid parochialism;

(c) draw on the specialist advice of permanent staff and of advisers from across the region as a whole, as well as on the expertise of local government;

(d) be flexible, breaking across rigid definitions of professional and amateur, looking at crafts and film as well as the other arts, and thus establishing a regional network through which central organisations (such as the Crafts Advisory Committee and the British Film Institute, as well as the Arts Council) could operate; and yet serve the interests of local authorities, audiences and artists;

(e) bring new sources of money to support the arts, by fund-raising, and publicising their cause;

(f) by publicity and dissemination of information, raise the public consciousness of the arts throughout their areas.

This approach appealed to the Government, which endorsed it in its 1965 White Paper, *A Policy for the Arts* (HMSO, Cmnd. 2601), in the following terms:

'Go-ahead local enterprises need more than encouragement and advice. They also need more financial help, and this is where regional associations for the arts can perform an important function, for regional planning is as valuable in this as in the economic sphere. At this level a small staff with a few keen local enthusiasts backing them can stimulate the co-operation of other authorities, and by calling on each for a fairly small levy provide funds with which to finance a variety of projects – concerts, exhibitions, film shows and lectures – which few authorities by themselves could afford. . . . A network

of this kind should be developed to cover the whole country. Once an Association has been formed it can act with and for the Arts Council in a mutually beneficial relationship.'

Though the White Paper did not fully recognise the wide-ranging nature of the new associations and still saw them primarily as promoters of concerts and lectures, it gave them strong support. The Arts Council soon adopted a policy of positive encouragement and associations were formed to cover the rest of England. A further endorsement of the associations came in the eighth report of the House of Commons Estimates Committee in 1967/68:

> 'Regional Arts Associations are the result of purposeful co-operation between local and national government. . . . Membership of the associations includes local authorities, commercial and industrial interests and artistic organisations. On the members rests the responsibility for the formulation and implementation of a coherent regional policy, based on surveys, research and, of course, on more immediate local contacts. . . . Your Committee appreciates the ability of a regionally-based body, dealing often in quite small sums of grant, to seek out areas where no activity exists and to see what can be done on a small scale in conjunction with the people living in the area, while at the same time being able to give the most expert advice to large organisations operating on a regional and perhaps a national scale.'

The regional arts associations now operating in England and Wales (with date of formation, area covered, population, total budget in 1975/76, local authority contributions in that year and Arts Council assistance over the years) are shown in Appendix 2. South West Arts has retained a strong interest in touring organisations, but has adopted the new style of operation set by Northern Arts (the title adopted in 1970 by the Northern Arts Association, itself the successor in 1967 to the North Eastern Association for the Arts when the latter incorporated Cumberland and Westmorland into its area). The Midlands Arts Association split in 1969 into the West Midlands Arts Association (which started work in 1971) and the East Midlands Arts Association (1969). Both of them began operating on the new pattern. The formation of almost all of the associations was substantially assisted by the Gulbenkian Foundation. At the present time, only Buckinghamshire remains outside the area of any arts association (though the Buckinghamshire district of Milton Keynes has joined the East Midlands Arts Association).

As can be seen from Appendix 2, Arts Council grants to the RAAs

have grown substantially in recent years, and in 1975/76 they form 7·3% of the total Arts Council budget. The Arts Council continues to give direct grants to many regional activities, including orchestras, regional theatres, touring, festivals, exhibitions, galleries, etc., and many of its other grants have significant regional effect, as do most of its own operations.

In 1968, Nigel Abercrombie, a previous Secretary-General of the Arts Council, was appointed by the Council to the new post of Chief Regional Adviser, a post which he occupied till his retirement in 1973. During his period of office, he was energetic in his encouragement of the regional associations and instrumental in persuading local authorities in several regions to co-operate in their establishment. The creation of the new pattern also meant that there was now a specific avenue whereby the regional associations and other regional bodies could channel their needs to the Arts Council, and the work of the Council could be linked with that of the regions. By the time of his retirement, however, it was clear that the volume of work needed more than one man and an assistant; indeed, the Standing Conference of Regional Arts Associations made a strong case for a new appointment with a wider term of reference. As a result, Neil Duncan (previously Director of the Southern Arts Association) was appointed Director of Regional Development to the Council, and a certain redistribution of responsibilities took place so that support for such activities as touring, arts centres, community arts, research, etc., as well as regional arts associations, came under his charge. But as the specialist departments of the Council (drama, art, music, literature) continued to make direct regional grants, the role of the Regional Department, notwithstanding liaison with the other departments, did not emerge clearly. At the time of writing, the Council is considering the best way to reshape this part of its organisation so as to carry out its regional policy more effectively in collaboration with the regions.

Returning to the RAAs themselves, it must be emphasised that each of them is a non-statutory body, registered as a charity. Though all of them were formed to meet a broadly comparable situation, the particular features of each area (and the different guiding hands in each association in its early days) have resulted in diversity. In consequence slightly different forms of organisation, constitution and aims, and different policies, have emerged. This is no doubt confusing for those who are dealing with more than one association (when arranging a national tour of an opera company, for example). Some associations

pay particular attention to the crafts, indeed to questions of 'heritage' as well as arts; others regard heritage as outside their remit, and the crafts as a borderline type of activity. Not all associations have specialist officers in the various art forms; this is sometimes because money has not been sufficient to support appointments, but sometimes it reflects policy decisions. One or two associations spend most energy (and money) on direct promotions, that is on organising, publicising and presenting their 'own' events, and give only a minor part of their budgets as grants to enable others to do such work. Most associations give revenue grants to organisations (and individuals), but not capital grants; most have a bias (sometimes an exclusive one) for the professional arts. Though confusing, this variety is not necessarily unfortunate; if decisions are to be devolved, the regional and local bodies must be free to decide their own priorities, their own reaction to their own area's culture or there is no genuine devolution. Some words of Lord Keynes are worth recalling. Shortly after the Government's decision in 1945 to incorporate CEMA as the Arts Council of Great Britain, he said:

'We look forward to a time when the theatre and the concert hall and the gallery will be a living element in everyone's upbringing, and regular attendance at the theatre and at concerts a part of organised education. . . . How satisfactory it would be if different parts of this country would again walk their several ways as they once did and learn to develop something different from their neighbours and characteristic of themselves. Nothing can be more damaging than the excessive prestige of metropolitan standards and fashions.'

If one takes an 'average' association, one might find at the head of its structure a general council (with representatives of most of the local authorities forming its majority, but with university, trades union and private member representation also) which is the legally controlling body of the association. From it is drawn an Executive or Management Committee which meets more frequently to discuss and decide day-to-day questions. A staff is appointed which may consist of a Director and about six officers, one of whom may be a Deputy Director or Administrator. There is a supporting secretarial staff. Premises are usually modest and salaries well below the equivalent remuneration paid to local government leisure officers. Each art subject will have an advisory panel drawn from those in the region knowledgeable in the subject. These panels discuss policy and review applications for

93

assistance, making recommendations either to the Management Committee for authorisation or to the General Council.

The main criticisms heard of RAAs were these:

(a) they are too conservative in their policies, and too long-winded in their procedures;

(b) they are too closely modelled on the Arts Council in their structures;

(c) they do not have enough money to be able to respond to new ideas in sufficient measure; too great a proportion of their money goes to 'regular customers';

(d) their panels are often composed of regular customers;

(e) their staffs are not of a sufficiently high calibre and lack experience;

(f) they are expensive in administration;

(g) they are doing jobs that could be better done by local government;

(h) they have not in general been able to convince local government that they are useful and efficient bodies, and so local government contributions to them have not risen as fast as was hoped;

(i) their geographic areas are too large to enable them to do a truly 'grass roots' job, and many of the regions do not have a genuinely regional character (though there are obvious exceptions);

(j) their panels absorb many highly qualified people for a lot of time in taking decisions about very small sums of money, whereas policy and performance are rarely well monitored;

(k) notwithstanding the local authority preponderance on general councils, it was often felt that the specialist panels in fact 'made' the decisions, and the panel members were undemocratically chosen and were not responsible to ratepayers, although spending ratepayers' (and taxpayers') money.

The criticism that local contributions have risen too slowly has posed a special problem. When the North Eastern Association for the Arts first made application for assistance to the Arts Council, it asked the Council to match locally-raised monies £-for-£; the Council refused, as such a formula-based contribution would have gone against its normal policy of assessment. It would also have meant a much larger grant, as the new association had such strong support from its local authorities. As more associations were established and as Arts Council policy swung behind them, the £-for-£ position was rapidly reached in each case. The Arts Council felt it would be wrong to get ahead of local authorities in funding RAAs, as this would weaken the

position of RAAs in their regions, and it would also imply that local authorities could in effect take decisions about the spending of Arts Council money without fulfilling their half of the bargain. Whilst parity existed, the offer of a matching grant was also a useful way of tempting local authorities into larger contributions to RAAs (and thus spending more on the arts than previously).

Some difficult years for local government and the growing needs of the supported organisations in the regions, coupled with the Arts Council's wish to devolve subsidising of many regional and local matters to RAAs, meant that the parity principle was broken. By 1974/75 the Arts Council was finding an average of about 70% of the budgets of the regional associations. In this situation the Arts Council became reluctant to continue increasing its grants in real terms to associations, and reluctant to devolve any further functions.

The Greater London Arts Association has special difficulties. Its area of action is identical with that of the Greater London Council whereas all other associations cover an area wider than any single authority and this is a powerful reason for their existence. Moreover, the GLC itself offers a considerable amount of grant-aid to artistic organisations which have a regional significance for London as a whole. The London Boroughs, the Common Council (of the City of London), and the Inner London Education Authority (ILEA) all give help in their areas as well. And the Arts Council gives large grants to the major London-based organisations. The GLAA had therefore to find a special role that was distinguishable from that of any other body, and which could be seen to be better performed by GLAA than by the bodies to which it looked for financial support. In fact, the Boroughs, through the London Boroughs Association, give the GLAA a grant (£17,000 in 1975/76) equal to about 6% of the Association's total budget, matched by a similar grant from the GLC. The bulk of the remainder of GLAA's budget is found by the Arts Council (plus a small but useful grant from the BFI). The Association has determined its policy as follows: no continuing revenue grants, but short-term support for particular projects; persuasion of local authorities to take further action themselves in arts promotion and support; services such as publicity for the arts; grants to individual artists; emphasis on the needs of the outer London Boroughs; community festivals; community theatre; film and video projects; and advice (particularly to the GLC, the Arts Council and London Boroughs, but also more generally to artists and the public). However, GLAA has not yet achieved sufficiently close

G

understanding with the local authorities to encourage them to make substantially higher grants to it.

One of the criticisms of regional arts associations (that they are too large in area to be truly effective at a local level) finds an interesting solution in the North West.

Here there are two *Area Arts Associations* within the region of North West Arts. One of them in particular has achieved an impressive level of achievement. *The Mid-Pennine Association for the Arts* was founded in 1966, just before the establishment of North West Arts (the regional arts association for Lancashire, Cheshire, Greater Manchester and part of Derbyshire). It stemmed from the Burnley and District Association for the Arts, itself founded as long ago as 1949. That Association, though it received substantial help from Burnley Corporation, was essentially a voluntary organisation, funded by voluntary contributions and without paid staff. It came into being in an effort to fill the gap caused by the closure of the town's theatre; it organised Civic Arts Weeks but emphasised the need for a new theatre or arts centre to act as a focal point for cultural activities in the area. In 1965, a conference was held (with the Minister for the Arts attending) to see if neighbouring local authorities would be willing to join a wider association so that a consortium of interests might be found to support a new arts centre. This was successful, and led to the formation of the Mid-Pennine Association for the Arts which now comprises the following districts in contribution to it: Blackburn, Burnley, Hyndburn, Pendle, Rossendale; and also the two parish council areas of Whitworth and Todmorden.

Though the idea of establishing an arts centre has remained a primary aim of the Association, and though Burnley has set aside a site for such a building, constantly escalating costs and some indecision on the part of the local authorities have prevented much progress towards the building since 1966. But the Association has been professionally staffed and extremely active in promoting events. Until local government reorganisation in 1974, promotions were often more easily arranged through such an agency as Mid-Pennine than by individual local councils; but since that date most of the councils in the area have wished to be increasingly responsible for the promotion of events (especially those which are not controversial in nature), and the Association has been adapting to this changed situation. It now lays a major emphasis on bringing new ideas and new talent to the sub-region, acting as a stimulus to local endeavours. This creative role is

well illustrated by the work of its itinerant theatre company 'Theatre Mobile', which works in schools, community halls and other small buildings throughout the area. More recently, the Association has appointed a musician in residence who, with a music group she has organised, will fulfil a parallel function in the music field.

The Association does not make grants to others in its area (this is done by North West Arts), but seeks to generate activity and to promote events. It also has a valuable role in spreading information and publicity for the arts.

Though the Arts Council eventually began to make direct grants to the Association in support of its work, in 1974 this policy was changed so that future responsibility for grant-aiding it passed to North West Arts. The latter looks to the County for its local authority subscription, while Mid-Pennine looks to the Districts (and the Parishes) in its area and finds it a disadvantage to have little direct contact either with County or Arts Council. Financially, it was established that the rate of subscription by local authorities to Mid-Pennine must be additional to that asked by North West Arts. This cumbersome arrangement at least shows the enthusiasm of the local authorities in the area, for they are paying not only for the work of their own leisure departments but also for the services provided by both Mid-Pennine and North West Arts. One local authority made it clear that it valued the work of Mid-Pennine more highly than that of North West Arts and thought its work of greater relevance to the area. Local authorities are represented on the controlling body of the Association, but so are artists and many others.

There is another Area Arts Association in the North West, the Fylde Arts Association (covering the Districts of Blackpool, Fylde and Wyre), but it is a more recent creation and does not yet seem to have caught the imagination either of public or local government.

Reference has been made to *The Standing Conference of Regional Arts Associations* (SCRAA). This organisation was established in 1967 as a loose-knit body to arrange for the exchange of views and experience between the various regional arts associations that had by that time been established and also to impress the Arts Council of Great Britain and others with the growth of the regional arts movement. An annual summer conference is arranged for staff and for Council and panel members of the various Associations, and for invited members of SCRAA (the Arts Councils, British Film Institute, Scottish Film Council, Crafts Advisory Committee, Calouste Gulbenkian Founda-

tion); and other meetings on specific topics are held from time to time. Recently SCRAA has adopted a new constitution and there have been suggestions that it should become a more formal body and less of a discussion forum: in short that it should have 'teeth', in representing the views and needs of regional arts associations to the Arts Council. We did not feel that this would be a desirable step.

The small expense of this organisation is found from contributions by its members. The work is done (with some secretarial assistance) by honorary officers elected from its membership.

There are three *Regional Arts Associations in Wales*, the North Wales Arts Association, South East Wales Arts Association and the West Wales Association for the Arts. These have already been referred to briefly on p. 47. The Associations have much the same structure as their English counterparts, and are funded by local authority contributions and by grants from the Welsh Arts Council. The following table shows how their income was derived in 1975/76, and how this was spent between activities and administration:

	NWAA £	WWAA £	SEWAA £	Total £	%
Income					
LA District	6,210	15,000	—	21,210 ⎫	31
County	20,500	15,000	30,000	65,500 ⎭	
WAC	40,000	50,000	75,000	165,000	60
Other grants	4,500	2,500	1,000	8,000	3
Earned income	10,000	1,500	1,000	12,500	4
Other	2,000	3,000	—	5,000	2
Total	83,210	87,000	107,000	277,210	100
Expenditure					
Activities	83,000	67,300	82,150	232,450	83
Administration	21,000	19,780	24,550	65,330	23
Surplus (Deficit)	(20,790)	(80)	300	(20,570)	(7)
Total	83,210	87,000	107,000	277,210	100

WAC/LA income ratio	1971/72	1972/73	1973/74	1974/75	1975/76
NWAA	3·6	2·9	2·8	2·2	1·5 (est)
WWAA	—	2·7	2·6	2·0	1·7
SEWAA	—	—	2·5	2·5	2·5

Though the North Wales Association was founded in 1967/68 its rate of growth has been slower than English associations; this is true

also of the more recently founded West Wales Association (1971/72), and to a lesser extent of South East Wales (1973/74). There seem to be various possible reasons for this difference between Wales and England. First, the sparse population produces a low rate product for local authorities, and this in turn has meant a low level of contribution to associations. Secondly, the reluctance of the Welsh Arts Council to devolve functions (and increase its level of grant) to RAAs until there was an increase in local authority support has recently resulted in a standstill situation, with not even the effects of inflation being fully met. Thirdly, the total population of Wales is less than that of some English regions and this has resulted in a real difference between the division of functions in Wales between Arts Council and RAAs, and that in England. The Welsh Arts Council has developed its own close relations with local authorities; there are not so many arts events and facilities in Wales that it is compelled to delegate; it has a particular interest in the development of the theatres and arts centres in the Welsh circuit; and it feels that most of its clients need to be dealt with on an all-Wales basis if there is to be comprehensive development. Moreover, it has not been practical for the Welsh associations to appoint specialists of their own in drama, music, literature, fine art, film, crafts, etc., so that they have remained at a low level of staffing. They have had to rely on the specialist staff of the Welsh Arts Council, but these officers cannot attend all regional meetings and still fulfill their functions at the Welsh Arts Council itself. For these and other reasons there have been special difficulties in defining the purpose and appropriate working methods of the Welsh Associations.

The facts remain, however, that the Welsh Arts Council could not manage all Welsh arts matters from Cardiff; that the regional associations are popular bodies in their areas; that but for them there would in some areas be almost no arts support at all for local events; and that they harness the energies of a great many enthusiastic people in their regions. They are particularly valuable in support for the amateur arts.

When viewing the limited finance available to Welsh associations, the paucity of physical resources for the arts, and the factors already mentioned above, the question arises whether the three associations should not act more as animating bodies than grant-giving ones. To some extent this is what they already do, in the promotion of tours, etc., but a clearer definition of functions might allow the major grant-giving to be done by the Welsh Arts Council in conjunction with local authorities, and for regional associations to pursue particular projects

and developments (also in conjunction with local authorities) rather on the lines pioneered by the Mid-Pennine Association for the Arts in England. This would leave the grant-aiding of amateur events in the hands of local government, and it may be that the local authorities would continue to need guidance from RAA staff on such grants. Certainly no division of functions on the above lines would work properly unless the local authorities not only agreed to continue funding RAAs but to undertake also financial support for amateurs.

Local Education Authorities (LEAs)

These are county councils (in the non-metropolitan or 'shire' areas) and district councils (in the six metropolitan areas); in the central part of the Greater London area there is a special semi-autonomous body called the Inner London Education Authority (in law, a committee of the GLC), and in the rest of Greater London the London Borough councils. These education authorities have a major influence on the artistic life of their areas, through what is done for the study and practice of the arts in schools, colleges and adult education. No figure for the total of all such LEA expenditure is available but it must be far larger than the annual expenditure of the Arts Council.

For the purposes of this Report, we are specially concerned with the role of local education authorities in extra-curricular and adult education, and with the ways in which the education authorities can help artistic activities of various kinds.

Extra-curricular activity takes many forms. Examples we came across include the subsidising of visits by schoolchildren to professional performances of drama, music, opera and ballet; the appointment of professional artists-in-residence in schools and colleges; the purchase and exhibition of works of art; the organising of county youth orchestras; the subsidising or operation of youth arts centres, drama workshops, music centres, etc.; and the use of educational buildings as community colleges, or as social and educational centres out of school hours.

Adult education covers the evening classes available in many arts subjects at small cost to the student. Some of these classes are quite informal and aim not so much at conferring a qualification as at raising standards in the use of leisure. Provision, however, is very uneven, with London and other densely populated urban areas having a wide variety of subjects readily available to the public, whilst in rural areas one may have to travel long distances by private transport to find

even a narrow range of choice. There appear to be few channels of communication between adult education provision and the 'arts world' (of professional performances, regional arts association publicity, etc.), and only a tenuous link even with the amateur societies.

Amateurs, however, often benefit from the use of school or college halls for their rehearsals and performances. The halls are let at cheap rates to the local operatic and dramatic societies as a form of subsidy; indeed sometimes no charge is made at all. As such halls are usually the only modern facilities in an area, they are an important element in local arts activity, just as the enthusiasm of school staff is often a crucial mainstay of the activities themselves. School equipment (lights, sound, office equipment, catering equipment) is also sometimes freely available.

But often we found that a new school had been built with superb equipment and at large cost but without prior consultation with arts interests in the community, with the regional arts association or with the Arts Council; indeed sometimes there had been no consultation with the local authority's own recreation, arts or leisure department. In consequence, a theatre or hall had been included in the building that was quite unsuitable for use by a wider public than the school itself. Common faults were lack of dressing rooms, lack of space backstage, no proper means of entry and exit to the stage, no emergency exits to comply with public performance regulations. Worse still, few school theatres seemed suitable even for school drama and music, because no advice had been sought from consultants on sightlines, acoustics and stage sizes. Stage floors are usually of such good material (if not solid concrete) that stage sets cannot be screwed into them. Lights and sound equipment are often afterthoughts bought bit-by-bit rather than essential components of a well-thought-out new building. However, the most common obstruction to the use of school buildings for other community purposes is failure to solve the problem of the caretaker.

Many local education authorities are beginning to realise the indefensible waste of money and opportunity involved in the design and use of schools for one purpose only. Better advice is now sometimes sought, and the community use of school buildings is more often considered at the planning stage.

Under sections 41 and 53 of the Education Act, 1944, local education authorities have a duty to secure the provision for persons over compulsory school-age of adequate facilities for further education, including leisure-time occupation in organised cultural training and

recreational activities. But at no time since the war has any Government felt able to allow, still less encourage, education authorities to give any priority, in the use of money or building resources, to the non-vocational further education that the Act envisaged.

Local Authorities

Some local authorities have had powers for over a century to spend money on museums, libraries, art galleries and concert halls. Bournemouth first established an orchestra in 1893, Birmingham in 1919. In general, however, local authorities could spend money only for the specific purposes for which the law made provision. There was no law permitting them to act generally in support of the arts until 1948, and until that year such support was exceptional (under private act powers). Moreover, it is broadly true that the economic need for financial support of drama and music has become acute in Britain only since the end of the Second World War, and so the lack of legal power for local authority help was matched by an attitude on the part of most councils that the arts were best left to fight for their own survival; if the art was wanted, people would pay for it. There was a traditional view that the local council was not there to engage in 'frills and luxuries', but rather to ensure adequate provision of such material services as street lighting, sewerage systems and roads. The social services and housing gradually came to be acceptable as local government services, but it was only the exceptional city that concerned itself with the arts.

The 1948 Local Government Act (Section 132) permitted (but did not require) all local authorities except County Councils and Parish Councils to spend a sum not exceeding a 6d rate upon the arts and entertainment for their areas. This was a new departure. The lessons learned from CEMA were perhaps behind the move; it was hoped that local authority provision would replace the direct provision of arts tours originated by CEMA which could not well be expanded by the new Arts Council. The new Act resulted in a very uneven response. It was estimated that if the 6d rate had been levied in full, it would have resulted in over £50m being raised annually by local government for arts expenditure. In 1975, we are still a long way from raising one-half of that amount from local authority sources.

The most encouraging response was from County Boroughs, the London County Council (later the Greater London Council), London Boroughs, seaside resorts and from certain local authorities that had

special interests in the arts in their areas. Little was spent at all in other parts of the country. The average rate product raised was less than 1d (in 1961/62, the net expenditure on the arts *and* entertainments of 532 authorities was only £2,549,186). By 1972/73 Norwich (population 120,000) was spending about £200,000 on the arts and museums, while Havant and Waterloo Urban District Council (population almost the same as Norwich's) apparently spent less than £1,000. As fractions of an old penny rate, these correspond to 2·89 and 0·01 respectively.

County Councils and Parish Councils were enabled by the Local Government (Financial Provisions) Act of 1963 to spend up to a 1d rate product on any purpose they deemed to be in the interests of their areas or inhabitants; indeed this widening of powers applied to all local authorities, and not only gave a power to Counties to spend money on the arts among other purposes, but allowed, for example, contributions to be made to arts organisations acting outside the geographic limits of a particular local authority. In their early days, many regional arts associations were aided by local government under this Act.

Section 20 of the 1964 Public Libraries and Museums Act permitted local authorities which maintained libraries, museums or art galleries to help arts organisations by allowing them the use of these premises for their meetings or for arts and educational events.

Local government reorganisation (the Local Government Act 1972, implemented from 1 April 1974) included revision of the 1948 Act. In clause 142, the new Act removed the limitation on spending, and all the new local councils became free to spend at their own discretion on arts and entertainments outside as well as inside their areas. The new wording spoke of 'the development and improvement of the knowledge, understanding and practice of the arts', a phrase clearly adopted from the Arts Council's Charter. Notwithstanding the unequal response to the 1948 and 1963 Acts mentioned above, there has been a great increase in local authority spending on the arts over the last decade. Total local authority expenditure on the arts was estimated in 1972/73 at about £15m, as opposed to the £2½m net expenditure eleven years before. Allowing for incomplete surveys, inexact definitions and difficulty of distinguishing arts spending from other leisure spending, it is still clear that local government has now begun to take the arts more seriously. Another example of the change is that in 1963/64, local authorities gave a total of only £76,000 to repertory drama companies in England, whereas the Arts Council was giving

£1,350,000. In 1973/74, the figures were £1,120,000 and £3,430,000 respectively, and some theatres were run by local authorities directly, without Arts Council support.

During the course of our enquiry we visited all the metropolitan areas in England, talking to councillors and officers of both Counties and Districts; we also visited other County and District Councils in every part of England and Wales. Additional views reached us through the Association of Metropolitan Authorities, the Association of County Councils, and the Association of District Councils. We met many other local authority members when we visited regional arts associations.

There is still wide variation in the way different local authorities approach the arts. Although little time has elapsed since reorganisation, we found a new readiness in local government to see the arts and the whole leisure field as an essential part of local life, and something therefore that is part of normal local government business. Some councils have set up recreation and leisure committees, with arts as a sub-committee; in other cases arts are linked to the education committee or the library committee. That there is no common pattern is less important than the willingness to appoint experienced staff and to engage both directly in the promotion and organisation of arts activity and, indirectly, in giving assistance to other bodies, amateur and professional, in the area.

We found some confusion, however, between counties and the districts within them. Frequently both had committees and departments dealing with the arts and, while co-operation was often good and definition of roles adequate, occasionally there was no such understanding. Nor was there often any agreed development plan for the arts, agreed between districts, county and regional arts association. This confusion seemed most acute in metropolitan areas, where some districts felt that the new county authority had no essential role in the arts but was attempting to create one artificially (and expensively) where it should be leaving matters to the districts.

In some shire counties, particularly those that are largely rural, there was as yet little progress towards greater arts support either from county or districts, though there were some notable exceptions, for example in Leicestershire. In these areas, the work of amateur-led societies and local arts clubs and associations was especially valuable, as was the touring work of regional arts associations.

In more urban areas, local authorities have often now taken owner-

ship of buildings for touring theatre, opera and ballet, and support their regional orchestras and drama companies. (This is mentioned again in greater detail in the next part of this Report.) Similarly, some counties, such as Norfolk, have now established unified museum and art gallery services.

With this wide variety of development and provision, there was a corresponding variety of local authority views about the role and usefulness of regional arts associations. Some metropolitan county authorities, such as Greater Manchester, felt that they could fulfil the role of a regional arts association themselves for their own area, and that the larger regional association was no longer serving their aims. In other metropolitan areas, such as Tyne and Wear, a clear agreement had been reached between the county, districts and regional arts association as to who did what. Most counties were sympathetic to regional associations but often felt that, in the absence of such a clear agreement, there was duplication with the county. Districts, in general, wanted to be left alone to get on with the job of promotion, and were grateful if financial help from regional associations went to help the arts in their areas. They were suspicious, however, of financial arrangements whereby they were asked for contributions which might or might not return to their own areas. In general, local government is still wary of regional arts associations, as it feels that they are not responsible politically and that they duplicate local government at high administrative cost.

Many authorities agreed that local government was better fitted for well-established arts functions than for innovation and experiment. Thus, the provision of buildings, running museums and galleries, giving assistance to orchestras and drama companies, assisting amateur arts organisations, all seemed acceptable functions to them. On the other hand, the experimental arts, some arts centres, direct grants to artists, and the introduction of new ideas to an area, were functions they thought better suited to an arts association. There was general agreement that counties should co-ordinate the actions of the districts and link them, in non-metropolitan areas, with education.

The over-riding obstacle to progress in local government support for the arts is the present economic stringency. But it was encouraging to find that although one might expect the arts to be one of the first areas to be cut at such a time, most authorities realised that if an attempt were made to save any significant amount of money in a small budgetary area such as this, it would do irreparable damage to the

programme as a whole. So far this has meant that most authorities have maintained the level of their support for the arts in 1975/76, though because of inflation this is equivalent in real terms to a cut. It is too soon to say whether this position will be maintained in 1976/77.

London was not subject to the 1972 Local Government Act, having had its own reorganisation in 1965 when an area of 618 square miles, with population nearing eight million, had been created. The Greater London Council (GLC) was given a strategic role across the whole area, but 32 new London boroughs and the City of London became responsible for most of the more local functions. Like counties and districts outside London, both the GLC and London Boroughs have concurrent powers (but no duties) in respect of the arts. But education (as mentioned above) is the concern of the Inner London Education Authority and of the outer ring of boroughs. Virtually the whole area is urban, with great problems of urban renewal and pockets of multi-deprivation. The GLC area is also that of the Greater London Arts Association, formed in 1966.

The GLC owns and runs the South Bank complex of concert halls, operates (through the ILEA) two museums and promotes a variety of events in parks. It is helping to build and maintain the National Theatre and grant-aids the English National Opera, London Festival Ballet, and the London Orchestral Concert Board, which passes subsidies on to four symphony orchestras and to several chamber orchestras and other groups. Apart from these large commitments in which it co-operates directly with the Arts Council (and which include no aid to Covent Garden), it also makes revenue and other grants to arts organisations whose sphere of action is wider than any single borough (in these cases it takes some account of the advice of the Greater London Arts Association). It does not have specialist arts staff of its own, seeing its role as a financial one. Its spending on the Arts in 1975/76 was:

South Bank Concert Halls	£770,000
Cultural facilities in Parks	149,000
Museums	609,000
The National Theatre	300,000
London Festival Ballet (includes a special capital grant)	325,000
English National Opera	375,000
London Orchestral Concert Board	270,000

Grants to organisations of regional or sub-regional importance	330,000
Capital contributions to cultural bodies, less sundry income	331,000
Debt charges	1,000,000
	£4,459,000

London retains many theatres, galleries and other cultural assets which receive no subsidy but, by virtue of London's large population and of its tourist and business visitors, maintain themselves commercially. However, there is indirect subsidy even here, as the theatres need talented writers, directors, actors and staff, most of whom gain their experience in the subsidised sector. In the autumn of 1975, of 34 shows running in the West End of London 19 had originated in subsidised theatres.

Though we could find little statistical evidence to prove the point, it was stated to us that the benefit to Britain from those tourists who are believed to visit London primarily to see London's artistic attractions, is greatly in excess of all public subsidy to all the arts in Britain. A survey of foreign tourists in 1973 showed that over half of them had as one of their main reasons for visiting Britain that they wanted to pay 'visits to the Theatre'. In that year foreign tourists spent £682m in this country.

Apart from the main types of local authority already mentioned, the 1972 Act also recognised Parish Councils (in England) and Community Councils (in Wales), and increased their powers. These bodies may levy rates, if they wish, for local purposes including a 2p rate for any purpose, including the arts, which benefits their area or its inhabitants. But generally speaking they are too small in area and population to be significant as supporters of the arts. Nevertheless, there are encouraging signs, as in the support given to the Mid-Pennine Association by the Parishes of Todmorden and Whitworth, that this is not always true. The Welsh Community Councils are at present discussion forums rather than spending bodies, but in this role they (and the English parishes) may well prove valuable to the arts.

Broadcasting
Radio and television play an extremely important part for the arts in Britain, and in several ways. Both reach very large audiences even for

so-called 'minority-interest' programmes, and these audiences include many that for a variety of reasons do not or cannot leave their homes in search of the arts. Broadcasting increases accessibility.

In so far as many people see or hear arts programmes who would not normally go to a theatre, gallery, concert hall or arts centre, it also increases knowledge and appreciation of the arts, whetting the appetite for more and perhaps thereby increasing audiences for live performances. On the other hand it is no doubt also true that if people can receive high-quality programmes in their home, they are less likely to go out and pay to see live theatre or hear a concert. This clearly happens at the expense of some types of cinema. However, in many arts programmes on radio and television the live arts are reviewed and discussed, and this serves only to increase live audiences.

Broadcasting is the largest single sector of employment for many types of creative and interpretative artist (writers, actors, musicians and the like) and the economic situation of the arts would be far worse even than it is if it were not for broadcasting.

With so little art from abroad now coming to Britain, the international coverage given by broadcasting, though not as great as it could be, is nevertheless most welcome.

Broadcasting also has a role as a patron in the literal sense, commissioning works from young and little-known dramatists and composers as well as major figures. Though this is an important function, supplementing the commissions otherwise offered by the Arts Council and many other patrons both public and private, financially only a small sum of money is involved: approximately £5,000 for ten works for BBC music in 1975/76, for example.

The record of the BBC in the arts field is recognised worldwide, particularly in music. The Corporation operates directly thirteen permanent music bodies, including the BBC Symphony Orchestra, the Academy of the BBC, the BBC Northern Symphony Orchestra, BBC Welsh Symphony Orchestra (which also receives assistance from the Welsh Arts Council), BBC Scottish Symphony Orchestra; it organises the 'Proms'; Radio Three is devoted largely to serious music; and television gives a substantial number of viewing hours, often at peak periods, to music, drama and other arts programmes.

Out of a total expenditure by the BBC of £141m in 1973/74, nearly £25m was spent on drama, serious music and arts features. The cost of the orchestras alone is about £2·8m a year.

The independent television companies have also played a worth-

while part with some fine programmes to their credit. The commercial pressure upon them, however, no doubt limits the extent to which they can give air-time and money to the arts, and the fact that ITV has so far been limited to one channel has also restricted the development of minority interest programmes. It is also true that commercial 'breaks' are more disruptive to the viewer when a programme is of high-quality music or drama than when light entertainment is being broadcast. Nevertheless, the record of most of the ITV companies is not as good as many people were led to expect from the proposals outlined at the time the companies applied for franchises.

Local BBC and some independent radio stations have often shown an interest in the arts and have in general a willingness to try new ideas. They are seldom, however, able to spend enough on a programme to cover Equity and Musicians' Union rates for serious drama or music programmes, though there are noteworthy exceptions in the larger centres. The amount of time they spend on publicising local arts events is significant. There have been some recent cases of good co-operation on such arts programmes between regional arts associations and local radio. The local cable-vision experiments in Britain are, with one exception, now defunct, killed off by rising costs and uncertain sources of revenue.

One point of continuing concern about television is its use of films. Not only has television seriously cut attendances at cinemas, resulting in the closure of all but a fraction of those that were operating only a decade ago (and about two-thirds of those that were open in 1945), but at present the only return given by television to the film industry (apart from the purchase price paid for the right to televise a particular film) is a grant to the National Film School. At the present time television may not show a film originally intended for cinema exhibition within a period of five years from the date of the film's first release to British cinemas; it is then a matter for the owner of the copyright to sell to television if he so chooses. It has been suggested that there should be an extra levy upon the showing of films on television, the proceeds of which could be channelled back into the production of British films. In effect this would be a large extension of the 'Eady Fund', a fund raised by a small levy on cinema seat prices for a similar purpose.

Grant-giving trusts, charities and foundations
The United Kingdom is rich in such institutions. They act within English charity laws dating back to 1601. Their registration and

operation is regulated by the Charity Commission. (In Scotland rather different arrangements apply, owing to differences in that country's legal system.) A list of British charitable trust organisations is to be found in the *Directory of Grant-Making Trusts*, Fourth Compilation, published by the Charities Aid Foundation, 1975. It lists a total of 2,049 trusts, only 86 of which were established before 1900. Those dealing with the Humanities constitute only a small part of the directory, other sections dealing with such categories as Medicine and Health, Welfare, Education, Sciences, Religion, Environmental Resources, etc.

There is no requirement for trusts to register with the Commission; some do not, and are therefore not listed. Registered charities have certain legal and other privileges, especially relating to property, rate relief, and exemption from taxes, but they may give grants only for charitable purposes, and this requirement is watched over carefully by the Commission. Some organisations which do not wish to be restricted in this way forgo the privileges and do not register. Some trusts, too, which are international in action and derive their income from overseas (or have their base registered overseas), do not register in Britain and are therefore not in the directory.

Trusts are managed in a wide variety of ways, and some of them are both archaic in their methods and secretive about their policies and operations. Many are small in terms of annual expenditure, and with outdated purposes. A Committee of Inquiry into Charity Law is at present sitting under the Chairmanship of Lord Goodman to look at these and other similar questions.

It is estimated that registered trusts and foundations provide £140m annually out of the total of £335m that flows to charitable purposes in this country. Of this total, a sum of £4m is probably spent annually by these organisations on the arts. Leaving aside those bodies which, though registered as trusts, derive their funds largely from public sources (as the regional arts associations do), there are only about a dozen trusts which are nationally important in the arts field, and their combined arts expenditure is probably less than £1m annually.

The main arguments put forward in favour of the trusts are: that they provide a multiplicity of funding sources so that if an applicant fails with one, he may succeed elsewhere; they are a source alternative to public money, and combat the danger of the public purse becoming the sole important patron; as they have no public responsibility, they can take risks in backing projects that public funding bodies would be

doubtful of supporting until the idea was shown to be a good one; they can help to provide specific funds for particular purposes (often capital items like buildings or equipment) which might not appeal as causes to the public bodies. The common factor in these arguments is that trusts help the applicant to retain freedom of action. Most of these arguments are also applicable to fund-raising from industrial and other sources in the private sector.

Though we have not looked closely at the private foundations or trusts during this enquiry, it is our impression that they are less useful than might be supposed. The small number of sizeable institutions and their very limited funds for arts purposes do not provide a multiplicity of sources. Few trusts are prepared to give grants to organisations unless there is a good indication of future viability, so that few risks are taken and private money tends to supplement public money rather than act as an alternative. Trusts registered with the Commission *do* have a public responsibility, but few of them show recognition of the financial advantages they enjoy by giving public account of their activities.

Only one or two of the largest foundations can afford to appoint specialist staff with a knowledge of the arts field. Their advisory committees and boards of trustees tend to be conservative in composition.

This generalised judgement does not apply to those few trusts that have done, and are doing, much enlightened work for the arts. The help given over the years by such bodies as the Carnegie UK Trust, the Pilgrim Trust and the Calouste Gulbenkian Foundation has been large in measure and adventurous in policy. This is not the place to recount their histories and achievements, but without them we would have been immeasurably the poorer. The scale of their help, however, has been much reduced by inflation, and it is now greatly outweighed by the increasing public provision. They remain useful bodies, often pointing to areas inadequately helped from public funds and themselves acting as valuable catalysts. But as grant-giving bodies they are less important than they were, and we must face the fact.

My hope is that arts-oriented trusts will not only move in the direction of more open action but will seek to concentrate their aid in ways designed to complement the public patron by relatively small grants at key points. For example, more could be done by trusts to aid the enterprise of individual artists, and to help organise the provision of information and research that would be valuable to public funding

H

bodies, arts organisations, local government, artists and the arts generally. No trust concentrates its arts activity on the experimental arts. Community arts, on the other hand, as part of social welfare, are within the traditional scope of many British trusts.

Commercial sponsorship and patronage
It is estimated by the Sports Council that business firms spend about £8m annually on sports promotion, but the Arts Council estimates that only some £500,000 is spent on the arts by business.

At the present time there seems to be some growth in commercial sponsorship. Examples, among many others, include assistance to the general costs of a symphony orchestra; sponsorship of a series of concerts in Bristol; help towards production costs at the Royal Opera House; assistance to festivals (at York, Edinburgh, Newcastle, Aldeburgh, King's Lynn, for example); assistance to Glyndebourne; sponsorship of a 'cello festival; a series of inexpensive gramophone records of operas; subsidised concerts in a firm's home town by major London orchestras; prizes donated to the Scottish 'Mod' and the Welsh International Eisteddfod; help towards the costs of building new theatres and arts centres. Most help goes to the major orchestras and to large national organisations such as the Royal Opera. Local events are the next largest category of recipients. Little help from commercial sources goes to the experimental arts or to events which would neither give the donor national publicity nor serve to improve public relations with the town in which his firm is based.

As businesses need to make profits net of taxation and are usually answerable to shareholders, it is natural for them to interest themselves in arts only if they expect advantage from enhanced prestige or larger sales. The arts, despite the attraction of their quality, have so far fared less well than sport, no doubt because audiences for the arts are far less numerous than those for many sports events. Moreover, the latter have been allowed more air-time on television and the sponsor's name has been unavoidably made public by BBC as well as ITV. The BBC has now modified its previous practice in regard to arts programmes which originate from sponsored events; this may well encourage firms to sponsor arts events which are also likely to be televised or broadcast.

Firms are naturally less willing to give funds to a body like a regional arts association, or indeed to a theatre company for its revenue purposes, than help finance specific productions, events or performances. They wish to be clearly associated in the public's mind with an

identifiable end-product. Although Northern Arts (and some other RAAs) have been successful in raising monies year after year from industry, this is because the firms wish to be visibly associated with a vital regional development – and even so it is now becoming more difficult to raise funds in this way. A better line of approach may be for associations to act as 'honest brokers' between firms looking for a suitable art event to sponsor (but not having the expertise to judge which one to pick) and art organisations of a type that can meet the criteria of business and need money for specific new developments.

We received interesting evidence from one firm that had set up an arts brokerage business of this sort, which would seem capable of development on a national scale. The Arts Council might use its great knowledge and prestige to increase its own work in this capacity to help the newly-formed Association for Business Sponsorship of the Arts.

No direct tax remission is at present given on business donations to the arts. It has often been urged in the past that the Chancellor of the Exchequer should alter the tax system to make such a concession. Without it, there is little incentive to industry to become patrons: firms, it is pointed out, pay rates and taxes to local and central government, both of which spend some tax income on the arts. On the other hand, most of the help given by business to the arts is not altruistic and is often allowable against tax as part of the firm's advertising budget. Apart from arguments of that kind, there is this hard fact: all business donations and sponsorship are subject to annual decisions by company boards, and in times of economic difficulty boards will cut back this help. The firms have no responsibility towards arts organisations, and the latter could find themselves overnight in grave embarrassment if they became dependent to any great extent on business patronage.

It seems right, therefore, that *public* patrons should accept responsibility for arts support, the private sector giving supplementary help by sponsoring particular events. It is for the arts organisations to make themselves attractive to business, though without compromising their artistic principles, while the Arts Council and RAAs as well as private firms expand the role of arts brokers. Arts administrators should develop in their training (see pp. 174-177) an appreciation of the ways in which it is most realistic and fruitful to approach businesses.

It is disappointing that trade unions in general have taken so little interest in sponsoring the arts. Some of the unions which are professionally involved (British Actors' Equity, the Musicians' Union,

ACTT, etc.) do make some grants and engage in some sponsorship of events, but it is not yet significant. Some other unions (the National Union of Mineworkers is an example) have also from time to time sponsored events. In 1960 the Trades Union Congress showed interest when it passed Resolution 42 in the following terms:

'Congress recognises the importance of the arts in the life of the community, especially now when many unions are securing a shorter working week and greater leisure for their members. It notes that the trade union movement has participated to only a small extent in the direct promotion of plays, films, music, literature and other forms of expression, including those of value to its beliefs and principles. Congress considers that much more could be done, and accordingly requests the General Council to conduct a special examination and to make proposals to a future Congress to ensure a greater participation by the trade union movement in all cultural activities.'

This was followed up by a movement, 'Centre 42', led by the playwright Arnold Wesker, which aimed at breaking through the barriers surrounding the arts and making them more accessible to all classes throughout the country. Festivals were organised in Wellingborough, Nottingham, Leicester, Birmingham, Bristol and Hayes and Southall, and the Roundhouse in London was presented as a possible national centre for the movement. An article 'Arnold Wesker's Centre Forty-Two: a Cultural Revolution Betrayed' by Frank Coppieters in the magazine *Theatre Quarterly*, no. 18, recounts the sad history of this movement which came to nothing, through indecisiveness on the part of the trade unions and the Arts Council, and partly through lack of experience among the organisers.

In 1975 the Trades Union Congress set up a working party to look again at possible trade union involvement in the arts.

IV *Results for the various arts*

Here we can do no more than give an incomplete report on what we found. Our time in each part of the country was far too short for an exhaustive review of all the arts. All we could hope to gain was a broad impression of how the various arts were faring within the present framework of support.

Drama
The changed scene in British drama since before the Second World War is probably the most remarkable of any of the developments we saw. The general position before the War was as follows. West End theatres operated by commercial managements toured productions both before and after the London run to a commercial network of large theatres in important regional centres (the 'No. 1 tour theatres') and to a circuit of smaller commercial theatres in smaller towns ('No. 2 tour theatres'). Many other companies mounted productions specifically to tour these centres and in the hope of finding a London theatre in the event of success. Further, there were one or two permanent companies outside London (for example at Birmingham and Stratford-on-Avon) which achieved high standards; and there was a large number of permanent repertory theatre companies, usually operating on one-week or two-week runs, in old buildings in towns all over the country. Though music-hall was even then in decline, there were still some houses devoted entirely to that form of theatrical entertainment.

After the war, television, changing economics and changing public taste brought about rapid change in the provinces. The remaining music-halls closed, touring declined greatly and many of the smaller theatres closed too. Much of the loss was in light entertainment. Many of the buildings that closed were old fashioned both technically and in terms of comfort and convenience. A large number of the small repertory companies also died, but there was a strong movement from

local authorities and from the Arts Council to preserve and improve drama provision in the regions.

Thus the best and the strategically placed repertory companies gradually became subsidised, and were encouraged to break away from the short runs (which limited the type of production possible, as well as preventing the achievement of high standards) and perform more adventurous plays for two, three or even more weeks each. In 1956 the Arts Council was subsidising 22 such companies in the regions; by 1971 the number was 45; in 1974 it was 48, plus a number of itinerant companies. Apart from the transformation of old companies, there has been a resurrection of drama in towns where theatre had died, and there has also been the creation of companies where there was none before. More companies and longer runs represent a large growth in audiences who can now see fine examples of modern and classical theatre, performed at standards of production which are as good as in London and sometimes better.

The buildings to house these companies are almost all new, or so much improved as to offer excellent facilities. During the 1950s and 1960s Britain saw a spate of theatre building, greatly encouraged by the Arts Council's Housing-the-Arts Fund which often proved a vital catalyst in attracting support from local government and the private sector. Many of the buildings have studio theatres in addition to the main auditorium, and this allows for experimental work, visiting theatre groups, theatre-in-education work and the like. The broader question of Housing-the-Arts is considered later in this Report (see pp. 169-174).

The Arts Council's Report *The Theatre Today* (1970) recommended immediate action to help save touring from collapse. In consequence the Arts Council took over the work of the Dramatic and Lyric Theatres' Association (DALTA), which had been an agency operated by Sadler's Wells, the National Theatre, the Royal Ballet and the Royal Shakespeare Company to co-ordinate their own touring. The new DALTA was given a wider remit to stimulate, co-ordinate and subsidise touring, initially of large scale opera, ballet and drama by companies of established national standard to No. 1 tour theatres. Development has been rapid. Local authorities have taken over, or grant-aided, the major No. 1 theatres (though this process is not yet complete); the Arts Council has also helped to improve the buildings through its Housing-the-Arts Fund; substantial audiences have been built up for co-ordinated seasons of events comprising opera, ballet and

drama (with increasing concentration on opera and ballet, to avoid duplicating the work of the repertory theatres); DALTA has extended its work vigorously to assist the touring of small-scale and experimental drama, and is now more and more involved in middle-scale (No. 2 tour) work.

In London the pre-war pattern has remained surprisingly intact. Some theatres have closed, but defence campaigns have become more effective. Most of the theatres are still commercially run. But, as was noted earlier, there is much interdependence between commercial and subsidised theatres, and this was recognised by the Report *The Theatre Today* which recommended the establishment of a Theatre Investment Fund to enable both public and private funds to be used for mounting and touring productions. So far this fund has not materialised, but there is expectation that it will shortly be established.

The major change in the London scene is the firm establishment of public-funded companies of national standing: the National Theatre in its new building, the Royal Shakespeare Company at the Aldwych, and the English Stage Company at the Royal Court Theatre. In addition there are theatres serving London audiences outside the West End (Greenwich, Hampstead, Bromley, Regent's Park) and in a ring round London (for example, at Guildford, Leatherhead, Farnham, Hornchurch, Watford).

Within London are many 'fringe' and experimental theatres which specialise in new drama in intimate settings. Examples are the Bush Theatre (above a public house in Shepherd's Bush), the Open Space Theatre (in a basement), the Soho Poly, the Young Vic, Oval House, the King's Head (an Islington public house), and the Half Moon Theatre (an ex-synagogue in Whitechapel). And there are many more, adding to the lively development of British Theatre and a valuable platform for new writing and experiment.

England and Wales are not large countries, and we now have, in addition to London's theatres, a notable number of regional companies in England, the Welsh National Opera and Drama Company in Wales, and a substantial amount of touring. But it cannot yet be said that drama is generally accessible. Cornwall and Cumbria, for example, are served badly, if at all, by any of the present means of provision; and there are many other areas where there is no provision of drama or no means of transport to it. One answer seems to be itinerant theatre companies, serving a county or several districts, and playing in school halls, community halls and other such places. Experiments of this kind

have been tried successfully by the Century Theatre, by Mid-Pennine's 'Theatre Mobile', by the East Midlands Arts Association (with its 'Emma' Theatre Company), by some of the other Associations, and notably by the 'Orchard' and 'Medium Fair' companies in Devon (aided by South West Arts). Most of these efforts, however, have succeeded only in the face of severe financial obstacles. Neither local authorities nor the Arts Council seem to have given them much backing – at any rate in the past they seem to have been less responsive to requests from such companies than from companies based on new buildings. There is now a change of attitude discernible at the Arts Council. Substantial support for itinerant community drama companies is seen as a logical extension of the policy of encouraging regional theatres; and in consequence the Drama Department of the Arts Council gives its backing to the relevant parts of budget requests from the regional associations. But this has yet to put the itinerant companies on any proper financial footing.

It should not be assumed that Greater London is adequately provided for by its West End theatres. Large sections of the seven and a half million Londoners do not find that West End productions are much use to them. It is still an unfortunate fact that the established arts retain an image in Britain of being only for the better-educated. This judgement does less than justice to many plays put on in London and the regions, but large sections of the population have never set foot inside a theatre (except perhaps to see a pantomime) and would think it was 'not for us'. This position is changing, but meanwhile there is every reason to seek not only new ways of encouraging new audiences to go to existing theatres but also new ways of taking the arts, including drama, to new potential audiences. This is a grave problem, especially in inner-city areas but in rural areas too. We have already spoken of itinerant theatre companies, and will later (see pp. 157-161) discuss community arts, as pointing to the solution of the problem.

All the theatres we visited, and all those who directly or indirectly gave evidence to us about the needs of theatre, made one simple basic point: that the subsidised theatre faces a particularly severe financial crisis. There have been sudden and severe rises in labour and material costs. Local government has in general not been able to respond by increasing grants to repertory theatres more than marginally – and local government at present shares responsibility for subsidising repertory theatres with the Arts Council, the RAAs helping sometimes towards exceptional costs or new developments. The Arts Council

has bailed the theatres out so far as the size of its government grant allows. Most theatres in the regions do not know what they are going to get in subsidy from local government or Arts Council until each new financial year has actually started, and hence can do no sensible planning. Indeed, they have to *assume* that they are going to get something because they have to prepare productions, contract actors and do publicity. Though this precariousness affects other arts organisations (orchestras, arts centres, galleries, etc.) it seems most acute for the theatre. We shall refer again to the desirability of not operating the arts of the nation on a 12-month stop-go basis, but rather giving every major organisation knowledge of its basic level of grant for a forward period of three years (a 'rolling triennial' grant).

As was said above, most of the repertory theatres are supported in approximately equal measure by the Arts Council and by local government (often by several local authorities, in recognition of the wide catchment area served). The management of the companies is usually in the hands of a trust, which seems preferable to direct management by the local authority. Even though many of the trusts are in fact controlled by local authority nominees, this arrangement places artistic decision and the day-to-day management at one remove from the political arena. Clearly local governors must take the decision to grant-aid, but artistic questions should be decided outside the normal procedures of local government. If the local authority dislikes the artistic operation as a whole, it can express its displeasure and, if need be, threaten to cut its grant in due course; but it is unwise for local governors to take responsibility for the choice of particular plays or directors.

The growth in recent years of theatre-in-education in Britain has been a remarkable phenomenon. Most regional theatres (as repertory theatres now like to be called) have a small team of actor/teachers who devise shows specially for children, intended for presentation in schools and with a minimum of scenery or complication. Occasionally these are complete productions which the children watch as an audience, but far more often the shows are flexible frameworks which can be adapted to different situations and allow for the imaginative and physical participation of the children themselves. Visits by such theatre-in-education teams are designed to complement the drama work done in some schools by resident drama teachers, or as a substitute where there are no such teachers. The educational arguments in favour of drama used in this way are strong. It aids the development of the child, particularly of children who lack self-confidence or have other personal

problems; it brings certain subjects alive in a way that is otherwise impossible; it leads to greater self-control and judgement in the child; and it helps to awaken and develop the artistic side of personality.

Many schools seem still to regard education as limited to the implanting of information and enabling children to pass examinations. The arts have crucial parts to play in education, both inside and outside the curriculum. The Arts Council is now showing a new interest in the educational role of the arts which for long has been in limbo between the Department of Education and Science and the Council. It would be one of the most important developments of the next decade in Britain if the arts became central and not peripheral to our education system. The Arts Council in conjunction with the Schools Council and local education authorities could do much to encourage such a move, but success depends most of all on teachers and the colleges of education where they are trained.

Although theatre-in-education is now a nationwide movement, it has not yet succeeded. The teams are understaffed, overworked, under-subsidised, and they operate over such large areas that they can rarely provide an adequate service or visit a school more than once or twice a term. Nor are the Education Authorities paying a fair proportion of the costs. A national focus is needed for this work. It should become the norm for every education authority to provide for realistic expenditure on theatre-in-education – and on the other arts-in-education teams and projects.

There is surprisingly little theatre for young people, apart from theatre-in-education and some subsidised visits of school-children to certain theatre performances. A notable start has been made in various places: the Unicorn Theatre in London (developing the late Caryl Jenner's work), the National Youth Theatre, the Everyman in Liverpool and the Phoenix in Leicester. All of these in different ways are admirable, but all major centres of population throughout Britain should gradually acquire their own.

Puppetry, on the other hand, has for long been associated almost exclusively with work for children, and this has limited its development. The many various companies we have in England and Wales are now breaking out of these constraints and learning lessons from some of the advanced puppet companies abroad. Puppetry, however, remains a uniquely valuable art form for children. The Arts Council of Great Britain for many years refused to consider applications from puppet companies unless live actors were also involved. This strange

policy (not followed by the Welsh Arts Council) has now been abandoned, but owing to lack of funds, no assistance has yet been given to English puppet companies or organisations. There are certainly promising developments to encourage, and a healthy sign is the establishment of the Puppet Centre Trust to act as a focus for the whole field and carry out common services for it.

The major national companies are corner-stones of the theatre profession and essential standard-setters. Their position must be safeguarded in the present period, and it is marvellous that at last after so many years of patient struggle we have a National Theatre Company housed in a building worthy of it. Almost every other country in Europe has long regarded such a company and building as an essential requirement of civilised society. Our other major companies provide invaluable diversification and enterprise; while they all attract criticism for allegedly consuming a disproportionate amount of total arts subsidy, the truth is that by any standards they are now run economically and earn a more substantial proportion of their cost at the box office than their continental or American rivals. Some argue that the major national companies (in drama, but also in opera and ballet) should be taken out of the Arts Council's jurisdiction and subsidised direct by the DES through the Minister for the Arts, or by the Treasury. The argument runs that the nationals are not judged by the Arts Council by artistic criteria but treated only as book-keeping operations, and that this work would be better done by accountants and civil servants. Hiving the organisations off in this way, it is claimed, would clarify the role of the Arts Council and remove a distortion from its budget.

I find this argument unconvincing. It would be a retrograde step to hand over to the Government the function of aiding these major artistic bodies and better by far that the 'arm's length' principle should be strengthened. If a future Arts Council devolves local and regional matters to local and regional levels, it must retain those matters that *are* national. Furthermore, the Arts Council will continue to have an important role in bringing together people concerned with drama (and the other arts) to discuss developments, new forms of co-operation, and the general progress of that art form, and it seems only sensible that funding and policy developments for theatre as a whole should be the responsibility of a single body.

Amateur drama has a long and honoured history in Britain, and there are hundreds, perhaps thousands of amateur dramatic societies in

the land. Almost no public money from central government sources finds its way to the amateur, though modest local government support is usually given if needed. The amateur arts do not carry the same overheads as do the professional, and production costs are usually low enough to be recovered from the box office. For this reason the Arts Council has not regarded amateur arts as its business and, far less defensibly, many of the regional arts associations have followed suit.

Amateur drama does not need large subsidies and could make excellent use of quite small sums. Some amateurs own their own theatres, not all of which are as large, modern or well-equipped as the Questors at Ealing or the People's Theatre in Newcastle. Most societies need help to maintain their buildings and acquire equipment. The work of amateur societies should receive more recognition and publicity, as a valid element in local dramatic life, from regional arts associations and the Arts Council. Whereas in music there is in Britain a strong tradition of collaboration between professional and amateur, in drama the relationship seems still to be one of articulate or inarticulate hostility. Certainly all repertory theatres could make more fruitful contacts with their local amateur societies, and the amateurs could recognise their interest in such contacts as well as the need to support professional productions. Many societies would like to exchange productions with other societies, in their region or farther afield, but cannot afford it without aid. Courses could be more widely organised and promoted on the pattern of those already run by the British Theatre Association. Those societies that would sometimes like a professional director to work with them might be given a grant towards the fee.

Music

The response to music is perhaps stronger in most people than the response to drama or the visual arts. We have also been accustomed from birth to hearing an incessant stream of all types of music, not in special places to which we have to make an intentional excursion, but at home, in the street, and nowadays in shops and restaurants, in railway stations and in our cars. The constant presence of music, and the not too complex written language of it, prompt people to try their own hand at playing an instrument. Such mass participation does not at present exist in other art forms.

Like those of most Western nations, our musical traditions rest upon an accumulated body of work produced by composers from many

European countries over the past three hundred years. England has provided noteworthy contributors to this panorama (Purcell, Elgar, Vaughan Williams, Britten, for example) but until the post-war period most of the major figures have been continental. The performance of much of the music in this Western European tradition requires orchestras, soloists and choirs of great ability who have undergone arduous training. To hear the music at its best often requires large halls with good acoustics. These requirements today mean great expense.

Orchestral provision in London in the 'thirties was confined in effect to the BBC Symphony Orchestra, the London Philharmonic Orchestra and the London Symphony Orchestra. We now have in addition the New Philharmonia Orchestra and the Royal Philharmonic Orchestra. These orchestras perform in the capital, but also on tour both in Britain and abroad. They play under British and foreign conductors and with British and foreign soloists. The BBC orchestra is funded directly by the Corporation; the others are subsidised for their London activity (the mainstay of their work) by the Arts Council and the GLC through the agency of the London Orchestral Concert Board (LOCB).

This body received £466,559 from the Arts Council in 1974/75, and £213,250 from the GLC (which also subsidises concerts given by the orchestras through its management of the South Bank concert halls). £96,750 of the total went in support of work other than that of the four symphony orchestras which therefore received an average of rather over £138,000 each, a figure which is extraordinarily modest in comparison with what an orchestra like the Berlin Philharmonic Orchestra or Holland's Concertgebouw receives. The orchestras may receive small additional amounts (for commissioning or performance of new music), but otherwise they need to earn their keep by either making appropriate charges to the promoters who wish to book them or by earning money at the box-office at concerts which they themselves promote. An orchestra, with good soloist and conductor, will usually cost more to book than can be expected to result from the box-office at most provincial halls. Except when a local authority decides on a policy of subsidising a series of concerts involving London orchestras, it is now rare to find them performing outside the capital.

To make matters worse, foreign orchestras, which are better subsidised and usually contract-based, can visit Britain and play at lower prices than our orchestras must charge. It is not surprising, therefore, that there is too little work for the full employment of all our

orchestras and that their underemployment is on an increasingly serious scale.

The London orchestras (apart from the BBC) do not engage their players on a full-time contract basis, but have first call on them, permitting them to engage in teaching and in freelance and 'session' work. This arrangement has certainly given London a pool of excellent musicians who are available to play individually or in different groupings at all manner of engagements, and thus add variety to the capital's musical life. On the other hand, it is thought to have prevented the orchestras from achieving the highest international standards.

There seems only one sensible way forward: a re-assessment of the quantity of work likely to become available in Britain for these London-based orchestras; a decision, if necessary, to phase out one or more of the orchestras; and then a much higher rate of subsidy (for activities both in London and in the regions) for the remainder, so that they can provide more continuity of work and remuneration to their players, if possible on a contract basis. The Peacock Report (*Orchestral Resources in Great Britain* published by the Arts Council of Great Britain, 1970) spelled out the situation clearly and strongly, but its main recommendation was rejected by the Arts Council.

Outside London, the major regional orchestras, most of which were in existence before the Second World War, have grown in importance. Such orchestras as the Hallé, City of Birmingham Symphony Orchestra, Royal Liverpool Philharmonic Society, Bournemouth Symphony Orchestra receive support from the Arts Council and from local authorities and, unlike the London orchestras, operate usually on a contract basis. They provide the mainstay of orchestral provision for their regions, but they also play in London and on tour in Britain and often undertake foreign tours. The Bournemouth Symphony Orchestra, despite its name, now serves much of the South West of England, and is managed by the Western Orchestral Society Ltd, which also manages the Bournemouth Sinfonietta, a chamber orchestra that works in parallel with the Symphony Orchestra. Like the regional theatres the main need of the regional orchestras appears to be assurance of grants in sufficient time to make forward planning possible. There is special need for the rolling triennial system in this area.

We have already mentioned that in Wales the BBC Welsh Symphony Orchestra receives additional help from the Welsh Arts Council. This enables it to take on additional players and to perform more widely in Wales than it could otherwise afford.

In recent years there has been a marked development of chamber orchestras. Besides the Bournemouth Sinfonietta, there is a contract orchestra in the north, the Northern Sinfonia. This is funded jointly by the Arts Council and Northern Arts, local authorities using the regional arts association as a channel for their support. There are other professional chamber orchestras in the regions, usually non-contract and based on the larger centres of population where part-time teaching and other work is available for the players. London-based chamber orchestras (such as the English Chamber Orchestra, London Mozart Players) have also provided concerts not only in London (where they, too, receive modest help from the LOCB) but throughout the country. Not only are chamber orchestras able to play in smaller halls than are symphony orchestras but they perform a different repertoire, ranging from the classical to the most modern. Several chamber orchestras, notably the Fires of London and the London Sinfonietta, have earned an international reputation through their performance of modern music, but they do not get direct help from public funds towards the basic costs of their operation except from the LOCB grant towards London concerts. Most of these 'national' chamber orchestras have been faced with the threat of extinction during recent years, but a combination of fund-raising, private and industrial patronage and enterprising management have just kept them afloat. There seems no good reason why, if theatre organisations receive grant-aid, these highly regarded music organisations do not. Much more work could be done, and standards maintained and improved, if a small amount of money could be made available towards the basic costs and administration of the chamber orchestras and groups.

Besides sustaining the inheritance of the past, music needs to explore new frontiers. Orchestras large and small, as well as soloists, must bring new work before an audience. But new music poses acute economic problems. First, whereas large orchestras need large halls and large audiences, new work does not usually attract large audiences. Secondly, if our composers are to develop their talents, they need to be paid more adequately than through occasional commissions for creative effort that involves many months of work. Again, when costs are soaring and ticket prices must be kept down to attract as large audiences as possible, there is a natural tendency to play the traditional repertoire rather than undertake new work that involves large extra costs in rehearsal time and attracts no extra members of the audience. Finally a difficult new work will not be fully appreciated if it is per-

formed only on one occasion. All these problems become more acute under stress of economic pressures. An increase of funds available for commissioning from the Arts Council and such bodies as the Gulbenkian Foundation would be specially valuable at the present time, but the conclusion must be accepted that this unremunerative essential part of music can flourish only if professional music as a whole is in a healthy state.

Broadcasting plays an exceptionally valuable role in the whole field of music, but most of all in the part of it concerned with new works. Though its direct commissions to composers are not numerous, the BBC broadcasts new and seldom-heard music on a scale which the concert hall could never rival, and which enables us to hear a new work often enough to know it well.

Recordings of modern music have a similar value. The commercial record companies produce some records of new music and of important modern works, though this can seldom make a profit. Sometimes firms produce such individual discs as part of their general policy; at other times they focus attention by producing a series ('Headline' by Decca, 'The Calouste Gulbenkian Foundation Series' by Argo, are examples). Some of these records are supported by private or public funds: the Arts Council contributes to a British Council fund that subsidises records of important works by British composers which need to be better known at home and abroad, but inflation of costs has reduced the value of this useful scheme.

A wide variety of music festivals, many of long standing, are held throughout England and Wales. English examples are the Three-Choirs Festival, those at Aldeburgh, Cheltenham, and in more recent times the English Bach Festival, Wavendon and the Teesside International Eisteddfod. The eisteddfodau in Wales have a special place in that country's cultural life. Many towns and cities have recently begun to run or assist general arts festivals which usually have an important element of music in them (examples are Bath, Birmingham, Brighton, Newcastle, Nottingham, Harrogate, King's Lynn, the City of London). All these festivals find joint support from local government, the Arts Council, RAAs and the private sector, each contribution depending on the local, regional or national standing of the festival. This arrangement has proved satisfactory, but the role of the Arts Council should be assumed by English regional associations as devolution gradually becomes practicable, for only a few English festivals are truly national in character, and still fewer international.

Most professional performances of orchestral music in England and Wales take place in buildings that are unsuitable. London is fortunate in having modern halls on the South Bank and in Croydon: the notorious echo of the Albert Hall has now been cured, and the Church of St John's, Smith Square, has been successfully converted. Outside London it is a different story. There is a new Guildhall at Preston, one or two good conversions (notably the Maltings at Snape), but nowhere else is there a purpose-built, post-war concert hall. Most large-scale performances at present still must take place in town halls, assembly halls, and other multi-purpose civic spaces that date back to Victorian times. Few of these buildings can house an audience comfortably. They lack refreshment facilities. There is little space back-stage. Acoustics and sight-lines are defective. Air-conditioning is below standard. The seats are hard and leg-room insufficient. In some places improvements can be made, and these should have some priority from local authorities and the Arts Council. Other buildings are so unsuitable, or so badly sited, that improvements are not worth the cost. The replacement of such buildings at strategic points should be considered, in consultation with the Arts Council and RAAs, when arts development plans are drawn up by local authorities.

Theatres can sometimes be used for medium-scale musical performances, but theatre acoustics tend to be much 'drier' than is suitable for music. Hitherto little attempt has been made to find ways of improving theatre acoustics for music, but sounding-boards or an acoustic shell will often help. The No. 1 tour theatres were built with opera and ballet in mind, as well as drama, and with slight modifications they would offer stop-gap solutions in some major regional centres until purpose-built concert halls can be provided.

Before building leisure centres with spaces designed for music, local authorities should seek specialist advice (from the RAA, from the Arts Council, from the administrator of a regional orchestra, or from all of these), so that their architect takes full account of the very special requirements of music.

Regional arts associations spend more of their income on music than on other forms of art. Apart from Northern Arts' grant to the Northern Sinfonia, usually RAAs do not give revenue support to orchestras but concentrate on grants to concert-promoting bodies (music clubs, choral and orchestral societies and music festivals), almost always directing grants towards the professional costs involved. They sometimes help to encourage promotion of concerts by the local authorities.

I

They often include jazz in their considerations, but not rock music. Most of them co-operate with the Arts Council's Contemporary Music Network, and some offer specific grants if promoters include modern works in their programmes. Grants of another type are given towards commissioning new works or (by Southern Arts, for example) towards establishing a 'composer in residence'.

Several RAAs provide a useful service by bringing together information about the availability and fees of soloists or groups of musicians who would be willing to perform at a co-ordinated series of concerts promoted by several music clubs and societies. In this way sensible tours can be arranged for which artists accept a reduction of their normal fee and publicity can be co-ordinated. Some associations arrange an annual 'market' at which representatives of clubs and societies gather to discuss bookings for the following season; others do the same job by post. Drama, poetry and other bookings are also sometimes made in these ways.

The National Federation of Music Societies (NFMS) is another source of support for public concerts, and in 1974/75 offered guarantees against loss totalling about £116,000 to 750 societies. Its income is derived from an Arts Council grant (£117,000 in 1974/75) and from subscriptions charged to member societies (£6 a year for each society being an average figure). A permanent professional secretariat administers these concert grants and various other services: a flat fee arrangement with the Performing Rights Society, an insurance scheme to cover public and other liabilities, a music hire scheme between societies, interest-free loans for piano purchases, a residential weekend course for society conductors, publications, and commissions to composers. The Federation also gives awards for young concert artists and organises the annual National Choral Competition. In offering guarantees against loss on concerts promoted in the regions, the NFMS works in consultation with the RAAs.

The Eastern Authorities' Orchestral Association (EAOA) has a special role in the promotion of music in the regions. It operates in East Anglia, the East Midlands and the Home Counties north of the Thames, spanning several regional arts association areas. Its membership consists of local authorities, and its small professional secretariat in London advises them (and other organisations) on the availability of orchestras and artists and on programming, administration and cost. The Association also helps to arrange school concerts. Its expenditure largely goes in guarantees against loss on the 80 to 90 symphony and

chamber concerts promoted each year by its members, but it is also the direct promoter of some ten concerts a year in towns that lack appropriate experience. It was established in 1965, emerging from an earlier system operated by the London Philharmonic Orchestra. Income is derived from local authorities contributing on a complicated formula, and from a matching grant (£34,000 in 1974/75) from the Arts Council.

It might be thought that this service could be undertaken by RAAs, but it would be a mistake, in my judgement, to change the present system. EAOA is in effect a concert agency, and it needs to act across a wide area. Its purpose is quite clear; its staff are expert in their special field, and administrative costs are small. The RAAs concerned have good relations with EAOA and seem happy with the present arrangement. The existence of EAOA, with funds derived from local authority and Arts Council money, has been a significant encouragement to local authorities in promoting concert seasons in this part of England. There seems no reason (except shortage of money) why the work should not expand throughout this area, nor why the experience of EAOA should not be used in other areas of England. The Welsh Arts Council itself performs a similar service for orchestral concerts in Wales.

If such development proves possible, it may be that the managements of major regional orchestras would be suitable bodies to administer the schemes, as an extension of the promotional work they do already. The Western Orchestral Society, for example, now manages two orchestras, promotes many tours and concerts, and does educational work. It seems possible for the major regional orchestras to become comprehensive music organisations for their areas.

In schools music is the most important and best funded of the arts. It is often available as a curricular subject and is an accepted element in primary as well as secondary education. Those who do not take music as a set subject can nevertheless often join a school orchestra, and most counties organise and subsidise a county youth orchestra. Though the accent is on classical music, facilities are also available for folk, pop and rock music groups to practise and perform. Though not every county has a drama adviser (and very few have visual arts advisers), virtually all education authorities employ at least one music adviser. These advisers perform an invaluable service, encouraging music on a county basis and the shared use of common facilities, organising orchestras, acting as spokesmen for music inside the authority, bringing the schools together and linking the local authority with the RAA and other bodies.

129

Many schools have excellent instruments, including pianos, but elsewhere the lack of pianos, properly maintained and cared for, is a major obstacle to the achievement of high standards, especially in concert performance. The owners of good instruments are naturally reluctant to let them out on loan. In many places charges for moving pianos are prohibitive and piano-tuners hard to find. RAAs can help to provide pianos for hire to music clubs. If education authorities were more willing to loan their instruments, the public interest would be significantly served.

Thanks to financial help from the Gulbenkian Foundation and the Leverhulme Trustees, an interesting experiment is being carried out in collaboration with the Hertfordshire County Council by the Rural Music Schools Association, to assess the Suzuki method of string teaching to very young children and discover how far the methods used are adaptable to British ways. There would be great advantage if the teaching of stringed-instrument playing could in future become widespread in primary schools, before students become ensnared in the examination process of secondary education. This would also enable very gifted children to be picked out earlier, so that their talents can be properly developed at special schools (such as the Yehudi Menuhin School) or at schools which place a special emphasis on music (such as the Wells Cathedral School). Fortunately the whole area of music training, including for the profession, is at present the subject of another Gulbenkian Foundation enquiry under Professor John Vaizey.

'Youth and Music' is only one example of the many pioneering services to music which we owe to Sir Robert and the late Lady Mayer. This organisation was set up in the 1950s to carry one stage further the concert work for schoolchildren initiated by the Mayers and now carried on by the BBC. Its aim is to encourage the musical interest of young people by enabling them to attend concerts and the opera. Initially, special performances were put on for the benefit of members. The accent has now shifted so that the individuals can go individually to ordinary concerts and opera at reduced prices. Youth and Music also helps young soloists to take part in international competitions abroad and in England, such as the Carl Flesch violin and viola competition in London and the Leeds International Pianoforte Competition. It encourages visits abroad and exchanges of youth orchestras, and represents Britain in the International Federation of Jeunesses Musicales which now comprises nearly thirty countries. Youth and Music receives a grant from the Arts Council. It has a small

secretariat in London, and its regional branches rely largely on the work of volunteers.

The National Youth Orchestra (NYO) was founded by Dame Ruth Railton during the 1950s. Competition to play in it is fierce, although most of the players do not intend to take up music as a career. They come (212 of them at present) from all corners of the country, mainly during holidays, for intensive training and rehearsal under leading professional teachers, and for concert-giving. NYO was the first national youth orchestra in the world, and its example has been followed in many countries. It now receives a grant from the Arts Council (as does its drama counterpart, the National Youth Theatre), but it would not have survived its early days without sponsorship by the *Daily Mirror*.

Amateur music is a term covering so much variety and so much activity that justice cannot be done to its importance within the scope of this short review. Pop groups, folk guitar classes, music of our ethnic minorities in Britain,* local competitive music, dance and drama festivals, many excellent choirs and choral societies, amateur operatic societies and orchestras – these constitute a national asset of incalculable value. In the past little central public financial support has been given to any of these activities, though local authorities have been helpful to many of them. RAAs have tended to ignore amateur music unless it involves the introduction of professional 'stiffening' for an orchestra or a concert. But they are well placed to seek ways of actively encouraging and stimulating amateurs. At present few RAAs have any sizeable amateur representation on their music panels. If this fault is corrected, RAAs will at least become aware of the needs to be met as soon as their financial position makes this possible. Meanwhile amateurs must continue to look to their local authority for aid in the first instance.

Opera
To some critics opera is an artificial and old-fashioned art form that has no right to survive at the expense of work in other arts fields that relate more directly to the life of the community today. Others see opera as a supreme art form, a synthesis of theatre and music that can produce great beauty. They maintain that opera is not a museum art, but is rapidly developing in exciting ways that are as different from

* The position of Ethnic Minority Arts in Britain is described in *The Arts Britain Ignores* by Naseem Khan, published 1976 by the Community Relations Commission, Calouste Gulbenkian Foundation and the Arts Council of Great Britain.

traditional romantic opera as modern music or theatre from their nineteenth-century counterparts.

The staging and re-interpretation of the traditional repertoire, however, is an essential part of our cultural heritage. It attracts an increasing audience both in London and in the regions. Though it is highly expensive, calling for large casts and orchestras, most people would agree that we must preserve and cherish the companies we now have in Britain if we can possibly afford it. The Arts Council's grant-aid to the Royal Opera House Covent Garden in 1974/75 was £2,650,000 (and this included the grant in respect of the Royal Ballet). The English National Opera received £1,411,000 from the Arts Council (and £375,000 from the GLC), the English Opera Group £188,000 and the Arts Council also gave £538,010 to 16 other groups and companies in England (including Scottish Opera and Welsh National Opera when on tour in England). The Welsh Arts Council gave the Welsh National Opera a further £600,000 for its activities in the principality, and the Scottish Arts Council gave Scottish Opera £447,000 for its work in Scotland. This amounts in all to about one-quarter of the Arts Council's expenditure on the arts. As the Council's funds have risen over recent years, the proportion of total funds given to the Opera House, the English National Opera and the other major national companies in the other arts has fallen. The amounts quoted for the major companies may seem large, but are economical in comparison to the subsidies required to operate major opera houses in other countries. For example: in 1971 (the latest comparison available), and at 1971 exchange rates, the subsidy given to L'Opéra in Paris was £2·41m; La Scala, Milan, received £4·50m; Deutsche Oper, Berlin, £3·34m; Beyersche Staatsoper, Munich, £2·51m; Opernhaus, Hamburg, £3·0m; Staatsoper, Vienna, £3·56m. In that year the Royal Opera House, Covent Garden, received £1·64m and the differential today is reported to be in about the same proportion. Both the Royal Opera and English National Opera earn a much greater percentage of their income at the box-office than do the majority of foreign opera houses.

Critics ask if the costs of operation of the major companies cannot be reduced. The Arts Council commissioned a report by a firm of management consultants in 1970, to look into the operations of the major national arts companies and to make recommendations. Recommendations were indeed made and implemented, but on the whole the companies were found to be running their affairs economically. Since then, economic pressures on the companies have forced

them to cut staff and services to the minimum, and notwithstanding the seemingly large grants standards of production are now threatened. Opera companies on the large scale cannot be run at all below a certain level, and this in the opinion of the companies has now been reached. Large deficits had to be incurred in 1974/75, which were met by a supplementary grant-in-aid by the Government to the Arts Council.

The suggestion that the major companies and their financing and attendant problems should be a matter for the Government rather than the Arts Council has already been discussed (see p. 121). Despite the large scale of operation of the companies, the link through the Arts Council to the other arts organisations is valuable, and questions such as company touring can only be answered sensibly if a body like the Arts Council is dealing with them all. Indeed, dealing with the affairs of national companies is a natural and proper role for the Council.

The Royal Opera does not tour in Britain. The reasons given include the lack of proper facilities in regional theatres, the unwillingness of international artists to perform outside London, the extra costs that would be incurred, and the fact that stage sizes are so different from those at Covent Garden that productions would have to be altered and standards would suffer. To these arguments some critics reply that there is no reason why certain productions should not be mounted with the specific intention of touring them and therefore be designed for performance on No. 1 tour stages *and*, with necessary adaptations, at Covent Garden. No-one, however, can deny that some of the regional tour theatres *must* be improved so that they can take a big orchestra in their pits and provide good stage facilities, good dressing-room accommodation, and good sight and sound for the audience. The costs involved in this capital improvement programme must be met if we are to establish a circuit of theatres in the main regional centres that can take medium-scale if not large-scale opera and ballet. These costs must fall mainly on the local authorities. If they are met, the Royal Opera would need increased support before it could take on touring commitments, and this money should be found by a specific touring grant from the Arts Council.

The English National Opera, unlike national opera companies on the Continent, already undertakes a commendable amount of touring from its base in London at the Coliseum. It performs in English and does not rely on international stars from overseas. Its touring commitments date back to its days at Sadler's Wells and its incorporation of the Carl Rosa company, and form a cornerstone of its policy. When the

main company splits into two touring companies, the Coliseum Theatre becomes available for those visiting companies from abroad which need a theatre larger than Sadler's Wells.

Scottish Opera is subsidised by the Scottish Arts Council and based in Glasgow. Most of its work is in Scotland, but it tours extensively in the North of England (and sometimes further south), receiving from the Arts Council of Great Britain, as was noted above, an extra grant for these visits.

The Welsh National Opera and Drama Company (WNOD) is based in Cardiff, but tours in England in the same way as Scottish Opera. Apart from its major opera productions it also organises and promotes in Wales orchestral concerts and recitals. Unlike Scottish Opera, which has now acquired the Theatre Royal in Glasgow, the company has no theatre or concert-hall of its own. It employs, however, on a full-time basis a chorus of 42 and an orchestra of 51 (the Welsh Philharmonia), in addition to contract artists, technicians and management. Of its 26 playing weeks a year, one-half is spent in Wales and one-half in England. This benefit to England has now been recognised financially so that in future the company will receive one-half of its subsidy for opera from the Welsh Arts Council and one-half from the Arts Council of Great Britain (through DALTA). Without a large base-theatre of its own, and with a responsibility to provide opera, theatre and music for a large and sparsely populated country, the company is bound to require a larger proportion of subsidy to costs than do London-based companies. Grants provided 78% of income for the WNOD in 1974/75. The total expenditure of the company was just under £1m.

Glyndebourne, founded by the late John Christie and now managed by his son, is a unique example of successful private patronage in post-war Britain. The seasons of international opera at this marvellous miniature opera house in Sussex continue to be provided at a very high standard to full houses and at no public cost. The difference between box-office receipts and costs is made up from business sponsorship and private donations. One area of the operation does now receive subsidy (£93,000 from the Arts Council in 1974/75), the Glyndebourne Touring Opera. This company takes medium-scale works to many No. 1 and No. 2 tour theatres, and has the special value of giving promising young singers the opportunity to play important roles.

The English Opera Group has for many years been closely associated with Benjamin Britten, Peter Pears and the Aldeburgh Festival. It has

also regularly undertaken tours in recent years, as well as giving a short season in London. The works have been either chamber-scale or specifically modern, and it has provided more varied opera diet than the regions could enjoy if they received tours by the larger companies alone. In 1974/75, the group received an Arts Council grant of £188,000. In future the company (renamed English Music Theatre) will operate on a larger scale, continuing to commission new works but with a new emphasis on the development of 'music theatre' in Britain. The present economic stringency places these plans in some jeopardy, but the company has had a close relationship in recent years with the Royal Opera House, which gives it valuable administrative assistance.

The D'Oyly Carte Opera Company occupies a special position in English affections and is solely concerned with the presentation of the Gilbert and Sullivan operettas. It gives seasons in London and tours extensively. It has a nationwide following and, until recently, financial strength derived from copyright. Thanks also to the lower costs of mounting operetta rather than large-scale works, it has so far flourished without needing to call on public subsidy.

Kent Opera, as its name implies, is a regional company that now extends its tours to most of South East England. It works for limited seasons each year, and plays in a variety of halls and theatres some of which are by no means well-suited to opera. Nevertheless it has built up a strong following as a result of its high standards of production and performance. It receives an Arts Council grant of £31,000 (1974/75) and is well placed to extend its operations if more money can be found to help it.

Phoenix Opera also presents medium-scale opera and tours throughout England and sometimes abroad. Until recently it received a substantial grant from the Arts Council (£78,000 in 1973/74) and toured in Europe with British Council assistance in 1974; but this patronage has now ceased, the Arts Council being no longer satisfied with the company's work. Much acrimony resulted from this drastic change, but the Arts Council has stood its ground.

The Arts Council itself provides for a small-scale opera touring group in England, 'Opera for All'. The company is administered for the Council by the London Opera Centre. Performances are staged with small casts and minimal (though thoroughly professional) scenery and lighting, and take place in school halls and community centres in small towns and villages distant from any major town that receives tours by larger companies. Opera for All used to be a large organisation

with three companies, but its scale has recently been reduced. To present opera with only piano accompaniment is a hazardous venture and touring on this scale makes formidable demands on the performers, for without regular opportunities to vary their work by playing in London or in larger theatres standards are bound to suffer. Nevertheless the loss of this unit would be a blow to many isolated parts of England which have come to look forward to a visit by Opera for All as a most welcome event. Similar modest units operate in Scotland and Wales under the wing of their respective national opera companies, and these have been, in the opinion of some critics, more successful. The Scottish and Welsh units operate virtually without subsidy, though they benefit from services provided by their parent companies (the English unit cost the Arts Council a net £40,000 in 1974/75).

The total call of opera on public funds is not shown by Arts Council grants alone; a local authority will often make a special grant to its local theatre trust in support of a visit by one of the companies, or it may recognise the net costs of such presentations when settling what annual subsidy to pay the trust. When a company visits a theatre, a complicated financial arrangement is made which guarantees the company its basic costs and shares with the theatre management any box-office takings above that figure. Owing to the high costs of opera and ballet, this basic figure (even when account has been taken of Arts Council grant) is seldom exceeded by box-office takings. Even with full houses the theatre management is likely to suffer a loss. If it puts up seat prices, it may not achieve full houses, and in any case may deter young people and the less-well-off. (These considerations have already been mentioned on p. 68).

Arts Council grants to companies in aid of touring are channelled through its touring department (DALTA), which co-ordinates bookings and tours, assists with publicity and provides other similar services. In this work DALTA has established close relations with local authorities, festival organisations and theatre managements.

There are some other producing companies (most of them operating on a seasonal basis) which the Arts Council assists: New Opera, which specialises in first performances or works new to Britain, the Handel Opera Society, Basilica Productions (tours to No. 2 tour theatres), and several smaller groups.

Of many amateur operatic societies, some are ambitious, undertaking full-scale productions of the largest operas and often engaging professional orchestral players, professional conductors and professional

producers. Such a society as Northern Opera, for example, will book the local touring theatre and fill it (on both sides of the curtain) for a week quite easily. Most of the costs of such enterprise are recovered at the box-office but local authorities are usually generous in letting their theatre for such purposes at a less than economic rent. Regional arts associations may contribute to the professional costs of the productions or help, through their Travel Subsidy Scheme, to pay travel costs for parties travelling to the theatre.

Readers will be familiar with more modest local societies in all parts of England and Wales which often achieve high standards.

There have been discussions in recent years about the desirability of setting up a professional regional opera company in Manchester and building a new opera house for it (or adapting an existing theatre). This is a splendid idea, but to create and support a new company would cost more money in both capital and revenue terms than is likely to be found in the near future. Higher priority should be given to the radical adaptation of existing buildings in Manchester, and in two or three other major centres, where Covent Garden and other existing opera company productions could be performed without the crippling handicap of inadequate performance space. Meanwhile tours will continue to be the chief means of providing opera in the regions, supplemented by more programme time for opera on radio and television. Whatever results from the present discussions on devolution for Scotland and Wales, it is vital that the provision for opera be treated on a United Kingdom basis so that the most effective use can be made of the major companies away from their home base.

Dance
The pattern of provision for dance in England and Wales is not dissimilar from that for opera. It is based on a few companies that set national standards, on one or two regionally based companies, and on touring. The Arts Council grant to the Royal Opera House at Covent Garden includes an element for the Royal Ballet, which operates two companies. The main company works at Covent Garden, and sometimes tours abroad (Korea and Japan in 1974/75). For the same reasons that apply to opera it does not tour in the regions of Britain. But it has appeared experimentally at Battersea Park, London, at Plymouth and at Newcastle, in a giant tent. Enterprising and welcome as that was, the tent cannot become an adequate substitute for good permanent theatres in major regional centres that can house medium to large-

scale opera and ballet performances. Meanwhile, the Royal Ballet's Touring Company appears extensively on tour in Britain – eleven towns and 96 performances in 1974/75 – besides playing for a three-week season that year at Sadler's Wells Theatre, London, and appearing in Athens for a week.

'Ballet for All' receives a separate Arts Council grant (£40,000 for 1974/75), but is administered and serviced by the Royal Ballet, from which it draws its dancers. This section of the Royal Ballet is now in its twelfth season, and continues to tour small-scale productions of high quality to many towns and villages throughout England and Wales (69 in 1974/75). About half of the 209 performances were one-night or two-night stands, but the company also plays in selected towns for up to a week. Programmes are specially devised for this company, so that it can present work that is both excellent and entertaining. A new production is added to the repertoire each year – except in 1974/75, when economy measures made this impossible.

The Royal Ballet includes new works in its repertoire, but is based on classical technique. The work of the London Festival Ballet is also classical. This company, managed by an independent trust, receives a grant from the Arts Council (£266,000 in 1974/75) and a similar amount from the Greater London Council. It gives London seasons (at the London Coliseum, the New Victoria Theatre, the Royal Festival Hall), and tours widely. Most of its productions are the big classical works, but it has also successfully commissioned a few new ones. Apart from offices in London, the company has hitherto had no base which could serve as rehearsal studios, workshops and store, but it has now obtained suitable premises and special grants from the Arts Council and GLC to assist it in the move.

Ballet Rambert is also managed by a trust. Before the mid-1960s its work was classical, but a decision was then taken that it should move, though basing its technique on classical methods, into a modern idiom. Today the company numbers 17 dancers, all of soloist standard, and presents works that have in the main been created for it by choreographers within the company or by commission. The company presents short seasons in London and tours widely. In 1974/75 it received an Arts Council grant of £130,000.

The London Contemporary Dance Theatre is in the hands of a trust which also manages the London Contemporary Dance School and 'The Place', the London base of all the Trust's activities. The company's work is modern (based on the methods of the American artist, Martha

Graham), and it is the leading exponent of this technique in Britain. Performances are given in London (at The Place and at Sadler's Wells Theatre) for short seasons, and taken on tour. In 1974/75 the company received a grant of £101,500 from the Arts Council and £10,000 from the GLC.

Northern Dance Theatre, based in Manchester, serves a wide area of the North of England with small and medium-scale performances. It sometimes tours Wales and Southern England. Its work is modern in idiom but based on classical technique. The company numbers 18 dancers and has its own offices, rehearsal studios, workshops and store. In Manchester it usually performs at the theatre of the Royal Northern College of Music and, when on tour, in large, medium and small theatres, school halls and other places, some of which are quite unsuitable both for artists and audiences. The Arts Council grant to the company in 1974/75 was £81,500; it received £53,000 from Greater Manchester Council, £1,000 from Lancashire County Council, £600 from Cheshire County Council, and useful sums from other local authorities and from Northern Arts. At the time of writing, the possibility is under discussion of amalgamating Northern Dance Theatre with the Royal Ballet's Touring Company, and basing the new company, which would be closely linked with Covent Garden, in Manchester. Clearly there is much to commend this idea, but it is important that small-scale touring throughout the North shall not fall victim to the demands of a larger company.

The Welsh Dance Theatre has operated for three years. It was modern in its technique and international in composition. It received a grant (of £25,000 in 1974/75) from the Welsh Arts Council, and substantial facilities from the University College Cardiff's Sherman Theatre where it was based. The company toured the Welsh circuit of theatres, and in addition to performances, took 'workshops' and demonstration sessions; it also toured occasionally in England. It was a courageous step to found a contemporary dance company in Wales, but a combination of factors, financial and organisational, forced the company to cease operations in early 1976.

Scottish Ballet is a classically based company, supported by the Scottish Arts Council. Its occasional tours across the border receive an extra grant from the Arts Council of Great Britain (£11,500 in 1974/75).

The major touring work of the dance companies in England is co-ordinated by DALTA, the Arts Council's touring department.

A few smaller dance companies have now been established and most of them receive small grants from the Arts Council. Examples are Sephiroth (£100) and Another Dance Group (£465). Many of these groups have been founded by graduates of the London School of Contemporary Dance who wish to explore choreographic ideas in small ensembles. Groups tend to come together for short seasons and then disband for lack of money – and perhaps also for lack of a consistent aim. Strider, which did for a time have a consistent policy, received £10,000 in 1974/75 but is now dormant. Most of the groups appear in London's experimental and studio theatres and arts centres, and they tour to universities and arts centres in the regions.

Education Dance-Drama Theatre is a permanent company based in London, which tours throughout Britain, and is developing the concept of 'dance-in-education'. It received £8,100 from the Arts Council in 1974/75.

Moving Being is a mixed media company which includes a substantial element of dance in its work. It is based at the enterprising Chapter Arts Centre in Cardiff but takes its productions on tour throughout Britain. It received a grant of £25,500 from the Welsh Arts Council in 1974/75.

There are signs that some more permanent groups may be set up, either by RAAs or with their assistance. Southern Arts, who wished to set up such a company two years ago, could not afford it. East Midlands Arts Association has recently appointed a regional dance director.

Apart from the London School of Contemporary Dance, the major training institutions in Britain for the professional dancer are the Royal Ballet School, the Rambert School, and the Dance Centre. There are numerous schools and tutors for younger children, who may or may not go on to enter the profession. Training for dance is the subject of a separate Gulbenkian Foundation enquiry under the chairmanship of Mr Peter Brinson.

In addition to the professional dance companies already mentioned, strong traditions of folk-dancing continue to flourish in various regions. Rapper dancing, clog dancing, Morris dancing, are all popular in England, and folk-dancing in Wales. The amateur folk-dancer has opportunities to display his skill at some festivals and eisteddfodau, but otherwise amateur dance gets little support from public funds.

Though most of Britain's universities have music departments and many of them drama departments, no university has yet established a dance department. However, some universities, polytechnics and other

colleges are increasingly interested in dance; modern dance techniques in particular have caught the imagination of many students and young people. Dance, in fact, expecially modern dance, is an art form of great promise at the present time.

In dance, as in opera, the Arts Council of Great Britain must continue to have general responsibility for the whole United Kingdom; one body is needed to influence development, encourage interchange of skills and experience between companies and co-ordinate their touring. One area that specially needs development is choreography. Here the Gulbenkian Foundation in recent years has taken various significant initiatives to raise British standards. It has encouraged companies to commission new works, given awards to young choreographers (and to designers and composers entering this field), supported such groups as Strider, made grants to aid the teaching of choreography and instituted in 1975 the National Choreographic Summer School. This School, under the direction of Glen Tetley, enabled sixteen young choreographers and composers to meet for a fortnight and receive tuition from distinguished teachers. It will take place again in 1976, this time directed by Norman Morrice, with Arts Council bursaries assisting its finances. Here is a good example of successful pioneering by a foundation which promises continuing improvement in artistic standards if it is followed up and carried further by the Arts Council.

Fine art
I use this term to include painting, sculpture, drawing and allied art forms (printmaking, etc.), photography, 'concept art', 'performance art' and some types of film-making ('artist films' and films about art). Crafts are considered separately (see pp. 165-168).

Britain has a high international reputation in this field. We have our historic schools of landscape and portrait painters. Moore, Hepworth, Nicholson, Hockney, Riley, Denny, Phillips and many other of our modern artists are world figures. The visual artist normally works alone, and by their very nature the visual arts are different in both kind and degree from the performing arts: the questions raised by them are how to foster individual creativity and how to bring the results before the public. There are peculiar difficulties in the solution of such problems because there are few institutions through which the needs of artists can be identified and met. But the visual arts escape some of the economic problems which performing arts must solve in bringing numbers of people together for a play or symphony.

Art is taught in most schools as part of the curriculum. At primary level the accent is on self-expression and little attempt is made to impart technique. In secondary schools there is a much greater concentration on technique, but art classes do not occupy many hours a week because most of the timetable is required for 'serious' subjects in which the pupils will be examined in due course. There is little attempt to treat art as essential to our understanding of the world about us. Nor is there usually much effort to pick out the really gifted child in order to develop talent from an early age. Nevertheless, a substantial number of students wish to go on either to part-time or to full-time training in art schools, colleges or polytechnics.

In 1959 there were 180 local authority art establishments, but only 111 in 1970. Most of this decline is due to the amalgamation of smaller units, and in recent years the process has gone further through the absorption of many art colleges in polytechnics. During this period total student numbers dropped from 130,000 to 100,000, but the reduction was in part-time students only: full-time student numbers went up (in line with the general population increase) to about 30,000. The costs of these establishments (except the Royal College of Art) and support for the majority of students is met by local authorities. Though there are still a few private art academies, such as the Royal Academy Schools, almost all art education in Britain is now state art education.

Over the past 15 years art colleges have moved away from the tradi-tional education pattern. The tendency has been to treat each student on an individual basis and give him separate attention. Staff/student ratios have been high, a fair proportion of the teachers being practising artists who teach part-time. This system has obvious advantages for the art student – and for the artist/teachers, both in income and in variety of work. However, during the last three years art colleges have been encouraged to cut down the number of part-time teachers, to the dis-may both of the students and the artists. It is too soon to judge what effect on art education these changes and the absorption of art colleges in polytechnics have had.

Until recently art courses did not usually lead to an examination but to a 'Diploma in Art and Design' awarded by each college whose courses were approved by the National Council for Diplomas in Art and Design (NCDAD). Students produced works which appeared in diploma exhibitions but their quality was also judged by continuous assessment. This pattern is still followed, but the National Council has

now been taken into the Council for National Academic Awards (CNAA), the body concerned with the academic standards of all degree-awarding institutions. Art graduates therefore now receive a degree, and students wishing to enter an art course must now reach the educational standard required for entry to a polytechnic. A loophole is left by which some talented art students are not excluded for want of academic ability, but much disquiet remains about the narrowed range of opportunity.

Few of the art courses make any serious attempt to prepare students for life as an artist. Some of the most serious problems facing artists when they emerge from training are these: how to find and pay for studio space and meet the cost of materials and equipment; how to publicise their work and interest galleries in it; understanding how commercial galleries operate and what arrangement should be sought between artist and gallery; how to find part-time teaching work; the position of a self-employed person for income tax and national insurance purposes.

Few artists are taught at college about the patronage structure on which many of them will rely for help, or about rights to public assistance. More serious is the absence of an advisory service about career prospects for the professional artist, comparable to that offered students by the appointments service of a university. There would be great national gain if talented artists and designers, trained at national expense, could be attracted into employment by British industry and commerce. But this will not happen on the desired scale unless new efforts are made both by employers and by art training institutions to encourage artists to choose such careers.

Many of the problems facing the artist are aspects of one basic problem: he does not earn enough from sale of work to make a living. The market for modern art is not a large one either in Britain or internationally. Some well-known artists can ask high prices for their works but the great majority cannot. There is no convincing evidence about the earnings of the visual artist, but the available statistics show that a majority live at a level lower than the national average and many near the level of poverty. Earnings from sale of work constitute only a small part of their income, and this is supplemented, if possible, by teaching, by manual labour or by other work unrelated to their training. Unemployment and supplementary benefits are often drawn on.

We need much more information about the artist's present economic

state and about other factors which affect the question whether the places available for training artists in Britain should be increased or reduced.

It is outside the scope of my Report to comment on the artist/ designer in industry or on the role of the Design Council. These subjects, however, are of great, and not irrelevant, importance. It seems clear that in present circumstances the artist is isolated from wide areas of activity in which his special talents are badly needed and could do much to improve our economic prospects as a nation.

The Arts Council spends about £1m (1974/75) on the visual arts. Of this, about £150,000 is spent in operating the Hayward and Serpentine Galleries; about £400,000 on exhibitions; £60,000 net on art films and film tours; and £360,000 on grants and guarantees (of which £42,000 are in the form of awards to artists).

The Hayward Gallery belongs to the GLC and forms part of the South Bank arts complex, but is managed for the GLC by the Arts Council. Opened in 1968, it is used for a variety of exhibitions, usually but not exclusively of modern work, which the Arts Council either itself arranges or imports from abroad. The Serpentine Gallery in Kensington Gardens, formerly a tea-house, was opened as a gallery under Arts Council management in 1970. It shows works by modern artists, with an emphasis on the younger generation and those who have not yet achieved wide recognition.

The Arts Council mounts about 25 exhibitions a year, many of which tour provincial galleries and arts centres. This is one part of the touring work of CEMA that the Arts Council has kept and expanded. The other source of exhibitions available for loan outside London is the Victoria and Albert Museum. In London, large-scale exhibitions are presented by the Tate Gallery, Royal Academy, Whitechapel Art Gallery, British Museum, Institute of Contemporary Arts and many other public and private galleries. Major exhibitions are arranged by museums and galleries in the provinces, such as the Laing Art Gallery in Newcastle-upon-Tyne, the Walker Art Gallery in Liverpool, Manchester City Art Gallery, the Whitworth Art Gallery; and also by specifically 'modern' centres such as the Museum of Modern Art in Oxford, the Arnolfini Arts Centre in Bristol, the Midland Group Gallery in Nottingham and Sunderland Arts Centre. Some of the Area Museum and Art Gallery Services arrange small touring exhibitions, and so do some regional arts associations – sometimes without adequate co-ordination.

In England the Arts Council gives grants in aid of some 60 of these galleries and exhibition bodies, to support special parts of their work. The Welsh Arts Council makes similar grants in Wales, and itself mounts and tours exhibitions.

The Arts Council has its own representative collection of modern British art and spends about £25,000 a year on acquisitions. When not in touring exhibitions, the works are loaned to galleries, universities and the like. Some help to enable provincial museums and galleries to acquire works for their own collections is given from a small fund administered by the Victoria and Albert Museum. The Arts Council helps to commission works of art for public buildings. It also makes some grants through its Housing-the-Arts Fund for gallery improvements, but solely for the limited purpose of housing temporary exhibitions.

The Council helps a wide variety of organisations to meet their running costs. Examples are the Arnolfini Arts Centre, the Ikon Gallery in Birmingham, the Photographers' Gallery, the Art Information Registry (AIR), and SPACE. The last two are linked organisations, operated by artists for artists. AIR keeps a register of artists' work, in the form of slides and other information, with the aim of covering comprehensively the work of living British artists. This 'bank' is useful in a variety of ways to artists, scholars and the public. SPACE acquires the lease of warehouses and other buildings, converts them into studios and lets them to artists at an uncommercial rent. These bodies share office premises (and a gallery) in central London. Another organisation of similar kind to SPACE is Acme Housing Association. Experience gained from this work in London is now being used and taken forward in some regions.

Art films are made by the Arts Council and fall into two categories: films about art and films made by artists as works of art. Both programmes have achieved much on a small budget in past years, the films winning many international awards and being shown on television. In Britain these films are available for hire and they are also distributed abroad. One of their uses is in film tours: an Arts Council van arrives at a local hall complete with films, projector, screen and projectionist. Until recently *art* films were the only film work done by the Arts Council, in close contact at officer level with the British Film Institute to avoid duplication. But the Council has now decided to extend film work to cover *all* its departments, its Film Committee reporting in future not to the Art Panel but direct to the Council.

Bursaries and awards to individual artists are offered by the Arts Council, the Welsh Arts Council, the Gulbenkian Foundation, and (on a smaller scale) by other trusts and some regional arts associations. Most of the smaller awards are intended to help an artist with specific costs such as for framing works for an exhibition. Only the Gulbenkian awards and a few from the Arts Council are in excess of £1,000 a year: these enable an artist to concentrate on work that will exploit his talents.

The British Council organises exhibitions of British art abroad and is a valuable ambassador for British artists. It owns a good and growing collection of modern British art. Some trusts and foundations (Gulbenkian, Stuyvesant) also have valuable collections of their own. RAAs have begun to purchase modern work connected with their regions, and one or two of them have small galleries too. They spend no large proportion of their budgets on the visual arts but some of their officers are very active in the field, offering useful advice as well as grants to regional galleries and artists.

Photography has now become firmly accepted as an art form, and there are several photographic galleries not only in London but in Southampton and York. Many of the arts centres and art galleries also show photographic exhibitions and there are many very active photographic societies throughout the country. A special stimulus to the recognition of photography has come in recent years from the National Portrait Gallery.

Local authorities play a major part in the field of visual arts. They own and manage many of our museums, galleries and arts centres, and they grant-aid many others. One Government after another over the years has lamentably failed to find national resources for provincial museums or ensure that minimum standards are achieved locally. In consequence there has been gross neglect in many places. But some local authorities have not allowed this to prevent their achieving notable results – for example, Temple Newsam at Leeds.

Magazines and journals are particularly important to the fine arts. But costs of producing good reproductions even in black-and-white are high and the market is not large. An excellent periodical such as *Studio International* sells, therefore, at a price which must deter the majority of potential readers. Although there are a few other good magazines at rather cheaper prices, a strange lack of enterprise is apparent in this field.

Amateur painters and sculptors are legion, and evening classes in these subjects are very popular. But there is a wide gap between the

type of work done by most amateurs and that of the professional artist (not only in quality of execution), and it goes deeper than that between the concert-goer and the composer of contemporary music.

Most of the public money that supports the visual arts goes towards the costs of exhibitions and galleries. This is inevitable. The heritage of the past must be conserved and made available for our enjoyment, and living artists must have the opportunity to show their work. But the provision of exhibition space is by itself not enough. Various expedients are therefore being tried in the hope of fostering creative talent. Among these are bursaries and awards to individual artists. But how should these individuals be chosen? Artists who are not chosen naturally believe that, whether traditional or avant garde, their work has been mis-judged by critics incapable of sympathy with their intentions. This has no doubt always happened, but for the public patron the problem is particularly acute, when, as at present, there is no widespread con-sensus about standards in any visual art.

One of the ways in which artists are helped is by appointing them 'artists-in-residence'. Some universities and colleges have made such appointments, not only of visual artists but of musicians, writers or dramatists. The chosen artist takes up residence at the institution and is given facilities to do his work and involve staff and students in it. He may have a specific function (a musician, for example, to coach the student orchestra) but in any case he makes himself 'available'. The Arts Council has supported residencies, as has the Gulbenkian Founda-tion; the Gregory Fellowships are similar. Recently this concept has been developed by placing artists in less academic situations: for example in secondary schools and community colleges (Gulbenkian Foundation), a hospital (Scottish Arts Council), a town (Scottish Arts Council and several new town development corporations), factories, offices and industry (Artists' Placement Group). Several artists have also been appointed by RAAs: a photographer by Northern Arts (in conjunction with Northern Gas); a composer by Southern Arts. And RAAs have often helped other bodies to make such appointments.

Some of these appointments have been an undoubted success. The artist does his own work. He is in contact with his public, and that public with an artist of flesh and blood. The host institution is subtly enriched. But other appointments have been failures. The artist has not understood the nature of the job or known how to tackle it; and he has had little guidance from the host institution or the subsidising body. He has felt lost and isolated. Experience suggests that two years are the

minimum time for such a post and three years are preferable; that the aim of the appointment must at the outset be clear to all concerned and that some means of continuous assessment must be found. Further, the community in which the artist works must not be too large and must be directly involved in the appointment from the start.

A rather similar scheme to 'residencies' is that operated in America (in New York State) by the Creative Artists Public Service (CAPS) programme. This was pioneered jointly by the New York City Cultural Council Foundation and the New York State Council on the Arts but is now an independent grant-aided organisation. Creative artists in 12 fields (painting, graphics, sculpture, choreography, music composition, playwriting, fiction, poetry, video, film, photography and multi-media) may apply for grants (which range in scale according to the art from £1,500 to £5,000) for the completion of some piece of work or for the creation of a new work within the following year. The applicant must be a professional artist resident in the State. Panels of artists make the selection 'on the basis of artistic excellence'. The successful applicant is obliged, in return for the money, to carry out 'public service projects' – such as that of artist-in-residence, leading a workshop, exhibiting or performing work in communities within the State. As only one-fifth of the award is set aside to pay the artist for this work, it seems from the daily scale of fees that artists need not do more than a week's 'public service' work in the course of the year. CAPS continues to publicise the work of artists and their availability when their award year is over. Nor is financial need considered in selecting applicants. In the first year 704 artists applied for an award. After four years, annual applications were at a level in excess of 5,700 (and the scheme needed a large staff), but only 178 awards could be afforded. The purpose of this interesting scheme is not so much to channel aid to artists as to bring talented artists into contact with the public.

An idea developed in several European countries (Sweden and Holland, for example) is that all public buildings should have some $1\frac{1}{2}\%$ of their initial cost spent on the work of artists. Thus government office blocks, embassies, universities, schools, nurseries, hospitals and town halls come to be decorated with sculpture, murals and the like. Each municipality has a committee, largely composed of artists or art specialists, to advise on such commissions.

In Holland a more radical idea is also followed. The Ministry of Social Affairs recognises the special employment problem of the artist

and, in place of unemployment benefit, deliberately widens the market for new works of art.

The scheme was pioneered by Amsterdam municipality in 1949 and was intended only to offer temporary help. It has now become a permanent scheme for the state purchase of new works of art. The artists' unions have been vigorous campaigners for its retention and expansion. About 1,200 visual artists in Holland benefit from the scheme, on which the state spends some £5½m annually.

Each province has a committee composed of artists, artists' union representatives (together constituting 50% of the committee members) and Ministry nominees. The committee decides whether or not to admit a particular artist to the scheme: an applicant must have been trained at an art college and have worked as a professional artist for at least two or three years; his quality as an artist and personal circumstances must be examined. Once admitted to the scheme, his needs are assessed (studio costs, materials, etc.) and account taken of dependants. He is free to sell work to the committee at agreed prices, payment being made in instalments which in effect constitute a salary. He will also receive 100% of his studio costs, two-thirds of his social security payments and a generous allowance for materials. An artist can thus earn an income only slightly lower than the average national wage.

Half the works bought by a regional committee are kept within the province, half go to a national collection. They are shown in touring and other exhibitions, or offered on free loan to schools, hospitals, colleges, galleries and government buildings. Even so, there is a long waiting-list of expectant borrowers.

The scheme is regarded as an employment one, not as arts patronage. No artist can claim its benefit as a right. The state acquires works of art, some of which no doubt appreciate in value, in return for what it spends. And part of what is spent would otherwise have gone in unemployment benefit to artists.

Holland also has a scheme whereby the private individual may buy the works of living Dutch artists at a reduced price from certain galleries. Provided these galleries exhibit modern works as a consistent policy, they can receive the price reduction as a state grant. There is also an Artist Provident Fund (introduced in 1936), which benefits all kinds of artist and is funded by the artist (16%), his municipality (34%) and the state (50%). Finally, Holland has a sculpture materials fund which makes interest-free loans to sculptors, covering capital outlay at the start of a work and repayable only when the work is sold.

Museums and Galleries

Many museums play an important part in preserving and displaying our cultural heritage. The ways in which this can be done are, at their best, exciting, educational and entertaining. At their worst they can be boring, confusing and depressing. We came across a wide variety of museums.

Only a small percentage of the country's 950 museums deal exclusively with art: most are devoted to local history, or to particular subjects which have local relevance: industry, crafts, archaeology, natural history, geology, and so on. London has the major national museums, but there are some collections of national importance in the provinces. One-third of our museums in 1973 had no full-time curatorial or technical staff. Only 48 of them had more than 10 full-time curatorial or technical staff. In 1970/71 only 55 of the 236 local authorities running museums in England and Wales spent on them more than £20,000. The total local authority net expenditure on their 468 museums was £5·85m in 1970/71, or less than 10p a head of population compared with 19p for the youth service, 20p for swimming baths and 50p for parks and open spaces. In the same year £14m was spent on the ten national museums in London and the National Museum of Wales in Cardiff. (Figures from the Wright Report.)

The majority of the important national institutions are independent bodies controlled by boards of trustees. Though there are some independent trust museums in the provinces, most provincial museums are controlled by local authorities. A few, mostly small, museums are private property. There is no legal obligation on local authorities or others to provide an adequate museum service. No direct central government financial aid is available to help local authorities in running or expanding their museum buildings (national institutions get direct grant-aid from the Department of Education and Science). There is no Museums Council to complement the work which the Arts Council undertakes for the arts generally.

On pp. 80-83 of this report we outlined briefly the work of the Area Museums Councils and the Standing Commission on Museums and Galleries, and referred to the recommendations of the Wright Report. The Standing Commission has established a working party on a 'National Plan for Museums' and is expected to report shortly. It is at present collecting evidence and views which will enable it to put forward suggestions about the establishment of a regional network of museums services, probably based on the country's most important

collections. In effect, this would mean a concentration on 'centres of excellence' and a reshaping of the Area Councils.

Since local government reorganisation, in some counties (such as Norfolk) county and district councils have come to an agreement about their museum and gallery functions, thus forming a new unified museum service for the whole area. This has obvious advantages. The various museums in the county can be related to each other, and a comprehensive development plan drawn up; conservation, publicity, transport and administrative support can be treated as common services. Such co-ordination also creates new opportunities for links with the education service.

All the local authorities we met who had museums or galleries felt the acute lack of central government help to enable them to improve or extend their museum buildings. Many provincial museums were built in the last century. By the early years of this century over 300 had been set up. Much needs to be done to improve these buildings and to remove the fusty Victorian atmosphere that many of them have. No less urgently they need to be equipped with proper air-conditioning, humidity and light control so that their contents do not deteriorate. Although the Area Museums Councils advise on conservation matters, the problem of arresting the deterioration of collections and then selectively restoring them is an immense one before which successive Governments have wilted. Nothing of any substance has been done, despite the recommendations of the 1973 Wright Report, the Gulbenkian Report (*Training in the Conservation of Paintings and Drawings*) and the recent Report of the International Institute of Conservation (UK Group). Though most museum authorities do the best they can, they neither have the resources nor the trained staff. Unless the Government takes swift action, many priceless collections will decay beyond the possibility of repair. Some already have. Unless some help can be given from a new Housing-the-Museums Fund (concentrating at first on centres of excellence) few local authorities can be expected to undertake alone the improvements that are needed to house collections adequately and display them in modern conditions to the public. Central help of this sort can best be channelled through an agency composed of experts in the field, with freedom to take particular decisions within the limits of an agreed policy. As soon as the need for Government funds is recognised the present advisory Standing Commission should be converted into a Museums Council under Royal Charter.

The Area Museums Councils need substantial strengthening, and their functions should be clarified and broadened. The Area Councils seem most at home when dealing with conservation (where some of them now provide useful services, especially for conservation work of medium complexity) and advice on questions of display, etc. If a national Museums Council is set up it should make it a first priority to strengthen Area Councils and encourage them to reach clear understanding with RAAs and County Museum Services as to their respective roles. It should use the Area Councils as its agents for as many purposes as possible.

Views were expressed to us that some regional collections should be subdivided and sent out on tour or loan to schools and other local institutions. But it would usually be wrong to subdivide them. The value of a good collection is greater than that of all the objects it contains, and there would be serious loss if it were broken up and could no longer give enjoyment as a whole.

On the other hand, it would be excellent if a national institution based in London, such as the Tate Gallery, could open a 'filial' museum in, say, the South West or the North East of England and send it a major section of its collections for a few months. Such an arrangement would have advantages over the present system of loaning individual works (usually from the reserve collection only). If well sited, the filial museum would not compete with already existing ones but would add a great enrichment to the regional heritage. Many of our national institutions have more works of the first quality than they have space to show them in. The National Portrait Gallery has given a lead at Montacute.

A few national museums are already actually based in the provinces as is the recently established National Railway Museum at York.

For museum staff, rates of pay, conditions of work and career prospects are much better in the national institutions than in the provincial ones. Naturally, therefore, there is a steady drift of staff towards the nationals and a serious lack of experienced and high-quality staff at senior levels away from London. In local authority institutions there is virtual anarchy, with similar positions under different authorities carrying salaries on quite different scales. There would be great advantage in moving towards an agreed museum-service scale for the whole country, but this is unlikely to happen until a national Museums Council has been established.

Though many local authorities make museum premises available to

local societies for meetings and concerts, this is by no means the general practice. Some curators resist such ideas, and indeed seem reluctant to welcome increasing numbers of visitors for *any* purpose. When the objections of the more old-fashioned curators are overcome, and more money becomes available from national as well as local sources, museums and galleries will become, as could libraries too, centres of wide cultural activity for the neighbourhood.

Most of the above paragraphs apply as much to galleries as to museums, but galleries have some particular aspects that need mention.

Especially in London, there is a large private gallery sector. These 'West End' galleries show a wide variety of works and, along with Sothebys and Christies, form part of the international art market of which London is a major centre. The galleries sell works and exist as profit-making companies. A few of them specialise in the work of younger painters and sculptors and, as the market for these is small, only with difficulty can they make ends meet. These small galleries fulfil an exhibition function no less than a sales one, but as profit-seeking companies they receive no grant-aid. As an exception the Arts Council two years ago gave certain private galleries guarantees against loss on some particular exhibitions. It might be possible in future for the Arts Council to give such guarantee for an occasional exhibition which some trust joined with a private gallery in organising.

Most of the national galleries that house permanent collections are in London: the National Gallery, the National Portrait Gallery, Tate Gallery and so on, the majority of them managed by independent boards of trustees. The Hayward Gallery, owned by the GLC and run by the Arts Council, is now the main centre for temporary exhibitions, but other important temporary exhibitions are held at the Arts Council's Serpentine Gallery, the Whitechapel Art Gallery (run by an independent trust), at the Tate Gallery, the Victoria and Albert Museum, the British Museum, the Royal Academy and at other museums.

Outside London there are not many private galleries and many of the few there are do not rise much above the level of a shop where pictures can be bought.

Funds for new purchases are hard to find. In present circumstances local authorities can offer little for this purpose and most galleries must look to the Purchase Fund administered by the Victoria and Albert Museum. The National Art Collections Fund provides some assistance, as does the Contemporary Art Society, and RAAs can sometimes help

galleries to acquire modern works, particularly by regional painters. However, these funds are quite inadequate in total.

The Arts Council can contribute towards the cost of gallery building or improvements only where the space is to be used for temporary exhibitions, but can also make small grants for purchase of gallery equipment. In general, therefore, the full cost of their galleries has to be borne by local authorities themselves.

Some universities possess museums and galleries of regional and sometimes national importance. This is true not only of Oxford (the Ashmolean) and Cambridge (the Fitzwilliam) but of some younger universities, such as Newcastle-upon-Tyne.

Most arts centres have a gallery and a vigorous exhibition policy (see p. 160).

In brief, the gallery position is less grave than that of the museums. The problems facing the latter are appalling: fifty years of neglect of buildings and collections; a backlog of extension and improvement schemes costed in 1973 at £22m; lack of staff; poor conservation facilities and no national body charged to do more than give advice. One passage from the Wright report sums up the story:

'In 1919 the Commission on Adult Education issued an interim report on Libraries and Museums. The Carnegie United Kingdom Trust commissioned reports on museums and galleries of the British Isles in 1928 and 1938. A major survey of provincial museums and galleries was conducted by the Standing Commission . . . in 1963. . . . It was most disturbing to us to note how similar the main recommendations over this half-century have been to our own and how little has in fact been achieved.'

Literature

The publishing, distribution and sale of books is an expensive business, but neither writing nor reading calls, as music or drama does, for large expenditure on buildings and performers. So long as publishers and booksellers can operate commercially, it is difficult to judge how, or on what scale, the art of literature should receive public patronage. In 1974/75 the Arts Council's literature budget was only some £200,000, nor did the RAAs add much to this. At the same time great help to literature is given by local authorities in the form of the free library service, though no appreciable part of that benefit yet reaches the writer.

Over the last few decades this situation has been changing. Publishers no longer make a profit unless sales of a book are far higher than they

used to be, and there have been steep rises in the price of books in hardback covers. Paperbacks can still be published much more cheaply but they are unsuitable for libraries. Libraries still pay no royalty on the use of books they lend, but legislation has for some time been promised to ensure authors a 'public lending right'. Bookshops are now much fewer in number and carry a much smaller stock of books; several counties scarcely have a single bookshop in them.

Publishers have seldom made much money out of poetry, but some of them regularly undertook poetry publication and offset the costs against profits on fiction. These days such practice cannot normally be followed: publishing profits now come less from works of the imagination than from educational and other such sales.

Very few writers can make their livelihood from literature. Even if what they write can find a publisher, the great majority must supplement their royalties by teaching, broadcasting or journalism.

Writers whose work has not been published cannot expect help in the form of bursaries from public funds, for there can be no yardstick by which to distinguish one applicant from another. But bursaries are of great value to the mature writer, about whose work at least some judgement can be made however difficult to justify, and the Arts Council courageously gave 45 writers a total of £47,800 in 1974/75.

Since a publisher is hard for the new unknown writer to find, literary magazines provide him with a valuable outlet for his poems and short stories. Nationally such magazines are rare, but the *London Magazine* and *The New Review* both receive Arts Council assistance. In the regions there are now dozens of less ambitious journals, published by writers' co-operatives or individuals, and it is not difficult for a writer whose work has merit to get into some kind of print. Many of these magazines are supported by RAAs. *Stand*, though published in Newcastle and supported by Northern Arts, is a national magazine. Small presses are also supported by RAAs and some of them by the Arts Council – they publish books rather than magazines but serve a similarly useful purpose for the writer.

The Arts Council now supports a Fiction Book Society which aims to increase the sales of new fiction. It is a book club which offers to its members good new fiction at a substantial discount.

Other schemes operated by the Arts Council include a National Manuscript Collection, a poetry library, the organising in conjunction with RAAs of tours by writers – to meet the public, give readings and

discuss their work; and similar tours to schools. It publishes a poetry anthology and a short story anthology; through its shop in London, the Arts Council also helps to sell poetry and prose publications. (The Welsh Arts Council and some of the RAAs also have bookshops or sell a selection of regional literature.)

Regional arts associations also give bursaries to writers, aid little presses and magazines, organise and subsidise 'Writers on Tour', and sometimes support a Writer-in-Residence appointment at a university or college. In general it is true to say, though, that RAAs do not spend much on literature and by no means all or even the majority of them have appointed a literature officer – those associations which have made an appointment have usually combined the function with another one (publications, publicity or even administration) which has meant that the officers do not necessarily have a specialist background knowledge of literature. Almost all RAAs have an advisory literature panel, however. Some associations, apart from publishing news-sheets or diaries of arts events in the region, also publish occasional literature journals, or make some space available for prose and poetry in their own newspapers and magazines.

The free public library service in Britain is an enormous cultural and educational facility. The foundations for it were laid by the 1845 Libraries, Museums and Gymnasiums Act, and later Acts have consolidated the position. Much is also owed to Andrew Carnegie, who extended generous help to local authorities when they were establishing libraries. It is tempting to think that public libraries could become not only a source of books for loan, but (in areas otherwise without bookshops) that they could sell books too. Such a step might require legislation but would transform the increasingly grim picture of shortage of book retail outlets into an almost ideal situation.

If such an idea is found to be impractical, it should still be possible perhaps for libraries to publicise new publications and to have order-forms for the public to enable them to order books easily by post.

Libraries are increasingly being used for small exhibitions, for film shows and for meetings and other cultural events. This is something much to be encouraged, and there should clearly be close links between the library service and a local authority's arts and leisure service. Unfortunately this rarely seems to happen as, outside metropolitan areas, the library service is operated by the county, whilst local arts events are the concern of the district. This division would become less of a handicap to the cultural use of libraries if counties were to draw

up an arts development plan in conjunction with districts and their RAA.

In 1974/75 local authorities spent approximately £100m on libraries, and central government spent £19m on national libraries. Thus public subsidies to libraries total nearly twice what we give to the arts as a whole.

The Poetry Society, which prints and publishes the work of poets, publicises poetry, and arranges readings by poets, the London Poetry Secretariat, PEN (a world-wide association of writers founded in 1921 to promote international communication among them), the National Book League, and the Society of Authors – all these bodies do valuable work to promote literature and protect the interests of authors. They all receive Arts Council assistance, but one particular organisation might be mentioned in more detail: the Arvon Foundation. This foundation is a charitable trust which runs two centres (at Totleigh Barton in Devon and Lumb Bank at Heptonstall in West Yorkshire). Week-long and other residential courses are run there for groups and individuals who are interested in practising one of the arts. The main emphasis is on creative writing, but other courses are concerned with music, drama, etc. About fourteen people on each course live together, work together and discuss their work under guidance of two professional artists. Although the courses are short, they succeed in developing individual talents in a remarkable way. Though much of its work is with teenagers, there are courses for adults as well. Arvon is supported by the Arts Council, the Gulbenkian Foundation, RAAs and local education authorities.

Community arts
This is a term which has come into common use only in recent years and there is still much confusion, especially in the minds of local governors, about its meaning. It signifies a special *process* of art activity rather than any special *product* – a process which seeks to involve action by the local population as a whole rather than passive interest of that minority (often estimated at some 5% of total population) which regularly attends performances of serious music, opera, ballet and drama or visits art exhibitions.

Community artists set themselves to stimulate rather than perform. Their profession is to encourage people of all ages and educational backgrounds to take part in arts activities of their own choice. Their conviction is that local people should not only themselves control the

buildings and equipment needed by the arts, but should themselves take the decisions about what is needed and refuse the exclusive role of passive audience. Community artists may be themselves professionally qualified in various art forms; alternatively, they may be full- or part-time 'animateurs' with professional skill in no one art form but in the techniques of stimulating response in others to any of the arts. They all aim at making themselves in the end no longer necessary, as they succeed in stimulating the local people to become their own community artists.

The arts are seen as only one aspect of community development, which should embrace community life in all its forms. Community arts are, therefore, conceived less as arts than as creative social activity.

The Arts Council set up an enquiry into community arts under the Chairmanship of Professor Harold Baldry which reported in 1974 (*Community Arts – The Report of the Community Arts Working Party*). The report recognised that the Arts Council under its charter had a concern to make the arts accessible to a wider public and recommended that although the border-line between community arts and social action was often a difficult one to draw, the Arts Council should set up a new committee to encourage community arts. The Arts Council agreed and in 1975 the committee was established for a two-year experimental period. For the first year the Arts Council was unable to allocate the full sum recommended by the Baldry Report but the experiment continues.

The regional arts associations are working closely with the Arts Council in the experiment, and applications to the Council for aid to community arts projects are first examined by the RAA concerned. Any aid given is often offered jointly by the association and the Council, sometimes with a local authority contribution as well. Community arts are by their very nature local and should therefore concern local authorities. RAAs hope that after the two-year experiment the Arts Council will devolve responsibility for community arts to them and that they in turn will be able to secure increasing interest and financial aid from local authorities.

The Arts Council's help is meanwhile concentrated on selected groups of community artists and on meeting the cost of particular activities. Such concentration is inevitable if the results of the experimental two years are to be seriously assessed. But there remains a fundamental question: what priority should community artists receive in competition for strictly limited public funds? Does their claim rest

chiefly on what they do to increase public participation in the arts rather than to raise standards or seek excellence?

This question of priorities is by its very nature local or regional rather than national. It seems best, therefore, for the Arts Council to devolve support of the community artist to regional arts associations when the experimental two years are over, and for the associations to encourage increasing support for community arts by local government.

Community arts embrace a wide variety of projects of which the common factor is active involvement of local people. Thus they include arts workshops which provide facilities for painting, pottery, and sculpture; encouragement of people to contribute their ideas about the visual improvement of their housing estate, by painting gable-ends, siting sculpture or decorating fly-overs; arts centres where local people themselves engender the activities; the publishing of books, poetry, newspapers by local people about their neighbourhood and for its sake. As illustrations of community artists in action, take the following: Elizabeth Leyh, employed by Milton Keynes New Town Development Corporation as 'Town Artist' to involve the residents in arts activities; the Bath Arts Workshop, where a team of 'animateurs' engage in a wide variety of work for the community; Interaction, perhaps the largest single community service unit in Britain, based in Kentish Town; Telford Community Arts, an arts team which centres its efforts on a housing estate devoid of any other arts facilities, by using video equipment, by play schemes, organising workshops, art groups, etc.

Community artists sharply distinguish themselves from teams of artists seeking a subsidy for their own work as artists. 'Hanging a picture on a wall and inviting people to come and look at it,' said one, 'is the easiest possible thing to do. We're trying something much harder: to tap the creativity in everyone.'

Many community artists approach their work through children, finding in them few preconceptions about what to expect in art and no reluctance to express themselves. But much work is also being done with adults (for example, old-age pensioners) and on housing estates. The Council of Europe has taken a special interest in 'animation' and documented much of the work being done in different countries. It has organised conferences to exchange experience and study the impact of community arts activities. In 1976 there is to be a conference in Britain to discuss the work of arts centres and the like in our new towns.

In Sweden animation seems to be scarcely needed, so large a part of

the population now participates in cultural activity, for which the various Workers Educational Associations provide facilities. The scale of spending on the arts generally, and in particular on arts in further education, is on an incomparably larger scale than here in Britain. The chief weight of support from public funds is brought to bear through further education, and the objective is rather to encourage widespread practice of the arts by amateurs than to seek qualitative excellence as a first priority. (See Appendix 3.)

'Arts Centre' is a more familiar term to most people than is 'community arts', but its meaning is now far from clear. Originally it was used to describe a building under the roof of which activities in more than one art-form took place and people of different interests and backgrounds came into social touch with one another. This still remains the central concept of an arts centre, but nowadays the term is used to cover a wide variety of places – village hall, school hall, art gallery, or even a large theatre; many arts centres present more than one form of art, but have no facilities for practising them; others, where arts are practised in a social setting, can be described as 'community arts centres', of which South Hill Park, Bracknell, and the Brewery Centre, Kendal, are notable examples.

A recent development which is already valuable and has great promise for the future is the Association of Community Artists (ACA). The ACA enables workers in this field to exchange experiences and gives the movement a concerted voice. It has established links with the ethnic minorities arts movement and with the National Association of Arts Centres. It is now compiling a directory of the community arts in Britain.

Further education centres and community colleges come under the aegis of local education authorities. Many of them provide not only classes but excellent opportunities for a wide range of interests, including arts. An outstanding example is Morley College in South London, but many education authorities – Cumbria and Leicestershire, for example – have fine records of achievement in this field. It would be tragic if present economic circumstances were allowed to harm further and adult education work of this kind.

There are strong arguments for now placing a special emphasis on efforts to widen public participation in the arts. Without lowering standards of excellence, we must search out new ways of involving more than 5% of the population in active enjoyment and personal experience of the arts. In particular, we must encourage the artistic

aspects of community development, bridge the existing gap between the arts and adult education and encourage amateurs in *every* section of society.

Film and Video

Here it is hard to be optimistic. Film production in Britain is almost at a standstill. The distributors operate restrictive policies. The closing of cinemas has continued until now there are many quite large towns without one. Most of these problems concern the film industry and I am in no position to bring them within the scope of this report. The latest examination of the subject is that of the working party chaired by John Terry which reported in January 1976: *Future of the British Film Industry* (HMSO, Cmnd. 6372). My concern is only with the support of film as an art. However, the health of the industry determines the health of the art: cinemas show art films as well as entertainment films, but they cannot show either if economic considerations force them to close. Indeed, it is impossible in cinema to distinguish 'art' from 'entertainment': many of the cinema's achievements derive from the very fact that it is a popular art-form. Chaplin, the Keystone Cops, Hollywood musicals, westerns, the gangster films all have as significant a part to play in the serious history of the cinema as have films of the French avant-garde or of the more sophisticated film-makers. Thus the accessibility of cinema is part of the concern of this Report.

Since 1965, the British Film Institute (BFI) has attempted to improve the accessibility of serious films by developing a chain of regional film theatres. There are now some 46 of them, most of which show commercial films when not being used as regional film theatres; others are housed within arts centres or theatres. Two (Tyneside and Brighton) are full-time. The BFI gives guarantees against loss only for the periods of their operation when 'quality' films are being shown. Some of the towns where these cinemas are found are large (Sheffield, Newcastle, Nottingham, Brighton) and some small (Bangor, Canterbury, Dartington, Whitehaven, Leatherhead). Their geographic distribution seems not to have resulted from a strategic plan; instead the BFI has responded to local initiatives and the willingness of local authorities to give support. In consequence Manchester for example does not now have a regional film theatre. Apart from deficit guarantees, the BFI gives capital grant-aid towards building improvements or film equipment for regional film theatres out of the Housing-the-Cinema Fund which is supplied as a special annual grant from the DES to the Institute.

For many years the Fund has remained at £100,000 and is of course now worth only a fraction of its original value. If, therefore, a city like Manchester now proposed to establish a full-time film theatre, the BFI would not be able to offer any sizeable help for the project.

The BFI sees its role in what some consider to be rather academic terms. The regional film theatres are managed independently, as a rule, by local committees or trusts. But the BFI's intention is that they should show films which reflect the best of world cinema or the high points of cinema history. The regional film theatre circuit now forms a substantial proportion of the available screens in some areas, and critics of the BFI policy see no reason why programmes should necessarily be 'structured around socio-aesthetic problems, issues and debates which are central to the key debates in the history of cinema and film criticism'. The audience in the Doncaster Film Theatre would be content simply to see good films – and that, critics of BFI say, is quite compatible with BFI purposes.

BFI policy seems also to have prevented it from supporting community cinema. As commercial cinemas close, it would be logical to expect some local authorities to take them over and run them in the interests of their ratepayers, as they have done with theatres. Not all the cinemas which are being closed make a loss: more often they do not show a sufficient return on capital to satisfy commercial standards. Local authorities could therefore run some cinemas at no cost to the rates and such civic cinemas might help to break the near-monopoly that British film distributors and cinema owners now enjoy. New life might thus be engendered in the industry.

Such civic cinemas could help to raise standards by a discriminating choice of films, both for the children and for adults, as civic theatres have done for drama. There could be special programmes for schools and to suit other local interests. Matinées for old-age pensioners would be a valuable service. The cinema could be used also by local film societies, which often now have to present their programmes in poor halls and under adverse technical conditions.

One local authority which, like others, has purchased a local cinema and run it in the public interest is Beaconsfield in Buckinghamshire. Having bought its local cinema in 1961, it has achieved good attendances ever since and runs it at a small profit. Apart from showing films, the cinema is used by the local amateur drama society and for a Christmas pantomime. Another example is Knutsford, now part of Macclesfield District, which bought an old cinema in 1960 and con-

verted it to one of smaller capacity. This cinema is now used not only for films but for meetings, amateur drama, bingo, and dances. In all, 19 of the districts in England and Wales now own cinemas, 14 of which are managed by the local council. Over 50 district councils provide film shows of one kind or another in a variety of buildings. None of these projects receive assistance from the BFI, nor has the Institute taken steps to inform local authorities of community film schemes or to encourage such developments.

 If a local district council cannot afford to purchase or to build a cinema, but wishes to improve film accessibility in its area, it can show films in such places as the public library (the London Borough of Lewisham is an example of such enterprise). Again, mobile cinema units are cheap to run and specially valuable in rural areas. They resemble the Arts Council's Art Film Tour unit, comprising van, projectionist, projector, screen and sound equipment. A village or school hall is quickly converted into a cinema and regular visits of the unit soon become established practice. Northern Arts has run such units for several years, and Kirklees Metropolitan District Council in Yorkshire now has its own unit. The British Film Institute could be of value to local authorities by informing them of such developments and encouraging film distributors to relax their present cautious attitudes and to co-operate with these units. The Housing-the-Cinema Fund might in due course be used to help local authorities to purchase equipment for their units.

 The aims of local authorities should centre upon making good films widely available and RAAs will share this concern across the region. Besides encouraging this approach, the BFI can help to open up new opportunities for experiment in film, to discover and encourage talented individuals, encourage film study and research, and maintain the National Film Archive.

 Despite television and the decline in numbers of commercial cinemas, cinema attendance in Britain still approaches three million a week. That is a very large figure in comparison with other performing arts, and it would be a larger figure still if cinemas were reopened in deprived areas. Nor can television replace the cinema as a medium for showing films. Wide-screen and stereophonic sound lend films in the cinema a quite distinctive quality; films made for television need to be shot largely in close-up or they will not be effective on the smaller screen.

 Film societies offer minority audiences the chance to see films which

find no commercial exhibition outside London or the towns which have regional film theatres. But they often must work with old projectors and in unsatisfactory halls. There are over 600 societies registered with the British Federation of Film Societies but the total number is probably near 1,000. Some societies open their membership to the public; others are confined to educational institutions, firms, factories or other places of work, and the trend seems to be away from the public society towards the institutional. Some 40,000 people are thought to belong to film societies and the societies mount some 7,000 performances a year; but numbers in membership seem to be declining: few societies have financial reserves, and many are now in danger of closing.

Film societies seem to find more difficulty in winning financial help than other local art societies. The best of them deserve backing from RAAs in their search for aid from local authorities.

Film production, except for some television film-making and documentaries for educational and industrial purposes, hardly exists outside the London area. Young people with creative talent gravitate to London for training – at the National Film School, the International London Film School, the Royal College of Art and some other film courses. Although in the 'sixties many films were made on regional subjects, they were London operations which used regional locations. A truly regional cinema must have its roots in a region and use native writers and directors. And perhaps we are beginning to see this happen. Most regional arts associations now give small grants to local film-makers with aims and abilities above those of the amateur. Northern Arts, for example, now spends about £20,000 a year on such assistance.

These local films, which are usually made on 16mm film-stock, are outside union rules and require only a small budget. The British Film Institute indirectly supports this work through the grants it makes to RAAs which have appointed film officers, but it gives little aid to specifically regional projects through its Film Production Board. Some regional film projects, however, have been helped through a Gulbenkian Film Award Scheme.

The BFI's Film Production Board itself has in recent years tended to concentrate its funds on larger-scale projects undertaken by those who have already proved their ability.

Film is neglected as a part of education. This is not only true of schools but also of universities where, more surprisingly, there is a

dearth of film study or research. The aesthetics, social effects and history of film and television receive only sporadic attention. No regional film archives have been established. Little interest is yet shown by education authorities in 'film-in-education' teams (such as 'Second Sight' in Yorkshire) which present programmes about film to children and involve them in the beginnings of creative work. Some schools, however, have for many years given special emphasis to film-making and produced excellent results. Here is another field of future work for the BFI and regional arts associations, helping more education authorities to become aware of the value of such work and how it can be done.

In Wales, the Welsh Arts Council acts as an agent for the British Film Institute and has a specialist officer. There is also an independent Welsh Films Board which makes films in Welsh, but the Board's funds are very limited, and it seems doubtful whether two separate sources of public aid are necessary. If the Welsh Arts Council and the regional arts associations formed one coherent pattern for aiding film-making in both the Welsh and English languages better use could perhaps be made of public funds.

Video is a term used to describe portable and closed-circuit television. It usually consists of lightweight cameras and recorders, related to a small studio where editing and playback can take place. A good example of such equipment is at the Bradford Visual Communications Centre, operated by the Yorkshire Arts Association; such work is being done at Kendal and by Interaction, by the Institute for Research in Art and Technology and by many others. Video is a technique favoured by many community artists and other such workers, for it enables them, with a minimum of technical equipment, training and expense, to involve local people in the direct experience of expressing their own thoughts and feelings.

Crafts
The crafts are an area of creative activity that has been ignored until quite recently by public funding bodies. In 1971 the Crafts Advisory Committee (CAC) was created on the initiative of Lord Eccles, and it has done much in a short time to focus attention on the artist-craftsman, give him support and raise his standards. The field covered by the term 'crafts' is huge, ranging from works of art, intended for pleasure rather than use, to thatching and other country crafts; it includes, for example, embroidery, weaving, and spinning; calligraphy and book-binding;

furniture and instrument-making; jewellery, pottery and stained glass.

The type of help offered by CAC through its specific schemes (for workshop training, studios and equipment, bursaries, special projects) is designed for those craftsmen who are attempting to use traditional media in new ways. The CAC's exhibitions, its magazine and its Index of Craftsmen have the same people in mind.

The CAC also encourages the craft societies and guilds which have large memberships and strong local or regional connections. In 1970 a national body, the Federation of British Craft Societies, was formed, to work with the CAC and represent the common interests of the societies and guilds and it has grown in influence over the last six years. The Art Workers' Guild, formed at the height of the 'Arts and Crafts Movement' in 1884, is also still active, organising lectures and exchanging views and experience between artist-craftsmen. Both these organisations are concerned with the Craft Movement as a whole. The individual societies and guilds tend to be cautious in their attitude to the CAC. Nor have they often obtained grants from regional arts associations.

The Federation of British Craft Societies is growing rapidly in membership and receives an annual grant from CAC for central administration; but its aim is to become financially independent. The Federation seeks mainly to foster co-operation between member societies and represent their needs to CAC and others. The total individual membership of its constituent societies already numbers over 10,000 craftsmen.

The specialist societies promote fine craftsmanship, help craftsmen to exchange experience and co-operate in projects and group exhibitions, but they also help the individual to show and sell his work, obtain commissions and so make a living. Those who are not themselves practising craftsmen but are interested in crafts, can usually join the societies as supporters. Some societies are specially concerned about the risk that special and sometimes rare skills will be lost permanently through lack of facilities for training. Many are regional in character (the Guild of Yorkshire Craftsmen, for example) and have specialised knowledge of the needs of craftsmen in their regions.

The Arts Council gives no support to crafts and few local authorities have ever done so. The only public support comes, therefore, from CAC and from one or two regional arts associations.

Both West Midlands Arts and the Lincolnshire and Humberside Arts

Association have shown an interest in crafts. West Midlands has an arts and crafts officer and receives a block grant from CAC towards supporting this appointment; the Association has also had CAC help towards the appointment of a craft fellowship at the University of Aston. Lincolnshire and Humberside has also appointed 'fellows' in various crafts and has established a fine craft museum, receiving CAC grants for both these projects. At least one other RAA is now considering the establishment of a committee or sub-committee to advise on support for craft activities.

In 1973 most regional arts associations co-operated with CAC in preparation for the national exhibition of crafts ('The Craftsman's Art') which CAC presented at the Victoria and Albert Museum, and some associations staged regional exhibitions at that time.

Several galleries and arts centres in the regions have developed special interest in crafts: for example, the Midland Group Gallery in Nottingham, Penwith Galleries in St Ives, Abbot Hall in Kendal, Arnolfini in Bristol, and the Gladstone Pottery Museum at Stoke-on-Trent. In addition, the CAC has a small exhibition space at its London offices, as has the British Crafts Centre.

Some crafts which constitute small industries in rural areas receive assistance from CoSIRA (the Council for Small Industries in Rural Areas) which itself receives grants from the Development Commission.

Training in crafts is either at art college or by apprenticeship, and there seems to be little agreement among craftsmen as to whether training should concentrate on design or on the development of manual skills.

A threat to high craft standards is presented by the tourist market and the ready sale that cheap souvenirs command in certain parts of England. The establishment, through the collaboration of CAC, RAAs, local authorities and the craft societies, of regional craft centres would be one way of raising standards – by the selection and exhibition of works of high quality and by helping craftsmen to purchase materials at bulk prices.

The Welsh Arts Council acts as an agent for CAC in the Principality and employs a member of staff with the title 'crafts and design officer', the only such appointment outside London. This post is financed not only by the Welsh Arts Council and CAC but also by a small grant from the Design Council. Design is therefore included within the general policy followed by the Craft and Design Committee of the Welsh Arts Council. There are few artist-craftsmen in Wales and few Welsh

firms have gained awards from the Design Council, but there are many small craft-based industries. Welsh policy has therefore been to promote exhibitions and small industries, rather than give individual bursaries or grants for workshop equipment. One or two bursaries are given, however, and a competition is organised in one craft each year. Individual artist-craftsmen in Wales can also apply to the CAC in London for aid under the various schemes it offers.

As for the future, I would conclude that the CAC should be given a larger DES grant and in due course be established as a national council in its own right, parallel to the Arts Council. Its aims should include all aspects of the crafts movement. The alternative, less satisfactory in my opinion, is to broaden the scope of the Arts Council to cover crafts and arts together.

Meanwhile, the CAC should form closer links with RAAs and with local authorities, both individually and through the local authority associations. It should also work more closely both with the Arts Council and the Design Council. Any chartered council that replaces CAC will have the same need to connect its work with that of other bodies in similar fields.

RAAs should be enabled financially to appoint craft officers (better still, 'craft and design officers', as in Wales) and should act as regional allies of CAC (in much the same relationship as exists between them and the BFI). The RAAs should build up close connections with craftsmen, craft societies and guilds throughout their regions, and with such bodies as the Federation of Craft Societies. In short, RAAs should regard the crafts no less than arts as their concern.

Local arts councils and associations

Wherever we went, we found a multitude of local arts societies, associations, federations and councils. These bodies are run by amateur enthusiasts and fall into two main categories: specialist societies (amateur drama, opera, etc.) which bring together those wishing to practise one of the arts and provide them with opportunities; and local federations of such societies, or general arts councils.

As for the general societies, their aims and functions vary but typically include the following: co-ordination of the events promoted by specialist societies, to prevent dates clashing; joint publicity for these events; speaking for member societies to the local authorities and RAAs; promoting events by visiting professional musicians, theatre groups, poets, etc; organising social events. Sometimes the local authority uses

the local arts council or federation to advise, or act on its behalf, in sharing among amateur societies such total sum as it decides to give in aid.

Some local authorities have been involved with a local arts federation from the start; indeed occasionally they have been prime movers in its establishment. More commonly, local enthusiasts have first come together without prompting from the local authority, which then has gradually come to recognise the value of a vigorous body of this sort.

RAAs too have been the means of bringing local societies together to form federations. When formed, federations provide focal points of known enthusiasm which RAAs develop. The federations are encouraged to promote local professional as well as amateur events, publicise the more distant ones, and form coach parties for concerts, opera, ballet and the theatre. Most RAAs give grants to local arts federations, particularly in the form of guarantees against loss for promotion of professional events.

A local arts federation tends to rely on the energy and abilities of one or two people. While such enthusiasts are active a federation, being less remote than the RAA and less formal than the local authority, can achieve more than either for the locality. But when the federation loses its key members, its effectiveness quickly declines. Most of the longer-lived of these bodies have passed through several fluctuations. Despite ups and downs, however, these local arts councils are indispensable to arts development.

The Mid-Pennine Association for the Arts (see pp. 96-97) began as a local arts council, and the development of arts councils in many London boroughs has been most successful. Again, the Mid-Northumberland Arts Group has shown a splendid range of action over the years. All of these councils began as bodies run by enthusiasts; some of them reached a level of activity which required full-time and experienced staff. This has meant that these exceptional organisations have been enabled to consolidate their success and undertake a wider range of activities. Not all local arts councils or federations need professional help, but in certain cases it can assist long-term local arts development. Meanwhile the right kind of local government officer in an enlightened authority can give invaluable support.

Housing the arts
The Arts Council's Housing-the-Arts Fund was established in 1965 as a result of reports on the subject which the Council had conducted in

1959 and 1961, and following the 1965 Government White Paper *A Policy for the Arts*. Although the Council had previously contributed towards the costs of capital equipment, this was the first time that it was enabled to contribute towards the cost of building schemes. It was given a special grant, separate from its general grant-in-aid and subject to special Treasury rules. In the first year, the 'commitment ration' (that is, the annual sum to which the Arts Council could commit itself though actual payments might not be required for some years) was £250,000. From the following year it was set at £500,000 and it stayed at that level until 1973/74, when it was increased to £750,000. In that year, too, the Treasury rules were somewhat relaxed to give the Council greater flexibility in making forward commitments. In 1973/74 the Council received an additional allocation of £675,000 to aid projects in the 'development areas' (much of Scotland, Wales, the North of England, and parts of the South West), but this was a once-for-all contribution. In 1975/76, actual expenditure was £850,000.

By March 1975 the Fund had paid or committed a total of £6,731,800, towards the cost of 241 projects in England, Scotland and Wales. The total cost of these projects was £36·75m and the Arts Council's average contribution was thus 18·3%.

Applications to the Fund are first considered by the appropriate department of the Council (Music, Drama, Art, etc.) or by the Scottish and Welsh Arts Councils. Recommendations are made to the Housing-the-Arts Committee (which consists of the Chairmen of all the specialist Panels of the Council and of the Scottish and Welsh Arts Councils) and then passed to the Arts Council. The committee is served by a specialist officer but often seeks advice on particular projects from experts in the field concerned: for example, from the Theatre Planning Committee of the Association of British Theatre Technicians, or from *ad hoc* expert committees in other fields.

The Committee also consults with RAAs about the viability and importance of a particular project. RAAs are often involved in the feasibility studies and discussions which give rise to applications and therefore well placed to give advice on all projects, and their assessment of any application for a grant of less than £15,000 is now normally accepted as decisive. RAAs sometimes help the projects themselves with small grants to enable feasibility studies to be made, or towards fees.

In this work the Arts Council has informal liaison with other bodies that may be concerned such as the British Film Institute, local authorities, trusts and foundations. Perhaps still closer links are needed between

the Sports Council and the Arts Council to ensure that, in all appropriate cases, new buildings are designed specifically to meet the requirements of both arts and sport. Before making grants from the fund, the Arts Council rightly seeks special assurance that the estimated revenue costs of operating the completed building are realistic.

Any project whose total cost exceeds £2½m or which requires a grant of more than £500,000 is beyond the scope of the Arts Council's Fund and must be referred to the Treasury (the National Theatre is an example). Nor is the Arts Council permitted to contribute more than half the total costs of any building. Its policy is to confine its help to buildings intended for *professional* activities.

Though the main purpose of the Fund is to contribute towards building costs, fees and major items of fixed equipment can now be included. Mobile and portable units, however, are outside its scope.

During most of its first decade the Fund has given priority to theatre buildings, especially to the rehousing or improving of theatres for repertory companies. Now that new theatres have been brought to many parts of England and Wales, the priority has shifted to a wide range of other projects: improvements for major No. 1 tour theatres, concert halls in major population centres, arts centres with an auditorium dedicated to a reasonable degree of professional use, improvements to galleries designed for temporary exhibitions, studio and workshop space for artists.

In considering applications the Arts Council's Committee takes account of many factors besides revenue implications. These include geography, public demand, use by professionals, security of tenure, suitability of site, technical competence of the proposed facilities, and architectural quality.

In using its Fund, the Arts Council in the main has sought rather to respond to local initiatives than to impose any arts development plan for the whole country. As an exception it has set out during the last few years to stimulate the improvement of selected theatres in the No. 1 tour circuit. Its help has often influenced local authority support of schemes: a grant from the Fund is seen by local councils as a seal of national approval. And local authority support has often been matched by money raised from industry, trusts and foundations, and the general public. In 1970, the Arts Council estimated that the £2¼m which it had then committed had generated no less than £5m from local government and £4m from the private sector.

The Council is now undertaking a survey of buildings available to

house the arts, in order to clarify where provision is inadequate and in what ways. It is also wisely exploring the possibilities of less expensive building, including the temporary and the portable.

The Housing-the-Cinema Fund is operated by the British Film Institute. Established in 1967 with a sum of £63,000, today it still stands at only £100,000. We have already made reference to the low level of this Fund and to the extent of its devaluation in real terms over the years. (It should be noted in passing that the Fund benefited between 1972 and 1974 from a special regional development allocation of £125,000.)

The Fund is administered by the BFI's Regional Department. The Treasury rules which apply to the Housing-the-Arts Fund also apply here. Applications are examined in the light of advice from RAAs, the specialist and technical staff of the BFI and other sources appropriate to a given case. A recommendation is then brought before the Governors for decision.

In 1974/75 grants were made for film equipment and facilities at Derby Playhouse, which houses a regional theatre company but is also a new part-time Regional Film Theatre (it has received grants both from the Housing-the-Cinema Fund and from the Housing-the-Arts Fund as have many of our new theatres); to a new touring theatre at Inverness which will become also a regional film theatre; to the Brighton Film Theatre; for film facilities at the Brewery Arts Centre in Kendal; and to Hull. These totalled £54,000; and the remainder of the commitment ration went on reseating the main auditorium of the BFI's National Film Theatre.

Some applicants for aid complain that the policies and priorities of the Housing-the-Cinema Fund have been unclear. In fact, the emphasis in recent years has been on the improvement and equipment of the regional film theatres. And a condition of grant has normally been that it should be matched by local funds. The Institute would now like to widen the use of the Fund and help to establish centres in the regions which will house facilities for film-making, film study and libraries in addition to film auditoria. These 'film centres' are proposed for major regional centres of population, but they are still only in the discussion stage. If this plan means new buildings or substantial alteration to existing ones, the present Fund will be quite inadequate to make significant contributions to the cost.

At present the Fund cannot be used to purchase vehicles or projection equipment for mobile cinema units.

Housing-the-Museums Fund. No central funds assist local authorities or other museum bodies outside London to improve the buildings or equipment of their museums. Following the Wright Report, the Department of Education and Science announced its readiness to consider the capital needs of projects that were of more than local significance if they were recommended by the Standing Commission on Museums and Galleries; but no such grants have yet been given.

Buildings for Arts purposes: the general problem. The Arts Council Housing-the-Arts Fund seems to work well, with clear information to prospective applicants and definite priorities. It has devised ways of seeking expert advice which work well for the theatre (through the ABTT) but less well for other types of building. There seems less clarity about the British Film Institute's Fund, and it is now in any case too small to be of much significance.

The Arts Council's past policy of response to local initiatives has produced excellent results, but as a result areas that are not articulate do not get help. The national funding bodies must, if they can, do more in future to encourage action by the local authorities in areas still without adequate facilities.

Industry and commerce would be much encouraged to contribute to the capital costs of an arts building if new tax concessions could be made available. Such contributions would be of the greatest value, but only if plans for the new building have taken full account of its on-going need for annual revenue. However expensive a new theatre or concert hall may be to build, the future costs of running it successfully will be far heavier. We must beware of raising money from private enterprise for a new building unless we can make full use of it over the years.

There is no independent agency (except the ABTT for theatres) to which promoters of a project can go for expert advice on their scheme's technical quality. RAAs, except in the South West, do not yet have staff with this expertise.

The cost of replacing old theatres by better modern ones is unattractive to commercial theatre owners. They would not see sufficient financial turnover to justify the large investment. Theatre sites, especially in the West End of London and other city centres, are consequently attractive for the commercial development of offices, etc. These questions are discussed more fully in the Report *Planning and Redevelopment in London's entertainment Area, with special Reference to the Theatre*, by Sir James Richards, published by the Arts Council in 1973.

Inflation has made unworkable the formula that was in effect used by

the Arts Council for many years. If local authorities could find one-third of the costs of a project, the Arts Council would match it from the Fund, and the remaining one-third would be found by the promoter of the project through fund-raising from the public. Buildings now cost so much that in most cases the public cannot find its third and local authorities are reluctant to put in more than theirs. Now therefore none of the interested parties is prepared to come forward with an opening offer. The question arises in this situation whether we can now afford more new large buildings for the arts; if we cannot, should we rather intensify our efforts to take arts to the audience?

Everyone agrees that the arts need good buildings. But there is always a danger of spending on buildings money which would go better to the arts themselves. If an area has no theatre, would money best be spent on enabling talented actors and theatre directors to work there and build up enthusiastic audiences which could then justifiably press for a better building?

Training arts administrators

During the course of the enquiry we met a wide variety of people who can be grouped collectively as 'arts administrators'. Such people manage the arts enterprises of theatres, galleries, concert halls, arts centres and opera houses, and they also manage arts companies and groups of artists. The late David Webster, when general administrator of the Royal Opera House, said that his job was to create conditions in which the aims and capabilities of artists could be most fully realised and the best possible performances presented. That is a good enough description of the arts administrator.

Sometimes an arts administrator works as a general manager in harness with an artistic director; sometimes he is himself the artistic director. In any case he must have an immediate sympathy with the aims of artists, an understanding of their quality, an ability to organise events and manage premises and personnel, give general help to artists, and bring their work before the public. Not only do such administrators work in theatres, galleries and arts centres but we find them increasingly in local government, in local arts councils and regional arts associations, in community arts work, and there are amateur arts administrators in the amateur arts.

This is no new phenomenon, but one that has been with us for many years. In the past our theatre and orchestra managers and other arts administrators acquired their skills by practice rather than study. There

were exceptions: museum staff, for example, could gain the qualifications of the Museums Association, local government leisure and recreation officers those of the Institute of Municipal Entertainment. Both these bodies continue to have training schemes, as does the Library Association, and their qualifications are widely recognised in local government and elsewhere. Until recently, however, most other administrators started their work without special training or worked their way up from a junior post.

Today the size and number of companies and buildings, the expense of running them, the complexity of organising any medium or large-scale activity, the need for accurate accounting (especially where public funds are involved) all mean that we cannot continue to recruit the managerial staff we need for all the arts in these old ways. Certainly some specialists can be attracted to the arts world from other professions: from accountancy, business and public relations. But there is a growing need for the professional training of young staff in the particular and general skills required for arts management. The arts need such trained people, for the sake of their own progress but also to assure local and central government that money is being spent in a responsible way.

In 1972, the Arts Council published a report (*Training Arts Administrators*) which resulted from a committee of enquiry under the Chairmanship of Professor Roy Shaw. The Committee found that there was indeed a need for basic training in arts administration which would enable qualified people to move freely from one type of organisation to another. It noted the increasing scale of activities needing skilled management and the direct and indirect involvement in the arts of public funds. The allied fields of radio, television, films and light entertainment could be expected to increase the demand for arts administrators, as would the creation of more arts appointments in local government. The report recommended continuation of a one-year course then administered by the Arts Council (in collaboration with the Polytechnic of Central London School of Management Studies) in Arts Administration and the establishment of shorter courses on special aspects of the arts.

The following paragraphs summarise the main training schemes that now exist.

The Repertory Theatre Trainee Directors Scheme. This was first set up in 1958 and received financial support from the independent television companies. It offers training to young artistic directors who

M

are seconded to work at a particular theatre company. The scheme does not award qualifications.

The Arts Council Trainee Theatre Directors Scheme. This continuing scheme was established in 1966. It gives bursaries to young directors and also to the more experienced. No qualifications result.

The Arts Council Trainee Theatre Designers Scheme. Begun in 1961, this offers selected managements a contribution towards the cost of appointing a young designer as an additional member of staff. No qualifications result.

The Arts Council Theatre Technicians Training Scheme. Begun in 1970, this is run for the Council by the Association of British Theatre Technicians. It consists of day-release training for stage and electrical staff. Examinations are set by the City and Guilds of London Institute.

Arts Administration Courses. There are two full-time 'long' courses: one at the City University, one at the Polytechnic of Central London. The course at the City University trains up to 18 people on a one-year course leading to a Diploma in Arts Administration. The aim is to improve and professionalise administration in the arts, especially the subsidised arts. The course is post-graduate and designed for middle management levels. Tutors are drawn both from the academic and the professional worlds. Work is increasingly based on case-study and a period of secondment. The cost of the course is borne by the University, but fees are charged and students can obtain grants or bursaries from the Arts Council, the Social Science Research Council and (for the unemployed) from the Government's Training Opportunities Scheme.

The Polytechnic of Central London's long course is flexible; it may last up to a year or be as short as three months, according to particular needs. It consists of a six-week course at the Polytechnic, followed by practical work on attachment to an arts organisation. It is more specially directed towards work in local government than is the City University course, and awards a Diploma in the Administration of the Arts, Recreation and Leisure. It takes up to twenty students a year. The costs of the course are borne by the Polytechnic, fees are charged and the students can obtain similar grants and bursaries as those available for the City University course.

The Polytechnic of Central London also runs two six-week short courses in arts administration which are aimed primarily at improving the knowledge of lower management staff already in post. These courses do not result in a qualification. No grants or bursaries are

available. Further, those wishing to attend the courses often have difficulty in obtaining leave of absence from their employers.

The Polytechnic also organises an increasing number of one-day and two-day short courses on specific subjects. One five-day course has been held on organising exhibitions.

In 1974/75 the Arts Council spent £19,000 on the Theatre Technicians Training Scheme (and a further £280 on bursaries to technicians), £7,510 on bursaries to students at the long practical courses at the Polytechnic, £16,800 on bursaries to students at the City University course and the following sums on other bursaries: actors, £1,815; designers £7,501; and directors, £9,860.

A summer-school is planned for 1976 at the City University. This will assemble senior arts administrators from many countries, to look at common problems and examine some British arts organisations in detail. It will follow lines established by the Harvard Business School.

Some University Drama Departments (Manchester and Bristol, for example) train for theatre management and administration as well as drama itself.

Research
British universities do less research into the arts than in most other fields. What they do does not serve many of the needs of grant-giving bodies, local government, arts companies or artists but is, not unnaturally, historical or theoretic. We must find other means to meet the rather urgent need for various kinds of relevant information and research.

The Arts Council is the source of many valuable reports and enquiries. A few examples are: *The Theatre Today, Orchestral Resources, Training Arts Administrators* and *The Arts and Museums 1972/73* (local authority expenditure). Other reports have come from the initiative of the Gulbenkian Foundation; for example *Going on the Stage* (training of actors), *Making Musicians, Help for the Arts.* Fortunately, both the Arts Council and the Foundation are continuing their programmes of research, and the Arts Council now has a research officer and a statistician. All this is useful but it is far less than we need.

Reports commissioned when an emergency arises often come too late. We need a continuing, co-ordinated flow of research studies and information if arts policies are to be settled in the light of reason. Neither the Arts Council nor any of the foundations has the staff to meet this need.

I would argue strongly, therefore, for the establishment of a research unit that can serve the need for practical information on many aspects of arts policy. My feeling is that such research is better done at one remove from the Arts Council if it is to serve all that can profit from the results – the DES, BFI, local government organisations, arts organisations, museums, crafts and film. Thus it would need to be centred in an independent body which was not itself responsible for fixing grants to the arts. Such an organisation exists, for example, in the Netherlands. It is an independent trust, grant-aided by the Government. Apart from undertaking specific enquiries referred to it by Government, local government or Arts Council, it also undertakes projects of its own devising and publishes its own reports. It has an extensive library of books, periodicals and other materials relevant to the arts, and it maintains contact with similar bodies in other countries. The cost of that operation seems relatively small and represents a sound investment.

Till now we have relied in Britain mainly on common sense and trial and error as guides to public spending on the arts. We should continue to do so, but make better use of practical experience both in Great Britain and abroad. A research unit such as the Netherlands one would prove an excellent innovation.

Appendices

Arts Council of Great Britain – Grants-in-Aid

	Total Grant-in-aid	Revenue Expenditure			Capital Expenditure (Housing the Arts)	
		England	Scotland	Wales	Total	Wales
1945/46	£235,000	£235,000				
1946/47	350,000	350,000				
1947/48	428,000	392,000	£36,000			
1948/49	575,000	533,000	42,000			
1949/50	600,000	558,000	42,000			
1950/51	675,000	593,000	82,000			
1951/52	875,000	823,000	52,000			
1952/53	675,000	618,000	57,000			
1953/54	785,000	679,250	75,750	£30,000		
1954/55	785,000	677,250	75,750	32,000		
1955/56	820,000	703,915	82,270	33,815		
1956/57	885,000	771,700	78,050	35,250		
1957/58	985,000	859,914	82,176	42,910		
1958/59	1,100,000	971,200	84,850	43,950		
1959/60	1,218,000	1,089,200	84,850	43,950		
1960/61	1,500,000	1,328,783	110,394	60,823		
1961/62	1,745,000	1,543,388	123,267	78,345		
1962/63	2,190,000	1,937,044	144,666	108,290		
1963/64	2,730,000	2,414,968	174,600	140,432		
1964/65	3,205,000	2,846,636	202,789	155,575		
1965/66	3,910,000	3,312,188	257,890	189,922	£150,000	£20,000
1966/67	5,700,000	4,744,714	450,286	305,000	200,000	—
1967/68	7,200,000	5,840,000	630,000	430,000	300,000	18,000
1968/69	7,750,000	6,207,500	705,000	487,500	350,000	40,000
1969/70	8,200,000	6,378,250	833,750	518,000	470,000	50,000
1970/71	9,300,000	7,206,000	950,000	564,000	580,000	21,000
1971/72	11,900,000	8,983,903	1,259,862	886,235	770,000	77,000
1972/73	13,725,000	10,613,649	1,400,000	886,351	825,000	108,000
1973/74	17,138,000	12,810,570	1,905,000	1,152,430	1,270,000[2]	405,500[2]
1974/75	21,335,000	16,518,150	2,414,700	1,852,150	550,000	46,500
1975/76[1]	26,150,000	19,950,000	3,000,000	2,050,000	1,150,000	62,500

Notes 1. Provisional allocations, increased during the year by a supplementary grant-in-aid. 2. Includes a special allotment for regional development areas.

APPENDIX 2 (*see end-paper for map*)
Regional Arts Associations. Arts Council grants to RAAs since 1962

	Eastern	East Midlands	Greater London	Lincoln-shire[1]	Mersey-side	Midlands[2]	Mid-Pennine[3]	Northern
1962/63	—	—	—	—	—	250	—	500
1963/64	—	—	—	—	—	325	—	22,000
1964/65	—	—	—	—	—	625	—	30,000
1965/66	—	—	—	2,000	—	1,250	—	40,000
1966/67	—	—	—	14,849	—	1,750	—	60,000
1967/68	—	—	2,500	15,000	—	3,065	—	73,250
1968/69	—	—	3,500	15,000	—	11,090	—	85,600
1969/70	—	—	6,500	15,015	—	21,675	—	93,350
1970/71	—	12,050	15,238	18,400	—	—	—	115,525
1971/72	13,330	16,750	38,830	23,250	22,110	—	300	145,857
1972/73	40,950	29,310	77,910	29,450	31,450	—	5,450	204,050
1973/74	55,440	64,650	159,850	45,026	51,565	—	4,800	287,280[5]
1974/75	80,076	86,826	184,900	66,602	70,812	—	—	323,610[5]
1975/76[6]	116,170	112,348	211,388	101,491	102,633	—	—	386,035
Year of formation	1971	1969	1968	1964	1968	1958	1966	1961
Total Budget 1975/76[6]	180,263	190,000	289,635	184,013	170,000	—	94,130	662,910
Total Local Authority Income 1975/76[6]	51,893	67,000	37,707	49,552	52,908	—	30,730	203,378
Estimated Population	4·4m	3·01m	7·5m	1·35m	1·9m	—	0·5m	3·15m
1975/76 ACGB grant per 1,000 pop.	£26·4	£37·3	£28·1	£76	£54	—	—	£122·5

Notes

1. From 1975/76, Lincolnshire Association became the Lincolnshire & Humberside Arts Association. Nort. Humberside had previously been within the Yorkshire Arts Association Area. The population figures reflec the change.

2. After 1969/70 the Midlands Arts Association split into the East Midlands and West Midlands Ar Associations.

North Wales[4]	North West	Southern	South East	South East Wales[4]	South West	West Midlands	West Wales[4]	Yorkshire[1]
—	—	—	—	—	2,000	—	—	—
—	—	—	—	—	2,000	—	—	—
—	—	—	—	—	2,375	—	—	—
—	—	—	—	—	3,250	—	—	—
—	—	—	—	—	3,750	—	—	—
),000	6,000	—	—	—	5,000	—	—	—
7,200	15,250	—	—	—	17,200	—	—	98
),000	30,900	6,250	—	—	25,390	—	—	3,890
),000	50,350	18,620	—	—	41,575	30,150	—	13,540
),000	63,010	35,250	—	—	46,550	29,450	46,628	37,427
),000	102,200	63,000	—	—	74,550	56,120	50,014	66,650
),000	160,952	93,665	8,500	15,248	115,453[5]	112,778[5]	51,613	95,826[5]
),795	172,103	125,202	59,192	75,000	147,400[5]	150,944[5]	51,095	117,217[5]
),000	203,525	168,985	84,925	75,000	205,438	196,213	50,000	139,438
)67	1966	1968	1973	1973	1956	1971	1971	1969
),500	331,000	252,850	128,650	107,000	243,188	280,817	87,000	237,380
),500	90,000	71,000	28,200	30,000	34,000	63,863	30,000	49,976
)6m	6·75m	3·75m	3·03m	1·28m	3·25m	5·15m	0·8m	4·06m
)70	£30·2	£45	£28	£50	£63·2	£38	£62·5	£34·3

From 1974/75 responsibility for grant-aiding the Mid-Pennine Association for the Arts (an Area Arts ssociation) passed to the North West Arts Association.
The Welsh Associations are grant-aided by the Welsh Arts Council.
Extra grants for Leisure or Marketing projects are not included.
Provisional figures.

APPENDIX 3

(The following paper on Sweden is reproduced here for the light it throws on a quite different approach to the problems of State patronage of the Arts.)

Notes on a visit to Sweden with members of the Standing Conference of Regional Arts Associations, 13-16 May 1975 by Anthony Phillips

Circumstances of visit

1. We were the guests of the Swedish Government, in particular the National Council for Cultural Affairs, and of Östergötland County. The time was spent in the two principal towns of Östergötland, which is a province in the relatively developed central part of Sweden roughly running between Göteborg on the west coast and Stockholm on the east coast. Norrköping is about 120 miles, Linnköping about 160 miles from Stockholm.

2. The purpose of the visit was to get first-hand experience of the Swedish pattern of decentralisation in the provision of the arts, particularly in view of the comparatively recent (1973) publication of a Government Commission's report and recommendations on cultural policy and the even more recent (October 1974) establishment of a central agency to carry out the recommendations approved by Parliament. These recommendations lay particular emphasis on the need for decentralisation. A confusing piece of nomenclature: the investigating commission charged with making the report and recommending the policy was called the National Council for Cultural Affairs (NCCA) and the Chairman was Paul Lindblom. A primary recommendation of the Commission was that a national cultural office should be set up: the body established in October 1974 has the same name and Chairman, but different membership and of course an executive function.

General remarks

3. First some generalisations. Sweden is a rich country with a large land area and a population of 7½ million people. There is a long, famous and much-debated tradition of non-aligned economic and political foreign policy, shrewd state investment in private industry and commerce and a practically unchallenged assumption that the welfare state should be an enlightened, benevolently paternalistic but nevertheless total provider of all society's needs. Swedish government has for many years presented a blend of democratic theory with a large dose of centralised practice. A few days necessarily give only a superficial impression, but this impression was, certainly for me, of a society with extremely few material worries and a degree of conformism that would be unthinkable in Britain. Taxation of the average income is about 53% and the average wage is

40 thousand crowns p.a. – roughly £4,000 at the present rate of exchange, which is particularly unfavourable for Britain. So despite the taxation, no one is poor.

4. One other generalisation: the quality of the theoretical planning seems to be very high indeed. One feels that, having relatively so few economic and social worries, the Swedes can afford to spend a lot of time conceiving, constructing, debating, modifying, consulting and reflecting on policies which are then presented with almost unarguable logic, vision and generosity. This is true, so it seems to me, of the Swedish approach to every aspect of life: architecture, education, transport, engineering. They are interested in function, not display. But however impressed you are with the thoughtful practicality of the planning, you cannot help feeling that the results very often do not match up with the planners' ambitions, and certainly this was true of the disappointing artistic productions, of whatever genre, that we were shown. This might be saying no more than the trite (quite possibly untrue as well) generalisation that the Swedish people are not aesthetically imaginative. In any case in my opinion the care and intelligence of the arguments contained in Swedish cultural policy are much too admirable and too important to be dismissed in the areas where we might find comparable situations in Britain.

Limitations of visit
5. We did not go to Stockholm, nor did we see any remote areas of the country. I believe that we were shown carefully edited institutions and facilities in a well-endowed part of the country. All the same, I should be surprised if Östergötland were not a reasonably representative County Council with a population of 385,000, and Norrköping and Linnköping reasonably representative municipalities of about 120,000 each.

The new cultural policy for Sweden
6. The objects of the cultural policy are stated unmistakably at the outset of the NCCA's Report: 'By cultural policy, the National Council for Cultural Affairs means a concentrated structure for societal measures (i.e. measures taken by society) in the cultural field'. 'The general goal of cultural policy to be to contribute towards *creating a better social environment and promoting increased equality.*'

The aim is to exploit cultural resources to improve opportunities and conditions for people, rather than to foster the development of excellence in art for its own sake. Consequently overall priority is given to structures and systems that tend to increase accessibility of opportunities to experience arts activities, most particularly by way of active participation. Decentralisation is seen as an essential instrument of this policy. To express this it is probably worth quoting the text, which will also give the flavour of the quality of analysis and classification which pervades the Report:

'The Council proposes:

the *General goal* of cultural policy be to contribute towards creating a better social environment and promoting increased equality.

To attain the *General goal* it is necessary to have the following 7 sub-goals:

(a) *Sub-goal of decentralisation*: that the activity and the functions of decision-making in the cultural field be more decentralised.

(b) *Sub-goal of coordination and differentiation*: that the measures of cultural policy be coordinated with society's efforts in other areas and be differentiated according to the needs of various groups.

(c) *Sub-goal of community and activity*: that the measures of cultural policy be formed so as to improve communications among various groups in society and give more people the opportunity of taking part in cultural activities.

(d) *Sub-goal of freedom of expression*: that cultural policy contribute towards protecting freedom of expression and creating real possibilities for this freedom to be utilised.

(e) *Sub-goal of renewal*: that artistic, creative and cultural renewal be made possible. Artistic work must continually experiment in order to find new and convincing expression for individual and collective needs and experiences, and to document artistically the changes in our surroundings. By tradition, society's support has been given to artists of certain genres in the various fields of art. The measures of society, however, should cover the areas of art as a whole and promote development also in those genres which up to now have received little or no support.

(f) *Sub-goal of preservation*: that the culture of older eras be preserved and vitalised. This does not mean one-sided insistence on national characteristics. On the contrary, it must be expanded to cover increased contacts with the culture of other countries. Our cultural inheritance is only a part of the world's common inheritance.

(g) *Sub-goal of responsibility*: that society have the main responsibility for promoting the variety and dissemination of cultural offerings and for reducing or preventing the negative effects of the market economy.'

7. Many of the points made in the Report are so well put that it is hard to resist the temptation to go on giving quotations. I should like to draw attention to certain characteristic attitudes which underlie the argument:

(a) As already stated, social aims are paramount. The extension of 'culture consumers' from the present admittedly narrow group, as in other countries, is the most important objective. There are particular proposals for the handicapped and the deprived.

(b) State responsibility for culture is seen as not merely overlapping but actually dovetailed with many other responsibilities so as to produce an integrated social and environmental policy. Thus cultural departments, at

national, county and municipal levels, infiltrate and are suffused with the policies, resources and staff of other departments, mainly social work, education, recreation, research and medical departments. Similarly external links with national and local statutory and voluntary organisations are actively built into the policy. This is helped by the Swedish government practice of having comparatively small civil service departmental establishments, whose role is confined to broad policy. Detailed policies are worked out by special commissions and implemented by special agencies, as in the case of the NCCA.

(c) The concept is of the arts and culture as part of the State's educational responsibility and not as something on its own. At national level the investigating NCCA presented its report to the Minister for Education and Cultural Affairs, whose Ministry has the title Ministry of Education, Church and Culture. Since there is an analogous (although much larger) independent Board for Education, the situation is that two theoretically equal independent agencies collaborate on policy, present estimates to the Government, which in turn allocates the funds and devolves the responsibility for implementing approved policies back to the Board for Education and the NCCA. At county level, cultural provision is the responsibility of the Education Committee. At all levels the many (and enormously powerful) Adult Education movements are seen as key providers of cultural services and facilities. 'Educational policy and cultural policy should be seen as a unit. Schools may be considered as cultural institutions which everyone comes into contact with during a period of his life. Society's methods of taking measures in the fields of education and culture are, however, so different, that it is necessary to treat each field separately. Interaction between the two areas is, however, extensive and important.'

(d) Within this dimension, 'culture' has a wide remit. It would be thought illogical, for example, to isolate libraries, museums, or amateur arts activities from the general cultural apparatus, by whatever means detailed policies are applied. This has to be borne in mind when considering figures.

(e) The business of help to the creative artist however is considered to be quite separate (subject to para 7b above) from the business of public provision and institutional support. This will be discussed later in the paper.

(f) The limits to the effectiveness and appropriateness of a central body are fully recognised. 'It should be possible to carry decentralisation relatively far. Responsibility should rest upon the local level as far as possible. Only those tasks which cannot be carried out locally should be referred to regional and central levels. Furthermore, the initiative for such regional and central tasks should come from the local level and be conditioned by the needs which exist there.' The chosen vehicles for this decentralised responsibility are, not surprisingly, the County and Municipal Authorities. It was acknowledged by the Chairman and the officers of the NCCA whom we

met that the whole realistic success of the policy depended upon the imaginative, effective collaboration of the local authorities. It was also recognised that the local authorities have autonomy in this respect and that the decision to rely upon them as links in the chain was taking a calculated risk. The only exceptions to this were the few directly funded national institutions like the Royal Stockholm Opera, the Swedish Dramatic Theatre in Stockholm, the Institute for National Concerts, the Swedish National Theatre Centre, the Regional Music Institution and the Swedish Travelling Exhibitions (the latter four are centrally funded bodies exclusively devoted to provincial touring). On the whole, they were publicly and privately optimistic about the attitude of the local authorities, and certainly there is no lack of goodwill on the part of Östergötland County Council, nor of Norrköping and Linnköping municipal councils. The feeling was that as much public and political debate and controversy as possible should be stimulated, to keep the interest alive.

(g) The Report talks little of standards. In discussion, however, the hope was that pluralism of interests and support sources – municipal, county and state authorities, popular education movements (see para 15), press and an increasingly educated consumer-public – would provide self-regulating safeguards against poor standards, political interference and sectional propaganda.

The role of the National Council for Cultural Affairs
8. As described above, the operational role of the NCCA is comparatively limited. The Director, Erik Virdebrant, described it to us thus:

(a) Coordination of the public's views and needs in cultural matters and representation of them to the Government via the Ministry of Education, Church and Culture. (This followed from the general conclusion of the Report that a central agency would offer a better basis for Government decisions than the previous somewhat fragmented cultural administration could provide.)

(b) Grant-aiding cultural enterprises of other agencies. These appear to fall into four main categories:
 1. Wholly state-financed national institutions with their own boards of management (see para. 7f).
 2. County and municipally run institutions.
 3. Cultural activities organised and promoted by the independent national popular educational movements.
 4. Other projects. *N.B.* these do not include awards to artists (see paras 12 and 13 below).

(c) Specialist advice and service to the main cultural institutions, the national popular education movements and local authorities.

(d) Communications, information flow and the production of written material.

(e) Research and investigation. Currently two research projects are under way, one into cultural provision for young children and one into provision by and for the commercial sector of the entertainment business.

9. It was explained to me by the Head of the Research Department of the NCCA, Mr Kleberg, that the budget of the NCCA is not strictly comparable to that of the ACGB in that the NCCA, though independent, is still an arm of government and therefore required to carry out government policies mandated to it. In the first place a good deal of the funds it receives from the Government are earmarked, and in the second decisions made by Parliament during the financial year may have a direct effect on the allocation spent via NCCA. It is more a question of the Government spending its money on these responsibilities via the Council, than the Council seeking government money to carry out its policies, as is the case in Britain. For example, the employees of the Royal Stockholm Opera are employees of the State, and the Opera is wholly supported by the State, which channels its allocation through the NCCA. Nevertheless the NCCA is naturally required to make estimates for submission to the Ministry, and the figures given below relate to these estimates for 1975/76.

10. The total budget for 1975/76 is 400 million Swedish crowns (very roughly 10 to the £). Of this, 80 million crowns are spent on the Swedish Dramatic Theatre and the Royal Stockholm Opera together – 20% of the budget. Other expensive customers are the touring producing institutions: the Institute for National Concerts, the Swedish National Theatre Centre, the Regional Music Institution and the Swedish Travelling Exhibitions. There is, not surprisingly, a lot of controversy about this. Libraries are mainly county and municipal responsibilities, but a small amount of about 4 million crowns of State money is allocated through NCCA for special projects.

11. The direct operational responsibilities of the NCCA *exclude* the following:
(a) popular adult education
(b) awards to artists
(c) art, music and drama education
(d) radio and television
(e) the press
(f) care of national antiquities and monuments

Awards to Artists
12. In its Report, the original investigating team decided that the whole question of help to the individual artist (characteristically described as 'cultural worker') was a related, but separate issue. A separate Report was therefore prepared and had only just been published when we visited the country, i.e. 18 months after the first Report. It is not available in English. The Report, entitled 'The Artist in Society', was being presented to Parliament in June.

13. It contains three basic avenues of help to the artist, presented in order of desirability:

(a) extension of markets. Encouragement of local authorities to buy work and employ artists; decoration of public buildings; subsidies to 'producing' managements, including publishers (see para 14 below);

(b) substantial extension of bursaries, scholarships, special project grants, commissions, prizes and other short-term specific awards;

(c) recognition of the artist as a qualified professional in all aspects of financial benefits, and job opportunity regulations, of the Social Security/Unemployment Benefit system.

The bursaries will be administered by a system of juries independent of NCCA. They will be composed mainly of representatives from the various artists' unions, with some outside representation (including NCCA). The problems of making quality judgements are not faced up to in this aspect of decision making: the attitude is that once a policy has been established and clearly explained there will be enough money for all eligible claimants. Although no one would say unequivocally that there is a bottomless pit, questions about exactly how priorities are to be assessed and how one is to do the assessment tend to get evasive answers.

Help for Writers

14. As well as the general proposals for help to artists, a special scheme for helping writers is now before Parliament. Depending on which version of the scheme is finally approved it will cost 3·3 or 4·8 million crowns this year, and this money is channelled through NCCA. The principle underlying the scheme is support to publishers, who of course accept the problem of selection and rejection on grounds of quality themselves. In return for accepting the subsidy the publisher guarantees to keep the retail price below 29 crowns and to distribute an agreed number of free copies to libraries and rural bookshops. There will be an upper limit of 400 titles (considered ample for all claims) a year and books must conform to general guidelines of the definition of literature. Eligibility, if in doubt, will be interpreted by a special panel.

Public Lending Right

15. Finally, it must be noted that Sweden has been operating a Public Library Lending Right for authors since 1954. This is administered by an independent board consisting mainly of Writers' Union representatives in whose interests it naturally is to keep administration costs as low as possible. The method of calculation used is not total recording but sampling, and payments are made on a sliding scale. The calculation starts with a unit of benefit to the author whose book is borrowed. This unit is calculated at 24 öre (about 2½p) in the current year, of which the author receives about 17 öre. There is an upper limit of

benefit: above this limit the best-sellers' surpluses and a proportion of the remaining 7 öre go to supplement the benefits of seldom-read writers.

National Popular Education, Labour and Trade Union Movements
16. These bodies are enormously important and influential in Sweden. It is estimated that nine out of ten adults are members of one or more of the adult education organisations, of which the largest is the equivalent of the WEA. Other educational associations are church, temperance, trade-union or party political based. Many of them have ambitious cultural programmes themselves, and are used as vehicles for State, County and Municipal policy in the provision of the arts. The technique used is the Study Circle: facilities and instruction are provided for any group of people who want to study or engage in any kind of educational or cultural pursuit. Great emphasis is laid on democracy: course programmes are supposed to be worked out by discussion rather than imposed, and tutors are described as 'leaders'. Again, the objective of equality of opportunity is dominant – a 'second chance' for those whose formal education left gaps of one kind or another. Alongside their educational programmes, the labour and trade union movements are behind the People's Houses. These are community leisure centres which often have quite good arts-promoting facilities and programmes. There are nearly 1,000 of these in Sweden.

Östergötland County Council
17. The County Council is the Education Authority and the Education Committee has overall responsibility for cultural matters. Following the recommendations of the NCCA report they are currently setting up a Cultural Sub-committee of the Education Committee. In addition to considerable expenditure on the cultural activities and facilities of its own institutions (schools, High Schools, hospitals, etc) the County Council spends about 4 million crowns a year in grants to other bodies. Some salient items are:

Regional Theatre Company	500,000 kr
Norrköping Orchestra	350,000
Touring theatre	33,000
Music clubs, etc.	56,000
County museum	390,000
Other museums	147,000
Cultural activities of educational movements	625,000

The County Council also supports substantially a voluntary organisation called Östergötland County Education Association. This exists to coordinate the activities of the dozen or so Popular Education movements, to act as a link between them and the County Council, and to promote arts performances and

exhibitions. In this role the County Education Association operates similarly to the tours promotions of some English regional arts associations, except that most of the promotional work is done by the education movements themselves, not by local arts societies. It takes care of all negotiations with artists and all financial risks. In the booklet advertising this year's offers there are 38 music groups, ranging from the Norrköping Symphony Orchestra to solo guitarists. There are about 18 drama offerings and half a dozen literature events.

Norrköping Municipality

18. The town of Norrköping has a population of 120,000 and is spending in the current year 17·7 million crowns (about £2m) on cultural activities:

Regional Theatre Company	2,200,000 kr
Norrköping Symphony Orchestra	2,400,000
Touring theatre and music	700,000
Central and branch libraries	6,500,000
Museums	1,100,000
Grants to Adult Education organisations	4,800,000
	17,700,000

19. The orchestra is fully professional and full-time. It has a playing strength of 47 but there are plans to increase this to 70. It gives at present 147 school concerts and 100 public concerts a year. There are no proper concert halls anywhere in Östergötland – the 600-seat Town Hall of Norrköping is its main base, and acknowledged to be inadequate. The theatre company is financed jointly by Norrköping, Linnköping and the County Council: it is officially based in both towns, and shuttles its productions. Both theatres are 19th-century renovations and seem excellent, with superb equipment. The museum is said to have the best collection of early 20th-century Swedish art in Sweden.

Conclusion

20. Unless we were being almost deliberately misled, there is a great deal of common ground between the state, the counties, the municipalities and the independent organisations in their desire to improve the quality and increase the accessibility of cultural life in Sweden. One can be pessimistic and say that the apparent lack of real imagination and talent in the artistic manifestations is the result of too much abstract theorising and bureaucratic planning, or one can be optimistic and say that the combination of a carefully thought out policy from the centre, allowing plenty of freedom of manoeuvre for the local and independent partners, already seems to have gained the active collaboration of local authorities and will, in time, begin to have a real effect on the arts and the quality of life.

APPENDIX 4

Those who have submitted written or oral evidence to the Enquiry, given information or been consulted

Nigel Abercrombie
ABF, Östergötland, Sweden (Workers Educational Association)
Action–Space
D. Adamson
Alyn & Deeside District Council
Viscount Amory
Sir Colin Anderson
The Marchioness of Anglesey
Lord Annan
Arnolfini Centre, Bristol
Art Workers' Guild Trustees, Ltd
Arts Council of Great Britain
Members of the Fringe and Experimental Drama Committee of the Arts
 Council of Great Britain
Artists Placement Group
Artists' Union
Arts Research Society
Arvon Foundation
Association of British Orchestras
Association of British Theatre Technicians
Association of Community Artists
Association of District Councils
Association of Metropolitan Authorities
Councillor B. Atha
G. Auty

Professor H. C. Baldry
Lord Balfour of Burleigh
H. Barton
Bath City Council
BBK (the Artists' Union), Amsterdam
Beatord Centre, Devon
Belgrade Theatre, Coventry
Maurice Bennett
Sir John Betjeman
Bexley Arts Council
Birmingham Arts Lab

Birmingham City Council
Birmingham Marketing Project (Peter Cox Associates)
Blackburn, Borough of
Miss Caroline Blakiston
The Dr E. Boekmanstichting, Amsterdam
Peter Booth
Sir Ben Bowen Thomas
Lord Boyle
Miss Su Braden
Bradford Art Galleries and Museums
Bradford Metropolitan District Council
M. Bradshaw
Geoffrey Brand
Bridgnorth Community Arts and Environmental Centre
Brighton and Hove Arts Council
Bristol Old Vic Trust, Ltd
British Broadcasting Corporation
British Council
British Dance-Drama Theatre (Educational Dance-Drama Theatre Ltd)
British Federation of Music Festivals
British Film Institute
British Society of Master Glass-Painters
Borough of Burnley
Bury, Metropolitan Borough of
Bush Theatre
M. Byrne

Miss S. Cameron
Campus West Leisure and Arts Centre, Welwyn Garden City
Canada Council, The
Canadian Conference of the Arts
Cannon Hill Arts Centre, Birmingham
Caradon District Council
Cardiff, City of
P. Carey
Carrick District Council
Mrs Ernestine Carter
Sir Hugh Casson
R. Chapman
Chapter Arts Centre, Cardiff
Peter Cheeseman
Cheshire County Council
Chesterfield Borough Council

Chesterfield Civic Theatre
Churchill Theatre, Bromley
Citizens' Theatre, Glasgow
City of Birmingham Symphony Orchestra
City University
Clwyd County Council
Colwyn Borough Council
R. Corder
Professor C. Cornford
Cornwall County Council
Council of Regional Theatre
J. H. Coultman
Countryside Commission
Professor R. Courtney
J. Crabbe
Councillor P. Cracknell
Crafts Advisory Committee
Crewe Theatre Trust, Ltd
Crucible Theatre, Sheffield
Miss Constance Cummings
Sir Charles Curran
Cwmni Theatr Cymru

Dance for Everyone, Ltd
Miss N. D'Arbeloff
I. Davies
Sir Alan Dawtry
Delyn Borough Council
R. A. Dennett
Department of Education and Science
Derby Playhouse
Design Council
Development Commission
Devon County Council
Digswell Arts Trust
Dorking Halls Concertgoers' Society
David Dougan
D. F. Dudley
Alexander Dunbar
Neil Duncan
Miss M. Dunn
Miss V. Duthoit and others

East Lincolnshire Arts Centre Ltd
East Midlands Arts Association
East Sussex County Council
Eastern Arts Association
Eastern Authorities' Orchestral Association
Mrs A. Ebbage
Viscount Eccles
Mr and Mrs M. Edwards
Captain J. Elwes
'Emma' Theatre Company
English National Opera
English Tourist Board
Viscount Esher
Everyman Theatre, Cheltenham
Everyman Theatre, Liverpool
R. Exley

Andrew Fairbairn
Dennis Farr
Andrew Faulds, MP
Federation of British Artists
Federation of British Craft Societies
Federation of Playgoers' Societies
Lord Feversham
'Fires of London'
'First Group' (Henry Anderson and others)
Alfred Francis
Foots Barn Theatre, Cornwall
Forum Music Society, Manchester
Clive Fox

Galactic Smallholdings Ltd
Gateway Theatre, Chester
R. A. German
Lord Gibson
T. R. Gibson
Gladstone Pottery Museum, Stoke-on-Trent
Lord Goodman
C. Gorman
Great George's Project, Liverpool
Greater London Arts Association
Greater London Council
Greater Manchester Council

B. Green
O. Greiner
Grove Park Amateur Dramatic Society, Wrexham
Mrs D. Guthrie
Gwynedd County Council

Hallé Concerts Society
Roderick Ham
Hampshire County Council
The Earl of Harewood
Haringey Arts Council
Harrogate Theatre
Hartlepool, Borough of
Harvey (John) and Sons, Ltd
M. Hawker
Hertfordshire County Council
Mrs Nina Hibbin
R. Hills
Mr and Mrs Victor Hochhauser
Denys Hodson
Dr G. T. Hughes
Hurlfield Campus, Sheffield
Robert Hutchison
Hyndburn District Council

Imperial Tobacco, Ltd
Incorporated Society of Musicians
Independent Broadcasting Authority
'Insticart', Washington New Town
Institute of Directors
International PEN
Interplay Inflatable Structures
Ipswich Theatre

Bernard Jacobson
D. E. P. Jenkins
Hugh Jenkins, MP
Mrs Annely Juda

W. Kallaway
Kent County Council
Kerrier District Council
A. King

Kingswood District Council
N. Konstam
Mrs B. Kulick

Lancashire County Council
S. Lane
Leeds District Council
Leicester City Council
Leicester Theatre Trust, Ltd
Leicestershire County Council
Harold Lever, MP
The Library Association
Lincoln Theatre Association
Lincolnshire and Humberside Arts
Lindsay and Holland Rural Community Council
Linnköping Municipality, Sweden
Little Theatre, Rhyl
Liverpool, City of
Liverpool Playhouse
Liverpool Visual Communications Unit
Llanover Hall, Cardiff
Lord Lloyd of Hampstead
London Borough of Camden
London Borough of Greenwich
London Borough of Tower Hamlets
London Boroughs Association
London Mozart Players
London Orchestral Concert Board, Ltd
London Sinfonietta

Iain Mackintosh
Bryan Magee, MP
George Malcolm
Manchester, City of
Miss R. Maran
P. Marcan
Marlowe Theatre, Canterbury
T. Martys
Stewart Mason
John May
Sir Robert Mayer
Stephen Mennell
Dr D. McCaldin
Gordon McDougall

Mercury Theatre, Colchester
Merseyside Arts Association
Merseyside County Council
Mid-Glamorgan County Council
Mid-Pennine Association for the Arts
Roland Miller
The late Sir Thomas Monnington
J. A. L. Morgan
Peter Morrison
Sir Claus Moser
Museums Association
Museum of Modern Art, Oxford

A. R. Nairne
National Association of Arts Centres
National Association of Youth Orchestras
National Book League
National Council for Cultural Affairs, Sweden
National Federation of Music Societies
National Heritage
National Institute of Adult Education
Netherlands Government (Ministry of Cultural Affairs, Recreation and Social
 Welfare)
Newcastle-upon-Tyne, City of
Nicholas Yonge Society
Normal College, Bangor
Norrköping Municipality, Sweden
North Cornwall District Council
North Devon District Council
North of England Museums Service
North Hertfordshire, the Arts Council for
North Staffordshire Polytechnic
North Wales Arts Association
North West Arts
North West Region Economic Planning Council
Northampton Repertory Theatre
Northamptonshire County Council
Northcott Theatre, Exeter
Northern Arts
Northern Dance Theatre
Northern Sinfonia Concert Society
Northumberland County Council
Nottinghamshire County Council
Nottingham Playhouse

Lord O'Brien
Oldham District Council
Orchard Theatre Company
E. Orr
Östergötland County Council, Sweden
Oxford Area Arts Council
Oxfordshire County Council

Palace Theatre, Watford
Palace Theatre, Westcliff
Miss G. Parkinson
Professor Alan Peacock
A. B. V. Pedlar
Pendle District Council
Mrs L. Pennant-Rea
Penwith District Council
Daniel Pettiward
Anthony Phillips
Sir William Pile
Play-Fair Productions, Children's Theatre Westminster, Ltd
Player (John) and Sons
Plymouth City Council
Polka Children's Theatre, Ltd
Portsmouth City Council
Powys County Council
Pump House Theatre and Arts Centre, Watford
Puppet Centre Trust

Quality of Life Experiment: Alyn, Deeside and Delyn
Quality of Life Experiment: Stoke-on-Trent
Quality of Life Experiment: Sunderland

Mrs H. Ramage
Reading Borough Council
Redgrave Theatre, Farnham
Stanley Reed
Sir Paul Reilly
Renaissance Theatre Trust
Restormel District Council
Rijkschouwbergcommissie, Amsterdam
Dr. and Mrs. Charles Ritcheson
W. Ritchie
The Earl of Rosse

Rossendale District Council
Rotherham Borough Council
Rowan Gallery
Robert Rowe
Royal Academy of Arts
Royal Exchange Theatre Company, Manchester
Royal Lyceum Theatre (Edinburgh and Lothian Theatre Trust)
Royal Opera House, Covent Garden
Rural Community Council, Isle of Anglesey
Rural Music Schools Association
Sir Gordon Russell
G. H. W. Rylands
D. Rymer

Salisbury District Council
Victor Schonfield
Robert Scott
Scottish Arts Council
R. M. Scupholm
Baroness Sharp
Roy Shaw
Sheffield District Council
Miss B. Skiold
Dr B. L. Smith
Society of County Librarians
Society of County Museum Directors
Society for Education Through Art
Society of Professional Arts Administrators
South East Arts Association
South East Wales Arts Association
South Glamorgan County Council
South West Arts
South Yorkshire County Council
Southampton District Council
Southern Arts Association
Mrs Joanna Spicer
Sports Council
Staffordshire County Council
Standing Commission on Museums and Galleries
Standing Conference for Amateur Music
Standing Conference of Regional Arts Associations
Peter Stark
Miss D. H. Stern

Norman St John-Stevas, MP
Eric Stevens
Stichting Culturele Raad Nordholland, Netherlands
Angus Stirling
M. Straight
Stoke-on-Trent, City of
Mrs Emily Stone
Sunderland Arts Centre
Sunderland District Council
Swansea, City of
Miss Elizabeth Sweeting
Norman Sykes

Miss S. Tarry
Tees-Side Federation of the Arts
Tegryn Art Gallery, Menai Bridge
Thamesdown, Borough of
Theatr Gwynedd
Theatre Centre, Ltd
Theatre Quarterly (TQ Publications, Ltd)
Theatres Advisory Council
Thorndyke Theatre, Leatherhead
Aneurin Thomas
Barry Till
D. Tinker
John Tooley
Torridge District Council
Trades Union Congress
Trafford, Borough of
Triad Arts Centre, Bishops Stortford
Tyne and Wear County Council
Tyneside Theatre Trust

Unicorn Theatre for Young People
University College, North Wales
University of Lancaster: Centre for North West Regional Studies

Professor John Vaizey
Victoria Theatre, Stoke-on-Trent

Wales Tourist Board
Wansbeck District Council
Wansdyke District Council

M. Weaver
Welsh Arts Council
Welsh Films Board
Welsh National Opera and Drama Company, Ltd
Welwyn and Hatfield District Council
West Glamorgan County Council
West Midlands Arts
West Midlands County Council
West Wales Association for the Arts
West Yorkshire Metropolitan County Council
Westminster, City of
Western Orchestral Society, Ltd
Sir Huw Wheldon
Eric W. White
Whitworth District Council
Sir Hugh Willatt
David Willcocks
Wills, W. D. & H. O.
Mrs Enid Wistrich
Mrs Oliver Woods
Woodspring District Council
Workers Educational Association, Gwynedd
Worthing, Connaught Theatre
Wrexham Maelor Borough Council
William Wright
John Wyckham

York Theatre Royal
Yorkshire Arts Association
Brian Young
H. Young
Youth and Music
Yvonne Arnaud Theatre Management Ltd, Guildford

Regional Arts Associations in England and Wales

1. Northern
2. Yorkshire
3. Merseyside
4. North West
5. Lincolnshire and Humberside
6. West Midlands
7. East Midlands
8. Eastern
9. South West
10. Southern
11. Greater London
12. South East
13. North Wales
14. West Wales
15. South East Wales

AREA ARTS ASSOCIATIONS
within the North West
Arts Association area

A. Fylde
B. Mid-Pennine

AREA NOT COVERED BY ANY
ASSOCIATION

C. Buckinghamshire

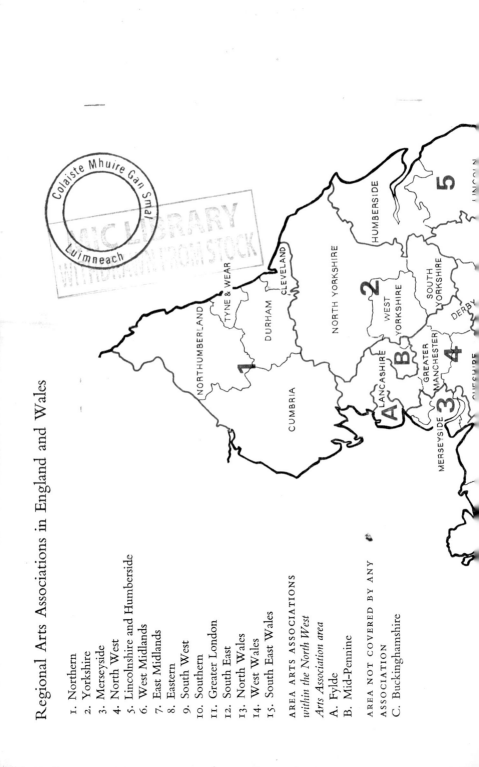